LEE MILLER
A
WOMAN'S
WAR

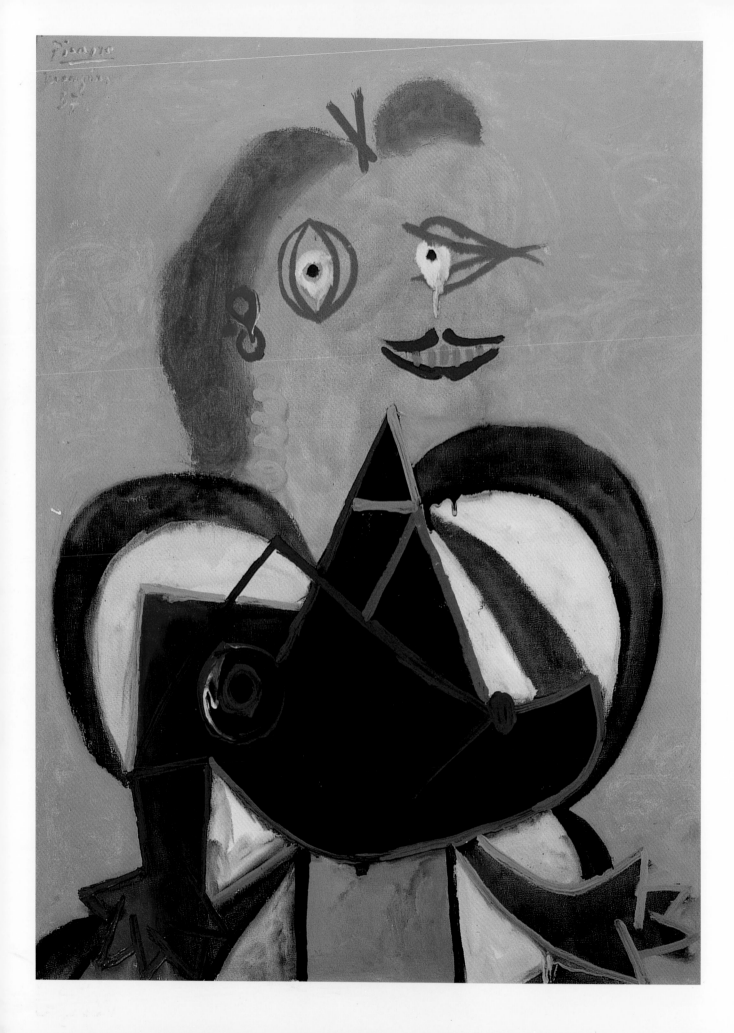

HILARY ROBERTS

LEE MILLER
A WOMAN'S WAR

INTRODUCTION
BY ANTONY PENROSE

Thames & Hudson

IN PARTNERSHIP WITH

IWM
IMPERIAL WAR MUSEUMS

First published in the United Kingdom in 2015 by Thames & Hudson
Ltd, 181A High Holborn, London WC1V 7QX

Published on the occasion of the major exhibition 'Lee Miller:
A Woman's War' at the Imperial War Museum, London,
15 October 2015 – 24 April 2016, sponsored by Barclays

British Library Cataloguing-in-Publication Data
A catalogue record for this book is available from the British Library

ISBN 978-0-500-51818-2

Printed and bound in China by C & C Offset Printing Co. Ltd

To find out about all our publications, please visit
www.thamesandhudson.com. There you can subscribe
to our e-newsletter, browse or download our current catalogue,
and buy any titles that are in print.

Hilary Roberts is Research Curator of Photography at Imperial
War Museums (IWM). A specialist in the history of war photography,
she works closely with photographers covering current conflicts as well
as collections of historic war photography. She has numerous broadcasts
and publications to her name, including *The Great War: A Photographic
Narrative* (2013). Recent exhibition projects include the highly praised
'Don McCullin: Shaped by War' (2010) and 'Cecil Beaton: Theatre of War'
(2012), both for IWM.

PAGE 224
How to Make an Art of the Happy Weekend,
Farley Farm House, Sussex, England, June 1973

A revitalized Miller, now Lady Penrose, prepares
a summer pudding in the 'Old Kitchen' at Farley Farm
House for a feature in *House & Garden* magazine. Miller's
interest in cookery helped her overcome the legacy of
war and provided a new outlet for her humour and love
of Surrealism. Having achieved fame as a fashion model,
artist's muse and professional photographer, Miller now
found celebrity as a Surrealist cook.

FRONTISPIECE
Pablo Picasso, *Portrait of Lee Miller as*
L'Arlésienne, Mougins, France, 1937

Picasso's perceptive portrait of Lee Miller as a woman
from Arles was painted from the imagination in the
south of France shortly before the Second World War.
Beautiful, charismatic and independent, but perpetually
restless and easily bored, Miller possessed many of the
characteristics of the stereotypical Arlésienne.

INTRODUCTION
LEE MILLER:
THE UBIQUITOUS IMAGE

Antony Penrose

In an interview of 1932, Lee Miller said: 'What you mostly do is absorb the personality of the man you are working with. The personality of the photographer, his approach, is really more important than his technical genius. All photographers work with the same means – cameras and lights. The thing that makes one man's work finer than the others is his honesty, his sincerity.'[1] Throughout her remarkable life, Miller worked with, inspired and was in turn inspired by an important group of innovatory artists and photographers, all of whom celebrated and exploited the female form. Through their perceptive but affectionate portraits of Miller, we gain a sense of this beautiful, talented and complex woman, as well as of the influences that shaped her own work. Lee Miller was my mother, and although I hardly knew her while she was alive, I have become aware of much of her life and personality through the legacy of these images.

The earliest portraits of Miller were taken by her father, Theodore. A mechanical engineer by trade, he was also a keen amateur photographer who used his camera to record the things that interested him. From her birth in 1907 onwards, his daughter was a constant presence in his snapshots. The 'cute' photograph of Miller aged eight months, seated on her potty (see page 26), seems innocent enough when viewed in isolation. But Theodore's photographs, as a body of work, suggest a consistent invasion of the natural boundaries between a father and his daughter. When Miller was eight years old, Theodore started taking pictures of her in the nude. In 1928, when she was eighteen, he began using a camera that produced 3D stereoscopic images (see page 29), a format often associated with pornography and burlesque. He continued this practice until Miller was in her early twenties.

Theodore's photography is made all the more startling by the fact that Miller was raped, aged seven, by the son of a family friend and infected with gonorrhoea. This trauma was a family secret, which Miller herself took to her grave. Theodore's nude photography might have been conceived as an attempt to help his daughter rediscover her self-confidence, but its predatory and voyeuristic nature suggests that he used the camera for his own gratification, particularly as the compass of his imagery extended to Miller's female friends in their late teens. Although he was described as an amateur photographer of note,[2] his images are mostly depressingly

banal. Theodore does not appear to have exhibited or published his photographs, and his membership of the Amrita Club, an exclusive, male-only domain in Pough-keepsie, New York, gives rise to uncomfortable thoughts about their potential use.

Although Theodore's nude photographs of Miller may have helped her to learn how to pose for the camera, she often looks ill at ease. Her detached gaze suggests a numbed blankness of dissociation, a behaviour she almost certainly adopted in order to cope with her childhood trauma. This dissociation served her well in later life and made her irresistible to men looking for a challenge in romance. It was also responsible for Miller's renowned fearlessness when covering combat in Europe during the Second World War. David E. Scherman, her friend and collaborator, once stated: 'Lee Miller was never afraid of the evil that men can do.'[3]

In 1927, while studying at the Art Students League in New York City, Miller was discovered by Condé Nast, publisher of such women's magazines as *Vogue* and *Vanity Fair*. A portrait of her by the French fashion illustrator Georges Lepape appeared on the front cover of American *Vogue* a few weeks later.[4] Miller went on to be photographed regularly by Edward Steichen, chief photographer at Condé Nast from 1923 to 1938, and she and Steichen developed a close friendship, one that would last until the latter's death in 1973. Steichen's distinguished career included roles as a pioneering artistic and military photographer, but his fashion photography was shaped by *Vogue*'s requirements for classically glamorous images. It was an ideal partnership. Every session was a photography tutorial for Miller, and Miller's looks favoured Steichen's style. His images show her as transcendentally elegant and sophisticated, an illusion of wealth and glamour a world away from her reality.

Miller's 'supermodel' career ended as suddenly and dramatically as it had begun when one of Steichen's photographs of her appeared in a Kotex advertising campaign (see page 28). Public reference to this recently invented feminine-hygiene product was strictly taboo in American society. No couture house wanted the 'Kotex Girl' modelling its fashions, and so the work dried up overnight. Having begun to tire of the life, Miller was not unduly worried; in fact, she had begun to aspire to become a photographer herself. 'I would rather take a picture than be one', she stated boldly.[5] In 1929, armed with an introduction from Steichen to the artist and photographer Man Ray, Miller left the United States for Europe.

Based in Paris, Man Ray had established himself as a painter, poet, maker of objects and one of the most exciting Surrealist photographers of the time. He photographed many of the leading Surrealists, and was friends with such luminaries of art and literature as Picasso, Max Ernst, Paul Éluard and James Joyce. Miller later recalled her first meeting with Man Ray: 'I told him boldly I was his new student. He said he didn't take students and anyway he was leaving Paris for his holiday. I said, I know, I'm going with you – and I did. We lived together for three years. I was known as Madame Man Ray, because that's how they do things in France.'[6]

Man Ray, who often worked as a fashion photographer, found Miller's understanding of the American market for fashion images useful. He in turn tutored Miller in photography. She learned the practice so rapidly that her own fashion work was published in French *Vogue* a year later.[7] Miller also posed for George

Hoyningen-Huene (see pages 34 and 35), French *Vogue*'s chief photographer from 1925 to 1935, finding herself effortlessly at one with his modernist style and learning from him advanced studio lighting techniques.

A continuous exchange of inspiration was part of Miller's life, and with Man Ray it went way beyond fashion. Miller was by nature a Surrealist. The movement for her was far more than art; it represented her chosen way of life. Miller bought a Rolleiflex camera and began photographing random 'found images' – the photographic equivalent of the Surrealist 'found object' – around the Parisian district of Montparnasse.

In terms of their professional relationship, Miller and Man Ray are best known for their rediscovery of the Sabattier effect – or 'solarization' as they called it – in 1929. While processing a negative in the darkroom, Miller was startled by a rat. She screamed and turned on the light. Man Ray, unconcerned about the rat but definitely not indifferent to the negative, snapped off the light and dumped the negative in the fixer. The result of the second exposure was the reversal of the darkest tones, with the mid-tones almost untouched but leaving a magical line along the boundary between dark and light (see pages 30 and 31). The technique, which they both used, became a symbol of their artistic association.

Man Ray's photographs of Miller are some of the finest of his career. They are informed by emotion as well as technique. Yet adherence to the Surrealist principle of free love and the easy exchange of partners did not allow for the old-fashioned, base emotion of jealousy. Man Ray's highly sensual image of shadow patterns on Miller's naked torso outwardly presents a celebration of erotic beauty (see page 32). Our perception of it changes, however, when we discover that the image is a crop of one of three photographs in which her head is showing. The triptych has the lyrical tenderness of a lover photographing his loved one, but Man Ray gives us a single image in which he has sheared off her head, depriving her of her intelligence, her will and her rights. In doing so, he reduces her to a beautiful, erotic object he can finally own and control.

During her time with Man Ray, Miller began to emerge as an accomplished photographer in her own right. Fashion and portraiture formed the basis of her commercial work, and her earnings allowed her to make some of her most exciting Surrealist images as a by-product. But his jealousy and her independence ended their professional and emotional partnership. In 1932, after three years together, they parted acrimoniously and Miller returned to New York. Man Ray re-entered her life as a friend in 1937. This relationship endured until Man Ray's death in 1976.

Between 1932 and 1934 Miller had her own studio in New York, occasionally doubling as her own model when money was short. This venture ended with her impulsive marriage in 1934 to Aziz Eloui Bey, an Egyptian businessman whom she had met in Paris. Miller moved to Cairo to be with her husband, and did not pick up her Rolleiflex again for almost a year. Her work from this period displays a freedom that she had lost in New York. But she was not interested in the social lives of the female members of the expatriate community that surrounded her. Eloui Bey understood that nothing could counter Miller's yearning for Paris, and in June 1937,

with the marriage in acute difficulty, he bought her a ticket to the French capital on Misr Airwork, Egypt's new airline.

On the night of her arrival in Paris, Miller attended a Surrealist fancy-dress ball. There, she met Roland Penrose, a quiet, shy Englishman who later described the experience of first encountering Miller as like being struck by lightning. At the time of their meeting, Penrose was a Surrealist artist of some distinction, known primarily for his paintings; later, he would also win renown for his collages incorporating images taken from postcards. Apart from a brief period of reportage during the Spanish Civil War (1936–9), Roland's photography served as an adjunct to his painting, with some images becoming source material for other works.

For the next three months, from June until mid-September 1937, Miller and Penrose were inseparable, visiting Cornwall with Man Ray, his new girlfriend, Adrienne Fidelin (known as 'Ady'), and Paul and Nusch Éluard. They also visited Mougins, on the Côte d'Azur, where Picasso – who was then at his closest to the Surrealists – was staying with his new lover, the Surrealist photographer Dora Maar. Using his bedroom as a studio, Picasso painted every day, creating a series of portraits in which Miller, Nusch Éluard and Maar appeared dressed in the style of the Arlésiennes (women of Arles). The Arlésiennes are known for their great beauty and striking local costume, but Picasso's choice of theme may have been inspired by Alphonse Daudet's short story 'L'Arlésienne', published in 1867.[8] The story is an account of a disastrous love affair in which a young man is driven to suicide by the brutal termination of his Arlésienne's love. The beautiful and libertine women surrounding Picasso, all living the Surrealist ideal of *l'amour fou*, may well have prompted a reference to the dangers of infatuation.

Picasso's portraits of Miller from 1937 contain many other truths. In the version that Penrose bought and gave to Miller (see page 2), Picasso colours her face bright sunshine-yellow, a reference to the intense warmth of her personality and the brilliance of her intellect. Even more compellingly, her facial profile closely resembles the pose she often adopted in photographs. The Arlésienne series represents a period of holiday fun and temporary relief from the horrors of the Spanish Civil War. Earlier in 1937, Picasso had painted *Guernica* – a twentieth-century masterpiece – and would continue to paint on this theme when he returned to Paris.

Miller returned to Egypt and Penrose to London, but their affair continued. Later that year, Penrose created his first painting of his absent love, *Night and Day* (see page 47). Ever intuitive, he succeeds in capturing much of her spirit. Miller is shown formed out of earth, air and fire; water, however, so often an artistic symbol for emotion, is absent. Although he was unaware of the cause, Penrose understood that Miller was emotionally dissociated. His painting therefore provided some funnels by which to conduct the water, or the emotion, safely away.

In June 1939 Miller separated from Eloui Bey and joined Penrose in London. Knowing that war was imminent, they paid a brief visit to their Surrealist friends in France, returning to England as war was declared. As an American, Miller was advised to return to the United States, but wanted to be part of the war effort.[9] Penrose painted her again at this time. In *Good Shooting* (1939; see page 56), Miller appears

chained to a bullet-scarred wall, her arms framing a scene evocative of the Norfolk Broads. The painting's French title, *Bien visé*, translates as 'well screwed', so it is something of a paradox that Miller's pubic area is hidden behind what appears to be armour plating. Perhaps Penrose was feeling protective or possessive in this moment, aware, like Man Ray, that Miller gave her body freely, but never her mind.

In 1942, shortly after America's entry into the war, David E. Scherman, a photojournalist for *Life* magazine, arrived in London. He and Miller became friends, collaborators and, eventually, with Penrose's blessing, lovers. Penrose, now a camouflage instructor, had recently received a commission from the regular army to help run a military camouflage school in Norwich. Finding it difficult to hold the attention of the troops, he asked Scherman to augment his lecture slides with photographs of Miller naked except for a camouflage net and a liberal coating of Elizabeth Arden's new camouflage cream (see page 89). As an American photographer, Scherman had access to supplies of Kodachrome colour film. The resulting photograph, created out of a shared love for Miller, became a shared image. Penrose later reported that his lectures were very popular, with some soldiers returning numerous times.

Miller had been working for *Vogue* magazine since the early days of the war, but it was Scherman who encouraged her to become a US Army war correspondent (see page 93), a position that would enable her to cover the role of women in the armed forces. In a film interview, he recalled: 'I explained to Lee – you are an American, why don't you just get a uniform and get accredited to the American Army? She said, "That's a good idea." So we all ganged up and got her accredited to the American Army. She promptly bought a uniform in Savile Row.'[10]

Miller's new status allowed her to produce a compendious photographic survey of servicewomen's contribution to the war effort in Britain. But this was not enough for Miller. In July 1944, a few weeks after D-Day, she returned to France, covering the work of the US 44th Evacuation Hospital at La Cambe during the fighting for St Lô. By now, with Scherman's guidance and support, she was supplementing her photography with text. Scherman later recalled:

> She was an absolute natural writer … I would help her – most of the help was in getting her brandy, or waking her up when she fell asleep or in punching her when she nodded over her typewriter. It was not the sort of help where I gave her words or filled in sentences for her because she was furious if anybody gave her any help at all whatever with her words.[11]

Miller's article 'Unarmed Warriors' heralded her domination of *Vogue* features for the next eighteen months,[12] as exemplified by her next dispatch from France covering the siege of St Malo in August 1944. Scherman's images of her as a war correspondent in the field bear no reference to the woman who was once a leading model. As a female war correspondent, Miller was strictly forbidden from entering a combat zone, yet this did not prevent her from throwing herself into

reporting the last five days of intense fighting by the US 83rd Division (see page 116). Briefly placed under house arrest for violating the terms of her accreditation, Miller was eventually permitted to travel to Paris, arriving as it was liberated. She remained close friends with the 83rd Division, following them across Europe into Germany in the spring of 1945 (see page 135, bottom).

In France, Miller had become aware of the internment camps for Jews and dissidents; in Germany, she was confronted with the concentration camps. She visited four in all, photographing Buchenwald and Dachau. Scherman described her taking photographs at the latter 'encased in an ice-cold rage, filled with hate and disgust'.[13] Miller's unflinching close-ups of the camp remind us that she was searching for missing friends, and the intensity of her coverage stems from her desire to let the world know of this unthinkable atrocity. That evening, she and Scherman travelled from Dachau to their luxurious billet in Munich. Unusually, given the acute shortage of coal, the bathroom had hot water, soap and an abundant supply of towels. Miller took a bath, and Scherman, realizing they had an unbelievable scoop, photographed her doing so (see page 163). For this was Hitler's bathroom in his apartment on Prinzregentenplatz. To show where they were, they placed a vanity portrait of Hitler by Heinrich Hoffmann beside the tub. A vile kitsch nude by Rudolf Kaesbach on the table provides a visual snub to Hitler's ideas on 'degenerate art', and Miller's boots have soiled the Führer's pristine bathmat with the filth of Dachau. This image is so much more than just a woman in a bath. Scherman shows Miller as a victor, trashing the most private space of the vanquished foe.

There is no erase button for the traumatic images that enter our minds. They are trapped inside, gathering potency with every attempt to suppress them. The unexpressed trauma of Miller's childhood rape and wartime experiences formed a corrosive cocktail, building in pressure until she had no option but to crack. Today, we would recognize Miller's condition in the post-war years as post-traumatic stress disorder, but for her there was no relief from the crushing fatigue and recurring mental torment. Penrose's candid photograph of Miller, taken in Arizona in 1946 shortly after her return from the war, sidesteps her instinctive model's pose, showing her completely exhausted (see page 180).

Penrose, always loving, kind and intuitive, was powerless to reach Miller as she drifted into a downward spiral of depression and alcohol abuse. His painting of her from 1949, *Breakfast* (see page 183), shows her as a monochrome silhouette. She shelters behind her newspaper, framed by a window that evokes the bars of a prison cell. The flamboyant colours he formerly used to describe her are replaced here with shades of grey.

In 1949 Penrose bought Farley Farm in Chiddingly, East Sussex. He thought the tranquillity of the old farmhouse might help Miller recover. Her first reaction was dismissive, but she slowly grew to love it, and the farm provided her with a location for her fashion photography. After the war, she continued to photograph for British *Vogue* but found the constraints of studio life unbearable. She was demotivated, and her ability to meet deadlines had deserted her. Audrey Withers, the peerlessly intelligent and sensitive editor of British *Vogue* from 1940 to 1960, was

sympathetic and tried to accommodate her. Eventually, however, Penrose secretly begged Withers to stop giving Miller assignments, as the mental anguish for both her and those around her was too great. Farley Farm House served as the backdrop for her last feature, 'Working Guests', a witty spoof in which she claimed to have made her friends do all the work needed to make the old farmhouse comfortable.[14] The final photograph of the feature, showing Miller asleep on the sitting-room sofa while everyone else works on her projects, was taken by Penrose (see page 181). Underneath the humour, a sardonic note can be detected. Miller's dissolute lack of focus bewildered him, and despite his compassion and love, an aspect of the image mocks her inability to cope. In common with most others, he had no understanding of her condition. He just struggled to cope with its effects.

I was born in 1947 as post-war austerity peaked. Postnatal depression, another condition barely understood at the time, added to my mother's woes. In the early 1950s she hit rock-bottom. She was battling both alcoholism and depression, and her life with my father was fraught with difficulties. The phrase 'nervous breakdown' was whispered in her direction. She and my father put a brave face on the situation while, backstage, much of her life was in ruins. A trip for the three of us to see her family in the United States seemed like a good idea. We visited the Florida Everglades, and for me it was a magical land filled with alligators, poison ivy and vigorous mosquitoes. It was my father who hesitantly took the holiday snaps; my mother could scarcely be persuaded to hold her Rolleiflex. In one photograph, she stoically poses with five macaws perched on her arms and head (see page 184), determined to set an example so that I should not be afraid of their sharp beaks, claws and raucous cries.

Miller had been glad to see her family, but the trip reminded her she was too Europeanized to feel at home. Yet in Europe she was the American, so had no real sense of a native land. Nevertheless, with her life at its worst, she was ready for her greatest achievement. Cooking had always been an interest, and now it became a passion. She began avidly to read cookery books and her trips with Penrose were opportunities for further research. At home, assisted by Patsy Murray, our housekeeper, she spared no effort in producing adaptations of traditional dishes or new creations, while the influence of Surrealism was ever present in the use of startling colourings, combinations and decorations. Slowly, Miller got her drinking under control, and with it the depression receded. Her social life resumed its colour and, accompanied by her closest friend, Bettina McNulty, she travelled and cooked.

Through friends, long-neglected connections with magazine publishing were revived, and Miller was written up in *Vogue*[15] and *House & Garden*[16] magazines. Ernst Beadle's photograph of Miller reinstates a sense of her fashion-model spirit, as she stands firmly, almost defiantly, in a room we all called 'the Old Kitchen' but which she referred to as her 'Project Planning Room' (see page 224). She was back in charge of her own life. It was her finest hour.

Every artist who depicted Lee Miller took a little piece of her for themselves. She gave it freely, and in return the artist's images of her retain a vital spark and immortalize her. We are fortunate that some of the leading artists and photographers of the twentieth century were inspired by Miller and, in turn, inspired her.

NOTES

1 Lee Miller, interview with Ruth Seinfel, 'Every One Can Pose', *New York Evening Post*,
 24 October 1932.

2 *Ibid*.

3 David E. Scherman, in conversation with the author, May 1982.

4 American *Vogue*, March 1927.

5 Lee Miller, recalled by Roland Penrose in conversation with the author, *c*. 1983.

6 Lee Miller, quoted in Brigid Keenan, *The Women We Wanted to Look Like*, London, 1977, p. 136.

7 French *Vogue*, September 1930.

8 Alphonse Daudet (1840–1897) wrote many short stories about Provençal life. 'L'Arlésienne' was
 first published as part of a regular series called 'Lettres de mon moulin' in *L'Evénement*, a magazine
 founded in 1866. The whole of the series, including 'L'Arlésienne', was published in book form
 in 1869.

9 Letter from Lee Miller to her parents in the United States, *c*. 1939, Lee Miller Archives,
 Chiddingly, East Sussex.

10 David E. Scherman, interview in *The Lives of Lee Miller*, dir. Antony Penrose, Penrose Film
 Productions Ltd, 1985.

11 *Ibid*.

12 Lee Miller, 'Unarmed Warriors', British *Vogue*, September 1944, p. 35.

13 David E. Scherman, in conversation with the author, May 1982.

14 Lee Miller, 'Working Guests', British *Vogue*, July 1953.

15 Ninette Lyon, 'Lee and Roland Penrose: A Second Fame – Good Food', British *Vogue*, April 1965,
 p. 139.

16 'How to Make an Art of the Happy Weekend: The Personal Strategy and Beautiful Food of Lee
 Penrose', *House & Garden*, June 1973, p. 68.

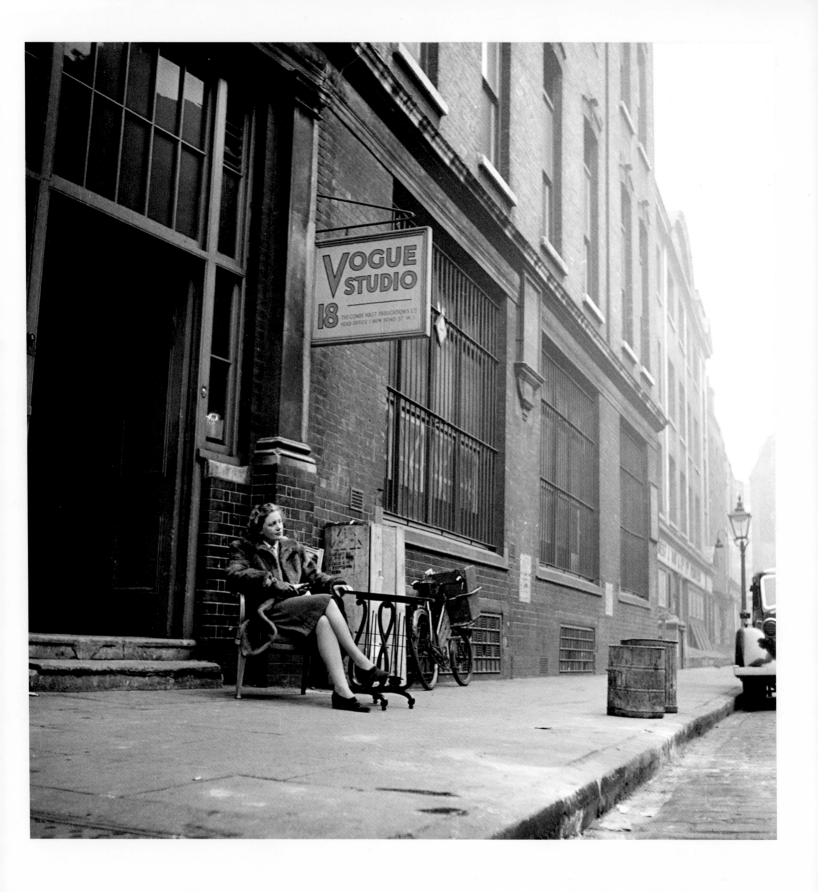

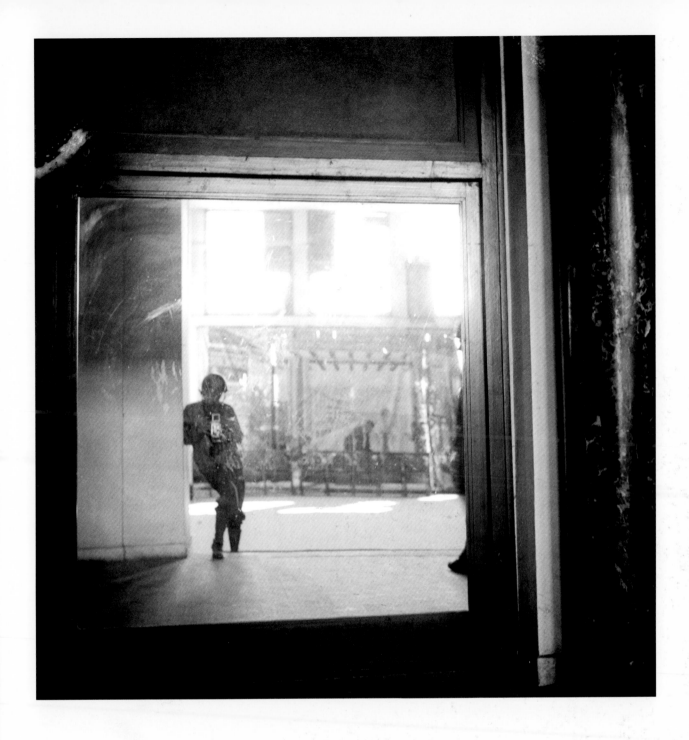

Lee Miller outside British *Vogue*'s London studio, England, 1943 (photo: David E. Scherman)

Miller ignored official advice to return to the United States in 1939 and offered her services as a photographer to British *Vogue*. Her offer was initially declined, but her persistence and the departure of male house photographers for war service forced the magazine to reconsider. Miller took over the bulk of British *Vogue*'s fashion and lifestyle photography in early 1940.

Self-Portrait: Lee Miller reflected in a mirror, St Malo, Brittany, France, August 1944

Miller was the only photojournalist to witness the American assault on the fortress of St Malo and to photograph the first operational use of napalm by the US Army Air Force. This experience of combat (her first) was the result of inaccurate military intelligence and totally unauthorized. Miller was forced to leave the area after the German surrender five days later, but retained her newly acquired 'taste for gunpowder'.

LEE MILLER:
A WOMAN'S WAR

Hilary Roberts

Lee Miller is remembered today as a woman equally at ease on both sides of the camera. She rose to fame as one of *Vogue* magazine's most beautiful fashion models in 1927 and subsequently evolved into one of its leading photographers. Although she was not a formal member of the pre-war Surrealist movement, the importance of her contributions to it, both as a muse and as a photographer, are widely acknowledged.[1] However, Miller's most important legacy is undoubtedly her photography of the Second World War. Commencing as a voluntary studio assistant for British *Vogue* in late 1939, Miller progressed to become one of four American female photojournalists accredited as official war correspondents to the US armed forces.[2] In this capacity, she documented the liberation of France, Belgium and Luxembourg before accompanying the American advance into Germany. Her subjects, which included the reality of war on the front line and the horror of German concentration camps, demanded that she work without any concession to her gender in a harsh and dangerous environment from which women were traditionally excluded.

In contrast to her more experienced colleagues (such as the celebrated Robert Capa or Margaret Bourke-White), Miller was entirely unprepared for such a role. In many respects, her life before the Second World War had been defined by her femininity. It attracted attention and opened doors, most notably to Condé Nast's stable of pioneering fashion photographers at *Vogue* in New York. But her femininity also rendered Miller vulnerable to exploitation. The intrusive and persistent photography of her father, a traumatic childhood rape and an advertising agency's decision to brand her the 'Kotex Girl' without her knowledge or consent are particularly important examples. Even Miller's most significant lovers of this period, Man Ray, Aziz Eloui Bey and Roland Penrose, combined generous adoration with a degree of manipulation. Man Ray's photography celebrated Miller's beauty, but also turned her into a sexual object. The luxurious Egyptian lifestyle provided by Eloui Bey (her first husband) combined material comfort with stifling emotional isolation. Penrose offered Miller the personal and creative freedom which her other lovers had denied her, but also exploited her image in his art with an occasionally unwitting disregard for her state of mind.

Miller belonged to the first generation of women entitled to vote, but was well aware that she lived in a man's world. The First World War had done much to demonstrate the ability of women to carry out roles hitherto reserved for men, but equality of opportunity and social status remained a distant dream for most in the decades between the wars. Women who cherished ambitions beyond domestic life faced an uphill struggle. Miller herself yearned for what she described as 'the utopian combination of security and freedom'.[3] When it came to selecting a professional name (her given name was Elizabeth Miller), her choice was deliberately androgynous; yet in other respects, Miller was unwilling to sacrifice her femininity in her quest for personal and professional fulfilment. It is no wonder that such fulfilment eluded her in the pre-war years.

Photography offered Miller an outlet for her personal frustration and a means of taking control. From 1930 onwards, she spent more time behind the camera than in front of it. Photography was one of the few professions deemed acceptable for women at this time, although most worked within the confines of a portrait studio. As a professional photographer, working first in Paris and then New York, Miller conformed to the established pattern, concentrating on creative and commercial portraiture before temporarily abandoning professional photography on her marriage to Eloui Bey in 1934. As a private photographer, working for pleasure in Egypt, France and Romania during the late 1930s, Miller began to take simpler and less contrived images that fitted comfortably into the categories of documentary photography and reportage. In so doing, she laid the foundations of her future career as a photojournalist.

Although she frequently photographed men, the majority of Miller's subjects were women, a fact that has been somewhat obscured by the understandable interest in her coverage of war on the front line. Whether experimenting with artistic techniques in Paris, creating commercial portraits of fashionable celebrities in New York, or documenting the vagaries of life in Egypt and Romania, Miller's pre-war portraits of women are a consistent celebration of her subjects' femininity and individuality. But a different theme is detectable in her photographs of women with their lovers. In Miller's portraits of Donald and Anna Friede, Max Ernst and Leonora Carrington, or Man Ray and Ady Fidelin, the women are clearly the focus of their lovers' adoration. However, the body language of these couples suggests that the price of such adoration is a woman's submission.

Miller's decision to remain in London with Roland Penrose when war broke out in September 1939 (rather than return to the safety of her native United States) changed the course of her life and transformed her photography. In the years that followed, the demands of war temporarily stripped away the constraints under which Miller had lived and worked, offering her an opportunity to employ the full range of her talents as a photographer for the first and only time in her life.

This transformation did not happen overnight. Although Miller immediately offered her services as a photographer to British *Vogue*, she was initially barred, by her nationality, from any formal employment. After working on a voluntary basis for some weeks, the issue of a work permit enabled her to join the

magazine in January 1940. From this point on, Miller photographed women exhaustively in a range of assignments dictated by her new employer's evolving response to wartime demands.

British *Vogue* was a high-quality, low-circulation fashion magazine aimed at affluent, upper-class women. A member of staff described its readership as consisting of two distinct groups. The first was 'a few thousand ultra-fastidious women to whom it is important to be constantly in touch with the latest style and fashionable goings-on. The second much larger group … derives a great deal of pleasure in reading about what the first is doing.'[4] In every sense, therefore, British *Vogue* was an elitist publication. However, Miller's coverage, when viewed as a whole, was astonishingly diverse. She photographed women from different nations and social groups, in a variety of styles, situations and genres, which ranged from theatrically posed high fashion in *Vogue*'s London studio to searing reportage in the ruins of Berchtesgaden and Budapest.

Such variety was a consequence of the wide-ranging and transformative effects of war on women's lives, including Miller's. However, it also reflected the enlightened wartime editorial policy adopted by British *Vogue*'s then editor, Audrey Withers. *Vogue*'s appointment of Withers, like its recruitment of Miller, was a direct consequence of the war: the magazine's serving editor, Betty Penrose, had been unable to return to Britain from a visit to the United States in 1940. Withers was an unusual choice for the editorship, as she herself acknowledged: 'I am very well aware that I would not have been an appropriate editor of *Vogue* at any other period of its history. I had come up through copy-writing and administration, with no fashion training.'[5]

In fact, Withers had studied politics, philosophy and economics at Oxford and was a strong advocate of social reform, particularly with regard to the role of women in society. As editor of British *Vogue*, she believed in allowing her staff to fulfil their potential and always took more of an interest in *Vogue*'s features on current affairs than in its fashion coverage. In this respect, her views and approach could not have been more different from those of Edna Woolman Chase. Chase, American *Vogue*'s long-serving editor, maintained an editorial overview of the editions of *Vogue* published in Britain and France but occasionally struggled to respond appropriately to the realities of wartime life in those countries.

The British Ministry of Information (MoI) also influenced the diversity of Miller's photography. The MoI was established in the University of London's Senate House within hours of the outbreak of war in September 1939. It was responsible for the management and dissemination of government propaganda, public information and censorship. The MoI performed poorly during the first eighteen months of war, hampered by inexperience, political infighting and adverse wartime events. But its effectiveness improved dramatically following the appointment of Brendan Bracken as Minister of Information in July 1941. Bracken, a successful publisher of newspapers and magazines (and a close friend of the then Prime Minister, Winston Churchill), overhauled the MoI, transforming it into an institution capable of outperforming its German rival, the Reichsministerium für Volksaufklärung und

WOMEN BEFORE THE SECOND WORLD WAR

In the years leading up to the Second World War, most women believed that the domestic home was their natural environment. But many also longed for improved social status, personal independence and equality of opportunity. International campaigns to improve women's lives had made limited progress before being interrupted by the First World War. This exacted a heavy price in human suffering but also presented women with new opportunities outside the home. Women, particularly the young and unmarried, found that the conflict offered them a form of emancipation and personal fulfilment that politics and social convention had denied them in peacetime. But such emancipation, driven by military expediency, was temporary. Although many countries permitted women to participate in political life after the First World War, demobilization, a harsh post-war economic climate and war fatigue informed a general post-war demand to reduce women's opportunities outside the home.

Women, like men, struggled to come to terms with the legacy of the First World War and feared that a second was inevitable. Life between the two world wars was characterized by a mood of frustration, restlessness and uncertainty. This mood was particularly strong among younger women, leading them to embrace such revolutionary 1920s trends as the 'flapper' style and Surrealism. The emerging glamour of the Hollywood film industry offered a welcome distraction from economic depression and the fascist threat of the 1930s.

Lee Miller's youth was shaped by these developments and her own life experience. After a difficult childhood, during which she was sexually abused, Miller became a much-photographed fashion model and artist's muse. Neither of these roles offered her personal autonomy, and in fact led to other forms of abuse. Her decision to become a professional photographer in 1929 represented a personal bid for the security and freedom that had hitherto eluded her. Her pre-war photographs, a complex blend of the experimental and conventional, offer a subtle commentary on women's lives and social status while switching restlessly between the worlds of fashion, glamour, Surrealist art and reportage.

Self-Portrait: Variant of *Lee Miller par Lee Miller*, Paris, France, c. 1930

This self-portrait – one of Miller's earliest photographs, taken during her apprenticeship with the Surrealist artist and photographer Man Ray – is notable for its simplicity, elegance and respect for the female form. Both the work itself and its emphatic title evoke Miller's determination to take control of her image as well as her life.

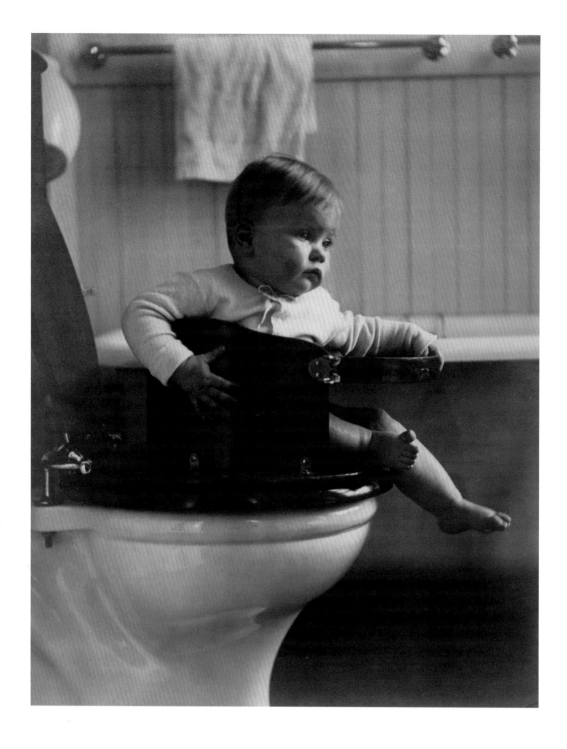

Lee Miller, aged 8 months, by her father, Poughkeepsie, NY, USA, 1907 (photo: Theodore Miller)

Miller's father, Theodore, was a skilled amateur photographer who photographed his daughter intimately and obsessively throughout her youth. This photograph was probably taken to catalogue her toilet-training progress.

Lee Miller, aged 7, with her mother, Florence, Poughkeepsie, NY, USA, 1914 (photo: Frederick A. Smith, Gallup Studio, Poughkeepsie)

Family photographs reflect Miller's happy early childhood. But her happiness was brief: soon after this photograph was taken, she was raped while staying with a family friend. Her horrified mother, a trained nurse, was forced to administer a painful and invasive treatment for gonorrhoea. The trauma, deemed unmentionable by the conventions of the day, shaped Miller's personality and adult life.

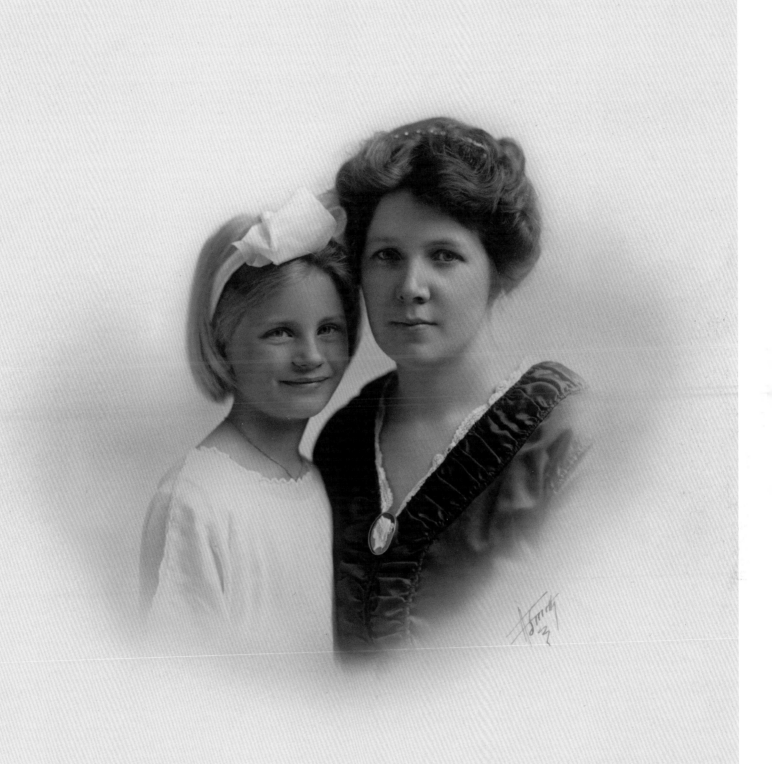

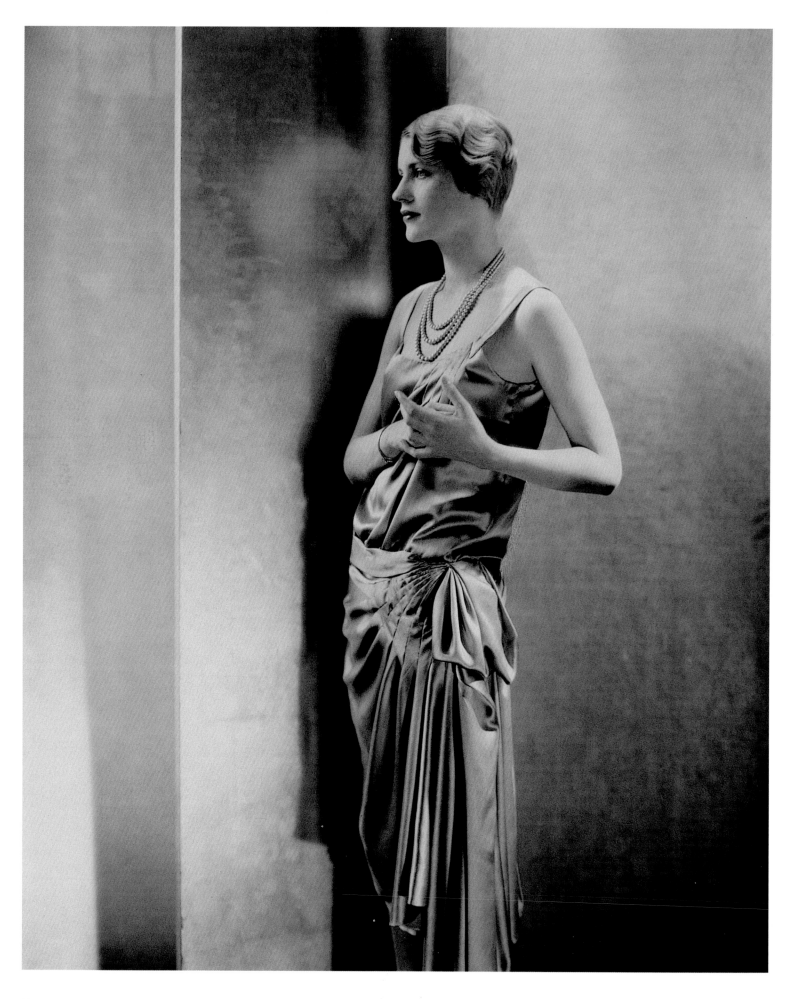

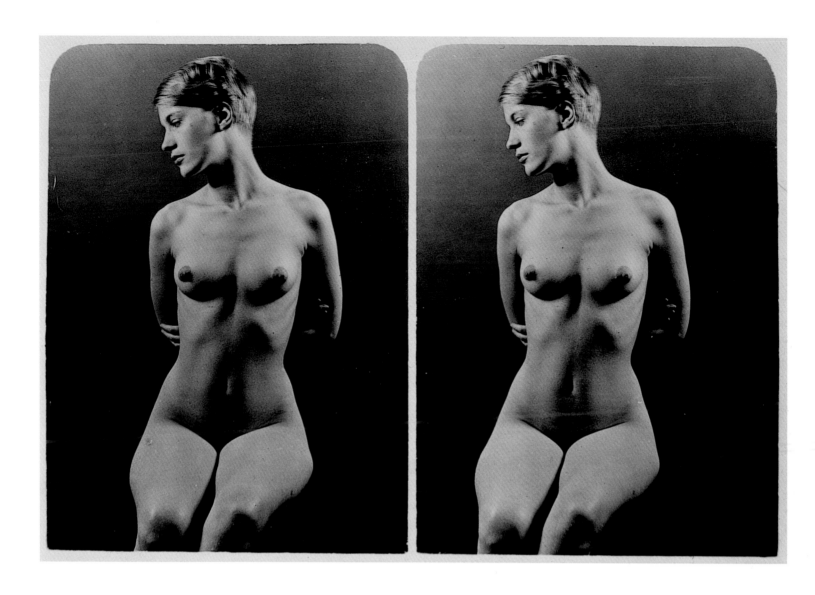

**Lee Miller models for Edward Steichen
at Condé Nast, New York, NY, USA, 1928
(photo: Edward Steichen)**

Miller was introduced to the art of fashion photography
by Edward Steichen, chief photographer at Condé
Nast from 1923 to 1937. Steichen (who had staged the
world's first studio fashion shoot in 1911) shaped Miller's
brief career as a glamorous fashion model for Condé
Nast's publishing empire. This photograph caused
her career to stall when it appeared in a controversial
advertising campaign for Kotex sanitary towels.
Miller decided to develop a career as a photographer
in Europe. Possibly by way of an apology, Steichen
provided her with an introduction to Man Ray in Paris.

**Stereoscopic nude study of Lee Miller
by her father, Poughkeepsie, NY, USA, 1928
(photo: Theodore Miller)**

Miller's father began to take nude photographs of his
daughter (under the guise of art) within months of her
physical recovery from rape. She quickly learned the
art of emotional dissociation while posing the feminine
body to artistic effect. As Miller matured into
a beautiful but rebellious young woman, her father's
3D stereoscopic studies became overtly erotic.
The beautiful but disturbing photographs helped form
Miller's uninhibited attitude to sexuality and her
love of art.

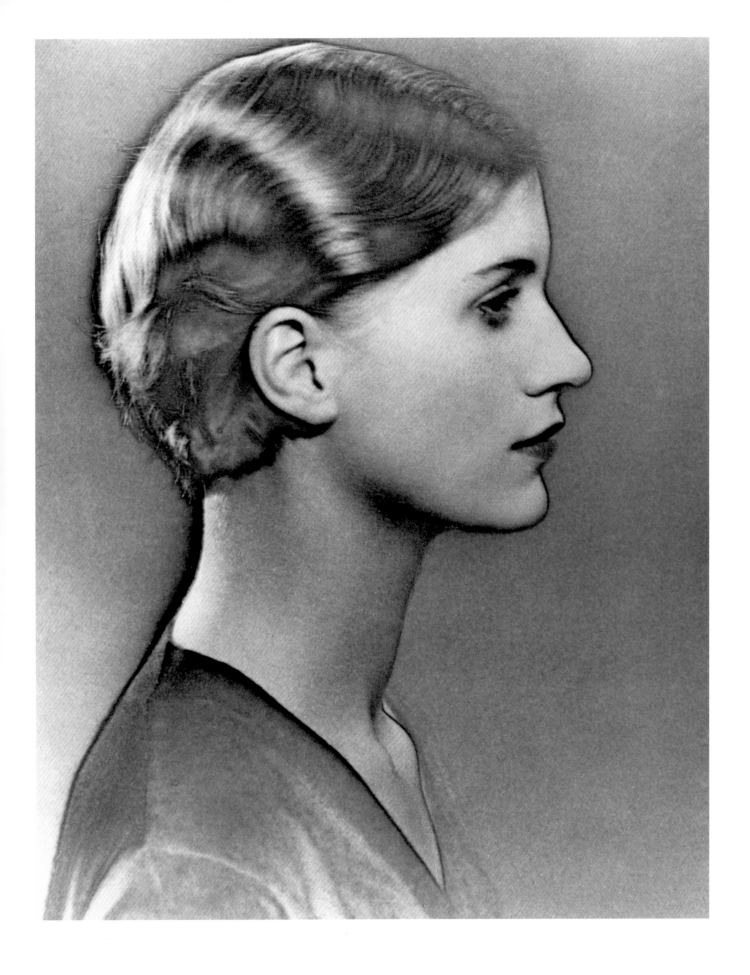

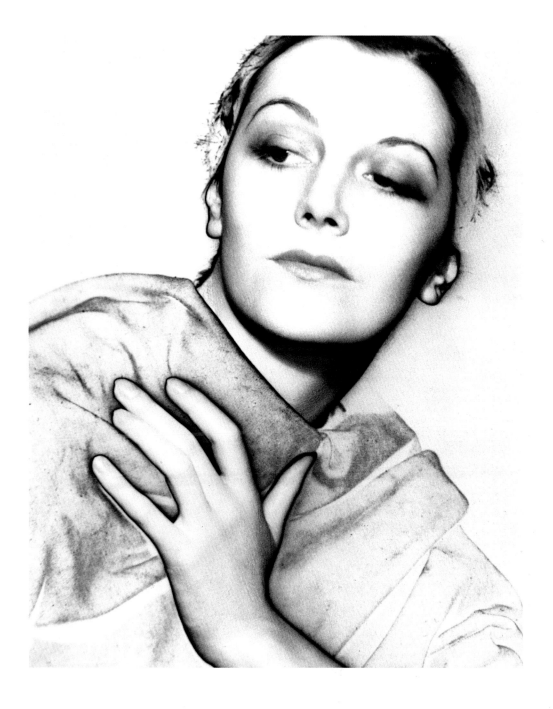

Solarized portrait of Lee Miller, Paris, France, 1929 (photo: Man Ray)

As Man Ray's student, assistant, lover and muse, Miller provided a creative focus and foil for his art. Their rediscovery of the Sabattier effect, which they called 'solarization', was one of their most important joint achievements. Guided by Man Ray, Miller became a committed Surrealist and highly competent photographer, but her desire for independence undermined their relationship.

Solarized portrait of a woman, Paris, France, 1932

Many female artists joined the Surrealist movement. This portrait, in which Miller skilfully manipulates the solarization technique to emphasize her subject's femininity, is thought to show Méret Oppenheim, a Swiss Surrealist artist who addressed the exploitation of women. Oppenheim's creation *Objet (Le Déjeuner en fourrure)* (1936), a fur-covered teacup, saucer and spoon, became one of the most famous Surrealist objects of its day.

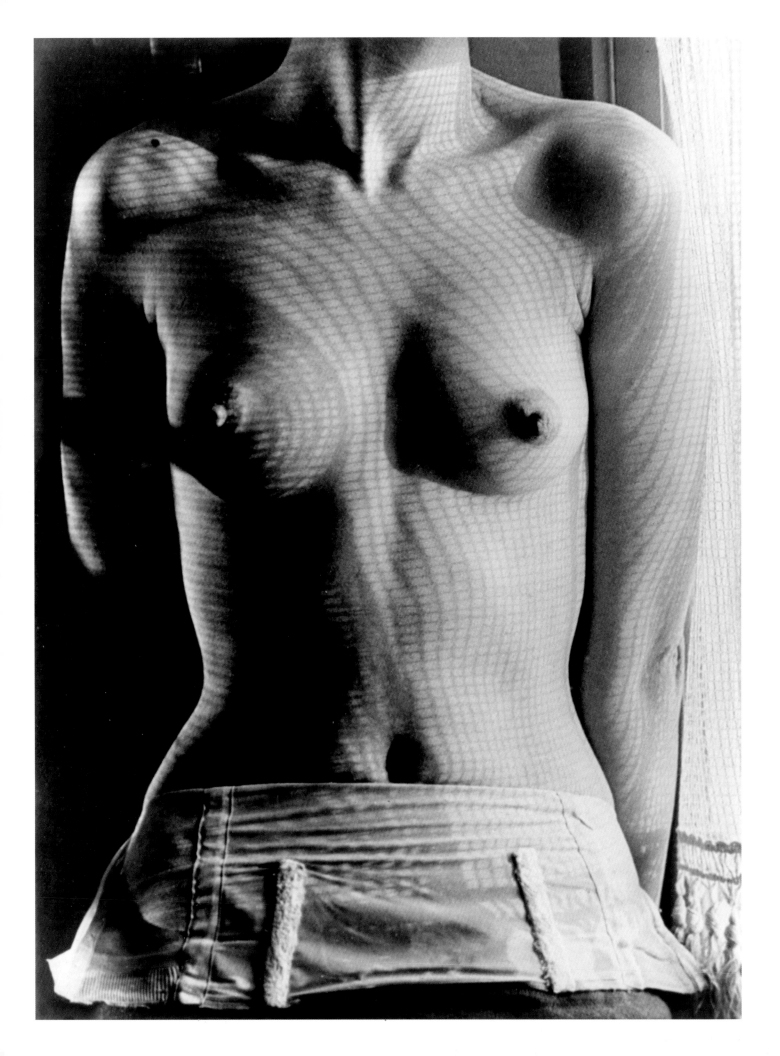

Shadow patterns cast by a net curtain on Lee Miller's torso, Paris, France, c. 1930 (photo: Man Ray)

For Man Ray (whose Surrealist vision of the female body was informed by the notorious Marquis de Sade), Miller's body represented a canvas on which to experiment in his exploration of female eroticism. Miller, generally a willing collaborator, was distressed when a magazine announced that she possessed 'the most beautiful navel in Paris'.

Nude wearing sabre guard, Paris, France, c. 1930

Miller often reinterpreted portraits of herself, created by her mentors, in her own work. This image is based on a Man Ray photograph in which Miller herself posed nude, her head masked and caged by a sabre guard. In contrast to Man Ray's humiliating treatment (and its sadomasochistic implications), Miller uses the sabre guard (a device employed in the sport of fencing) to celebrate her sitter's individuality and femininity. The sabre guard is transformed into a striking fashion accessory.

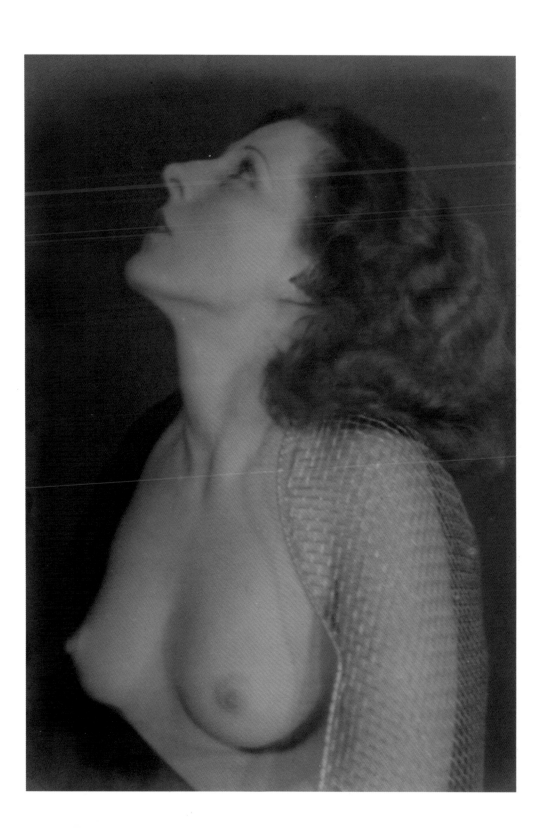

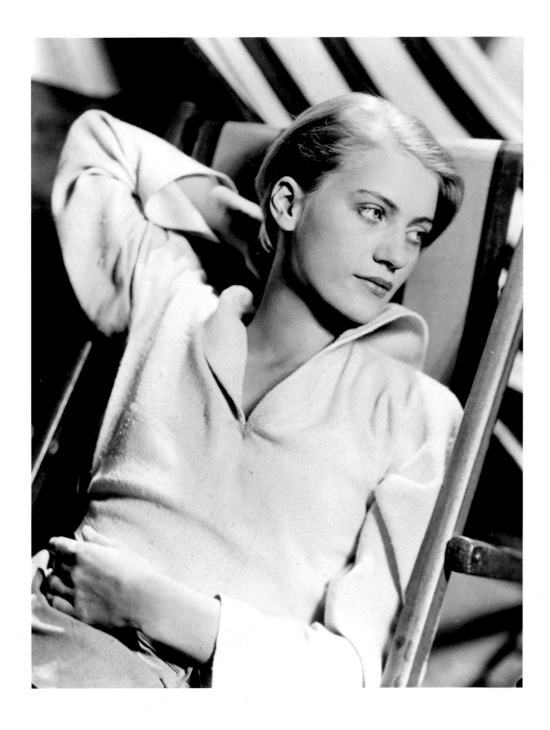

Lee Miller with crystal ball, Paris, France, 1932 (photo: George Hoyningen-Huene)

Hoyningen-Huene's mastery of lighting, reflections and Surrealist studio concepts would prove an invaluable source of inspiration to Miller when photographing wartime fashion for British *Vogue*. This photograph, showing Miller gazing at a 'vision' of Agneta Fischer (a *Vogue* model) in a crystal ball, is one of many that she later adapted for wartime use.

Lee Miller models Leisurewear, Paris, France, 1930 (photo: George Hoyningen-Huene)

While living in Paris, Miller occasionally posed for George Hoyningen-Huene, chief photographer for French *Vogue* from 1925 to 1935. Hoyningen-Huene broadened Miller's knowledge of portrait and fashion photography.

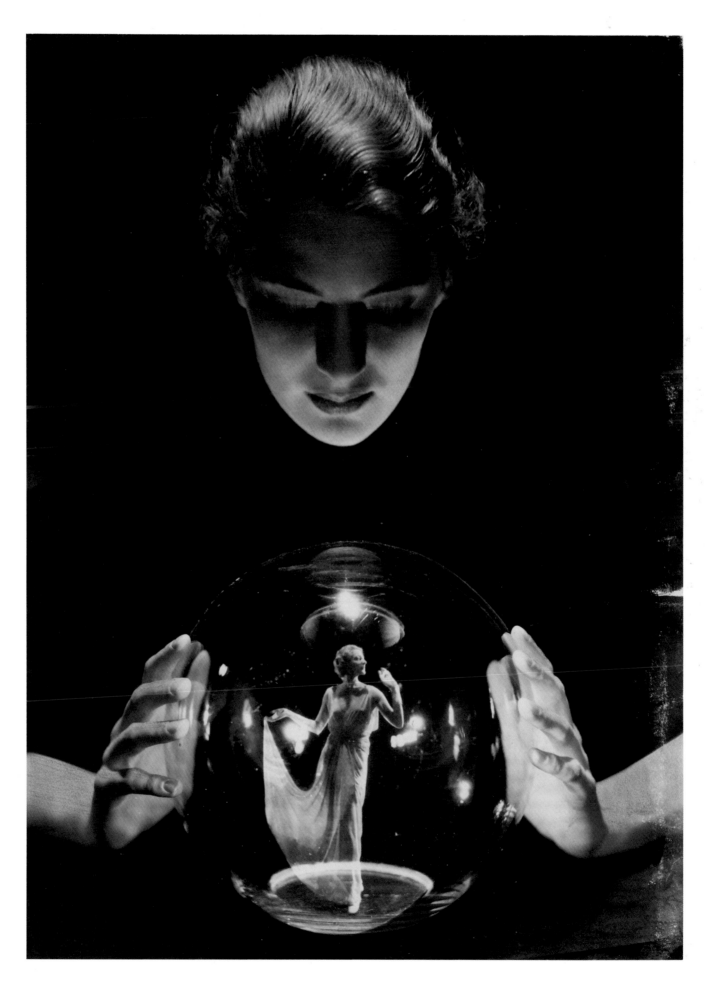

Donald and Anna Friede, New York, NY, USA, c. 1933

After leaving France and returning to the United States in 1932, Miller established a commercial portrait studio in New York. One of her first sitters was Donald Friede, a wealthy but notorious American publisher, and his third wife, Anna (née Fleischer). Miller's portrait offers a subtle comment on the couple's relationship. They divorced in 1936.

Eva Jessye, Choir Mistress, New York, NY, USA, 1933

Eva Jessye was the first black American woman to receive international recognition as a professional conductor and choral director. This portrait was commissioned to mark her successful collaboration in the groundbreaking all-black opera *Four Saints in Three Acts* by Virgil Thomson and Gertrude Stein. Miller's dignified and respectful portrait, which depicts Jessye in terms of absolute equality, is an implied criticism of racial prejudice and segregation in the United States.

Self-portrait with headband, New York, NY, USA, 1932

Miller's own appearances in front of the camera became increasingly rare. She occasionally photographed herself to test staging options in the studio, or when lacking a suitable model. This self-portrait was taken for a fashion article on plastic headbands.

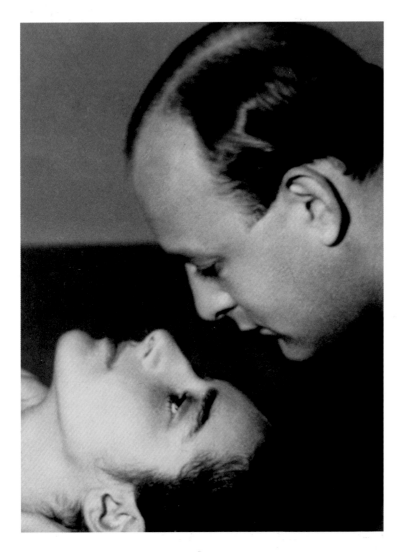

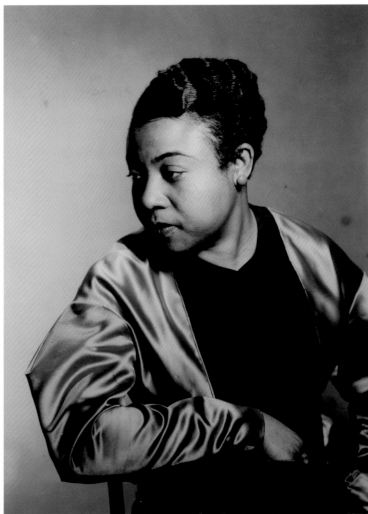

'WHAT YOU MOSTLY DO IS ABSORB THE CHARACTER OF THE MAN YOU'RE WORKING WITH. THE PERSONALITY OF THE PHOTOGRAPHER, HIS APPROACH, IS REALLY MORE IMPORTANT THAN HIS TECHNICAL GENIUS'

Lee Miller, interview for the New York Evening Post, *24 October 1932*

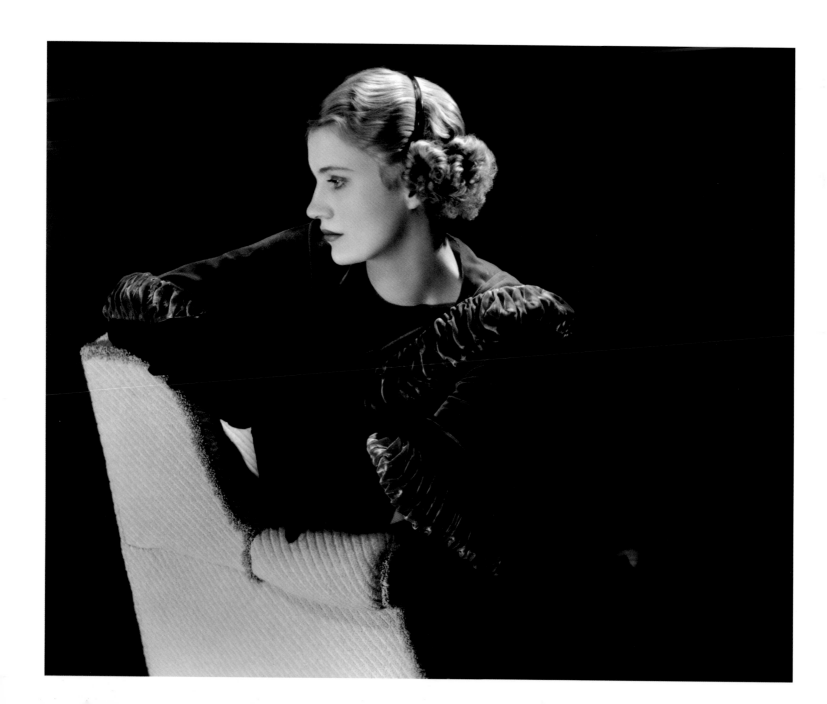

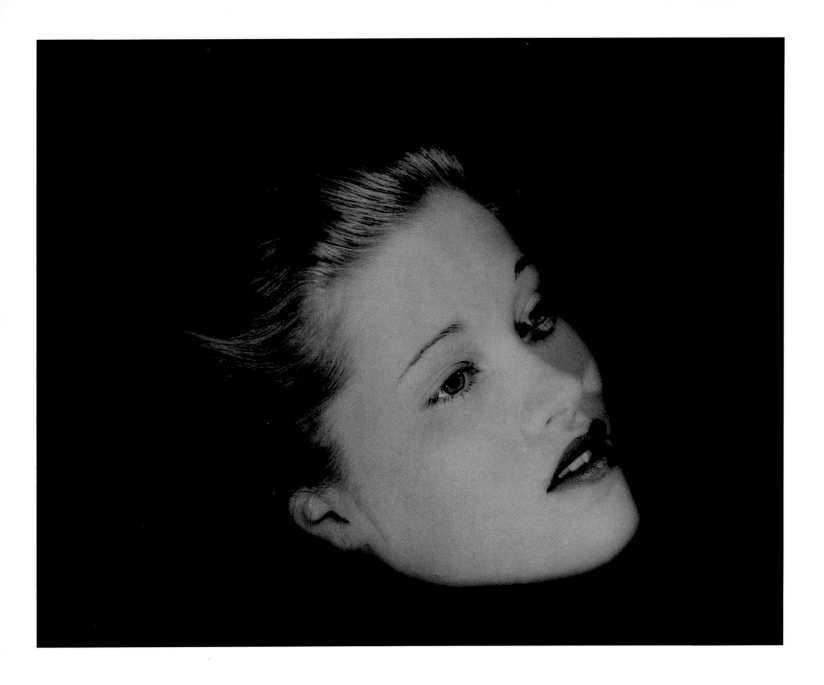

Floating head: Mary Taylor, New York, NY, USA, 1933

Pioneering chemotherapy treatment for cancer at the age of sixteen had left Mary Taylor with permanently damaged legs. She nevertheless became a successful *Vogue* model, photographed regularly in glamorous settings by Edward Steichen and Cecil Beaton. Miller's distinctive photograph is inspired by Man Ray (who believed that a woman's head embodied her complete physical portrait). Taylor became a successful film actress and civil rights campaigner. She interrupted her career to work as a volunteer nurse during the Second World War.

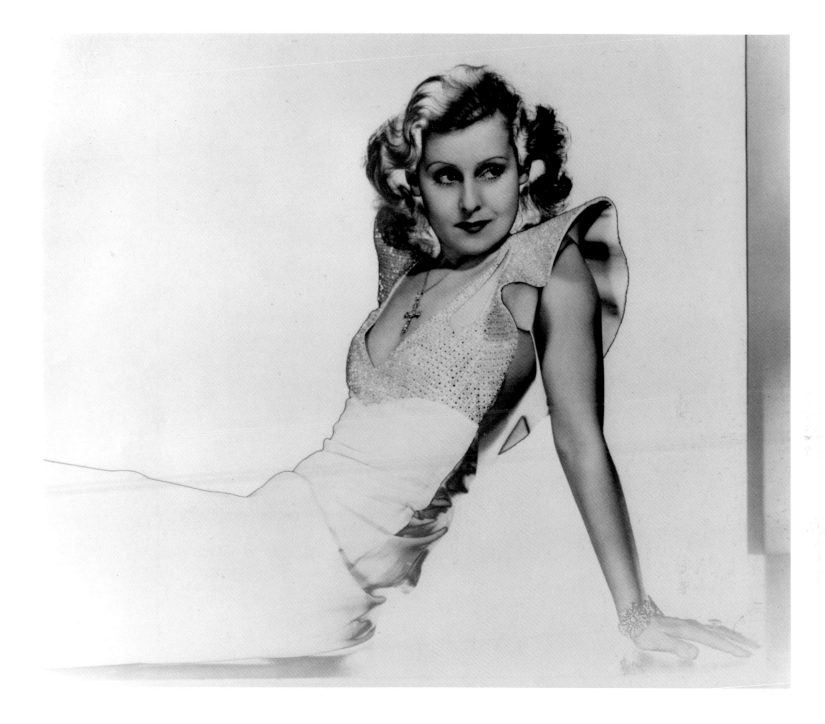

Solarized portrait of Lilian Harvey, New York, NY, USA, 1933

Lilian Harvey, a British actress who had starred in many German films, commissioned this portrait during an unsuccessful attempt to establish herself in Hollywood. Forced to return to Nazi Germany in 1935, she sacrificed her career and fortune by refusing to abandon her Jewish friends. Harvey eventually returned to the United States, where, like Mary Taylor (opposite), she became a volunteer nurse in 1942.

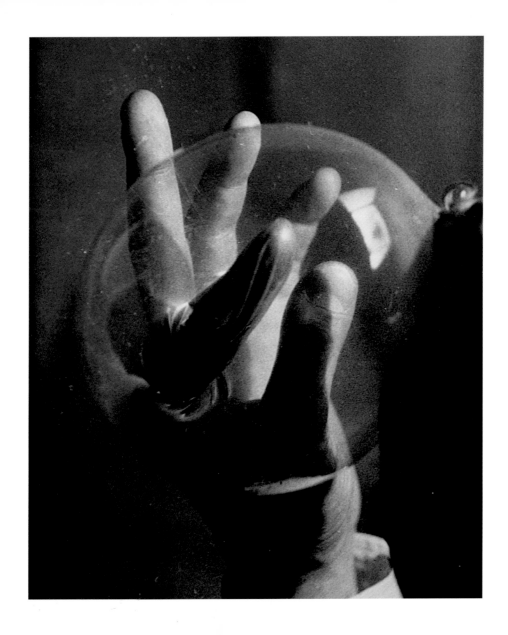

Condom, New York, NY, USA, c. 1934

Although largely suppressed in the context of her
commercial photography, Miller's Surrealist eye,
uninhibited sexuality and mischievous sense of humour
found expression in her personal photography.

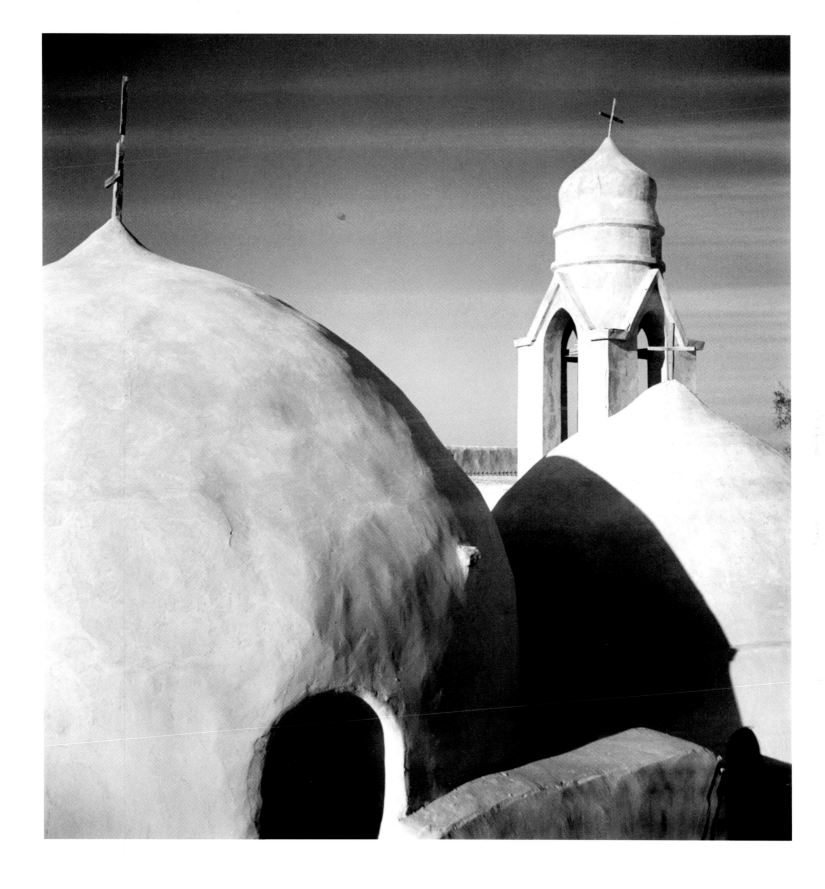

The Church of Maria Deipara at Deir
el-Syriani Monastery, Wadi el-Natrun,
Egypt, c. 1936

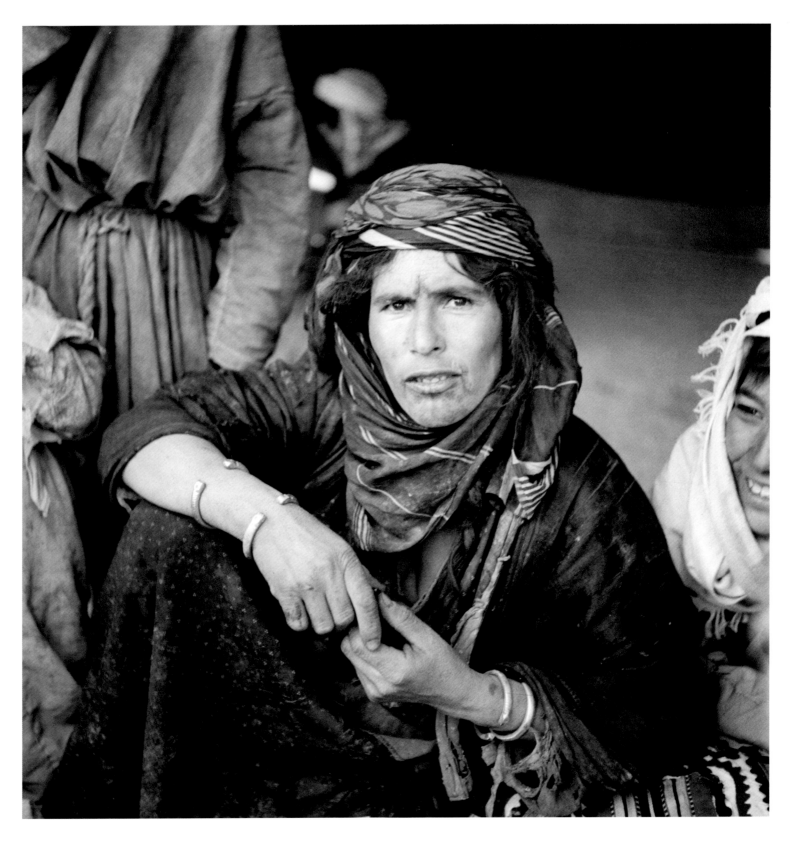

**Portrait of a local woman, possibly
in Siwa, Egypt, c. 1938**

Miller abandoned commercial photography when she
married Aziz Eloui Bey, an Egyptian businessman, in 1934.
While living in Egypt, she began to document the local
communities, highlighting the contrasting lives of local
and expatriate women. These images, made purely for
pleasure, laid the foundations for her wartime reportage.

LEE MILLER: A WOMAN'S WAR

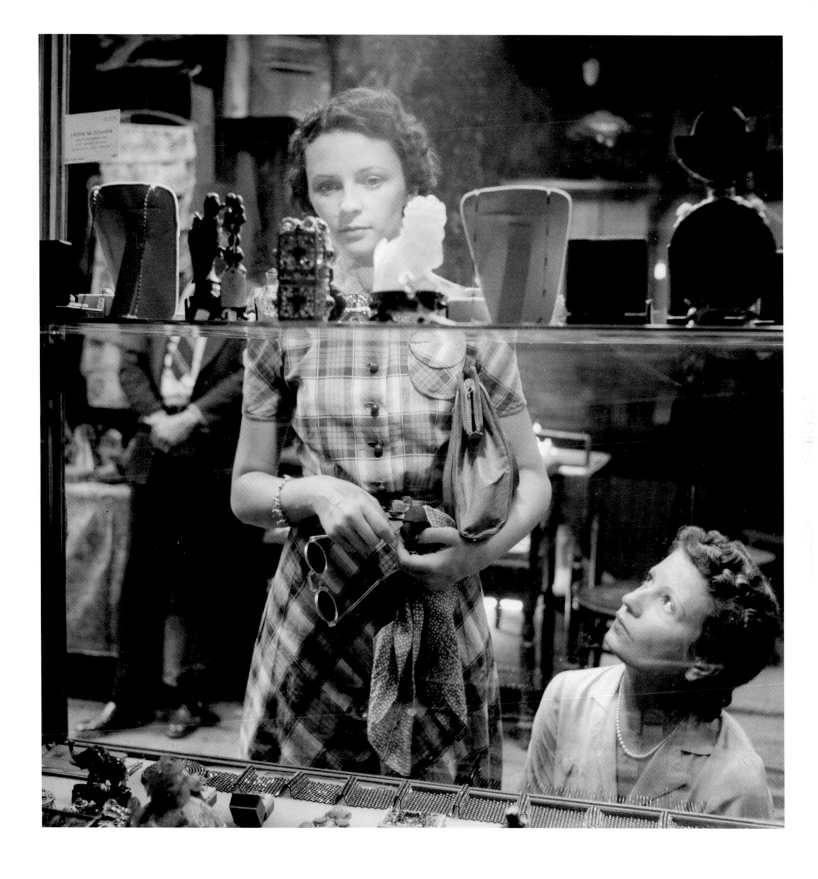

Mafy Miller, sister-in-law of Lee Miller,
in the Bazaar district, Cairo, Egypt, 1937

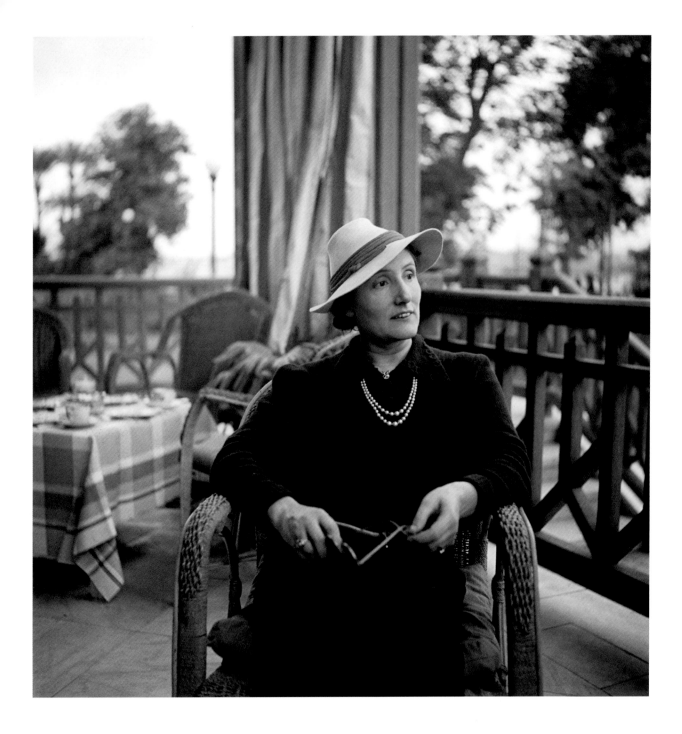

Surrealist beachwear, Mougins, France, 1937

Bored and restless, Miller sought refuge in extended trips to Europe, where she could freely indulge her interest in Surrealism and sense of fun. This photograph of an unknown woman wearing a basket hat may have been informed by Elsa Schiaparelli, an Italian fashion designer. Schiaparelli's Parisian fashion house had introduced a range of Surrealist-inspired beach hats in 1935.

Black Satin and Pearls set, Cairo, Egypt, c. 1937

Miller's personality and interests ensured that she was never truly at ease among the European women of Cairo's rigid expatriate community, whom she nicknamed the 'Black Satin and Pearls set'.

LEE MILLER: A WOMAN'S WAR

'SURREALISM ON THE HORIZON, STRAVINSKY IN THE AIR AND FREUD UNDER THE BED'

Eileen Agar, A Look at My Life, *1988*

Roland Penrose, *Night and Day*, London, England, 1937

Miller met Roland Penrose, a leading British Surrealist artist, collector and curator, while visiting France in 1937. Their passionate, turbulent yet highly creative relationship was informed by Surrealism. Penrose's intuitive portraits of Miller depict his evolving perspective of her. *Night and Day* (his first portrait) references some of the symbolism used by Picasso in *Portrait of Lee Miller as L'Arlésienne* (see page 2). The painting was completed shortly after Miller's return to her husband in Egypt.

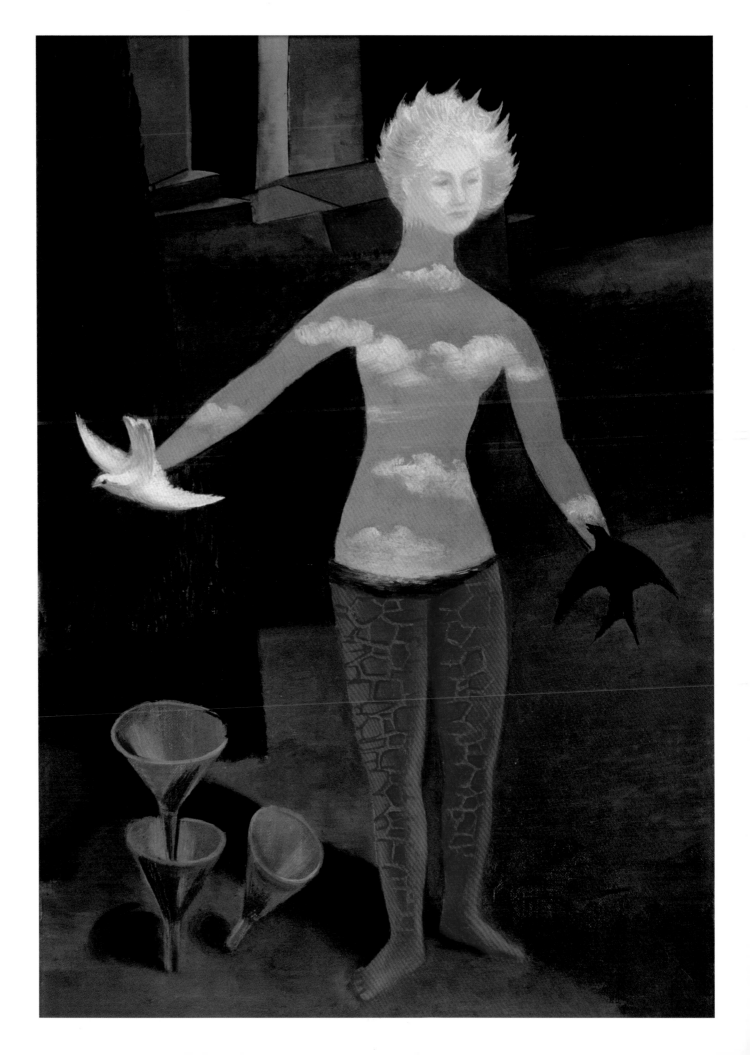

Ady Fidelin, Roland Penrose and Nusch Éluard, Mougins, France, 1937

Miller's photographs of hedonistic Surrealist gatherings in the summer of 1937 were taken as the rise of fascism propelled Europe towards war. Men and women are shown celebrating their freedom from traditional social mores in idyllic surroundings, but the photographs also suggest a lack of true equality between the genders. Surrealist ideals of sexual freedom and gender equality, often realized by means of free love, were rarely sustained without emotional cost.

Leonora Carrington and Max Ernst, Lambe Creek, Cornwall, England, 1937

Max Ernst, a German Surrealist artist, abandoned his second wife to move to France with Leonora Carrington, a young British artist, in 1937. The war brought their relationship to a distressing end. After being interned as an enemy alien in 1939, Ernst fled to the United States. Alone, Carrington made her way to Spain, where she suffered a nervous breakdown.

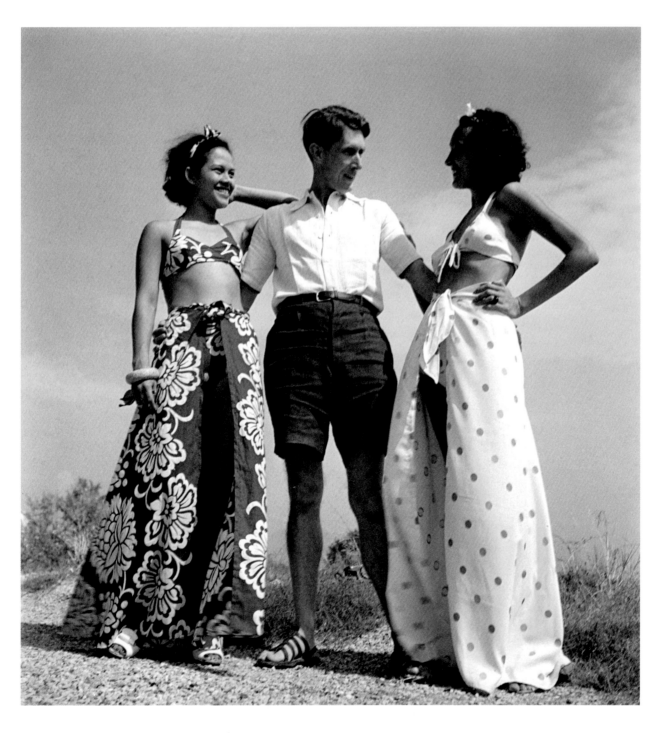

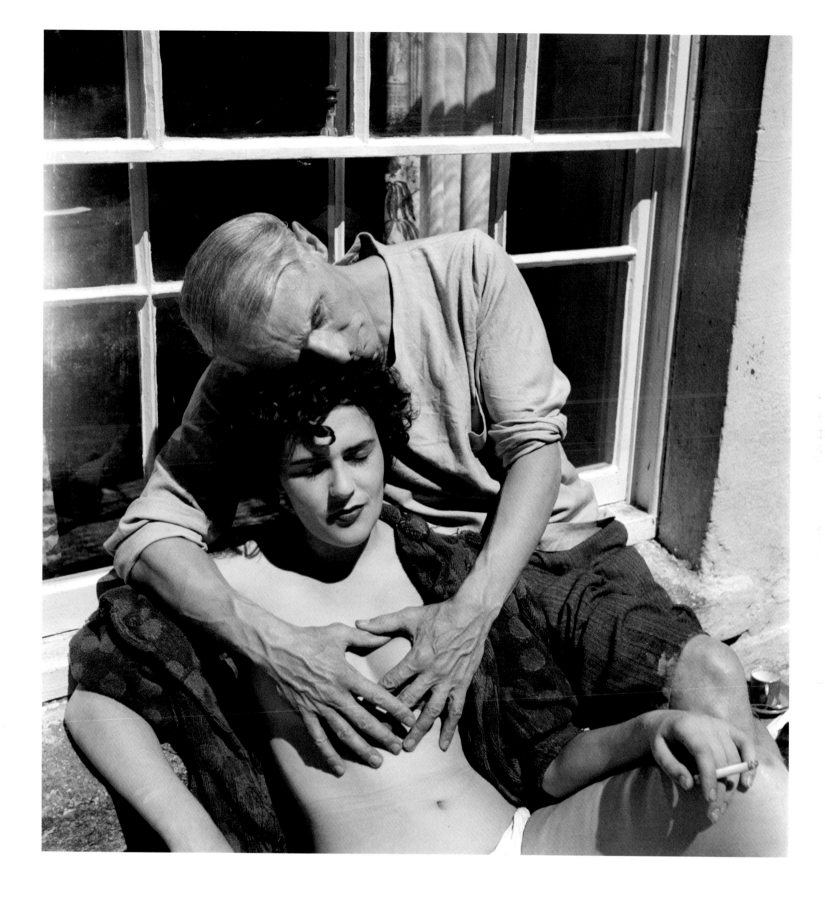

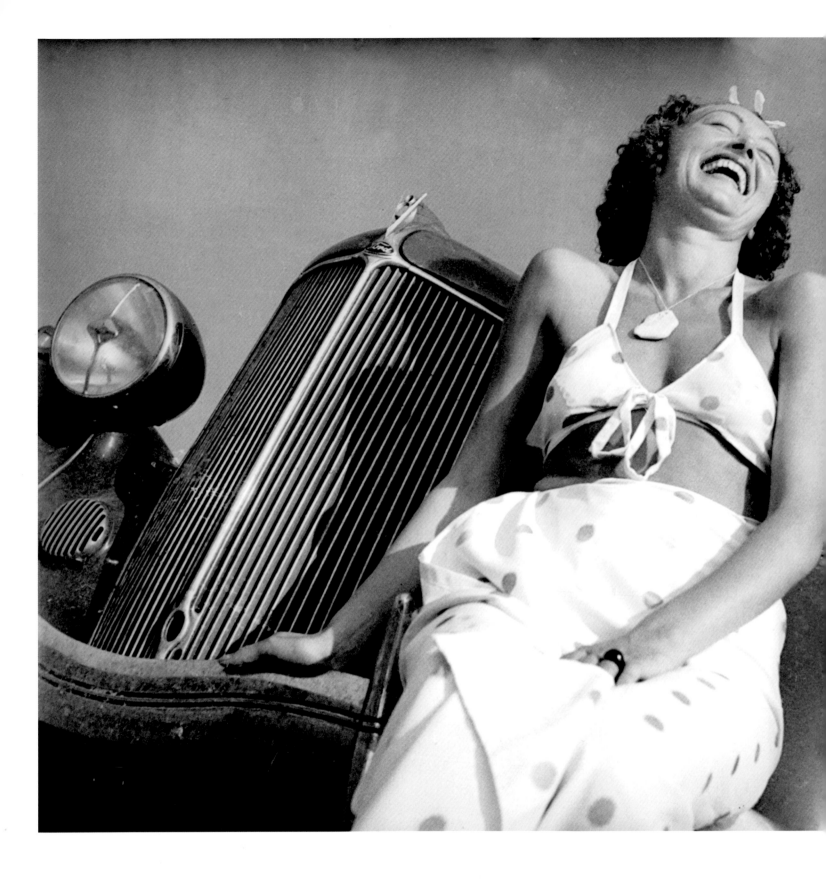

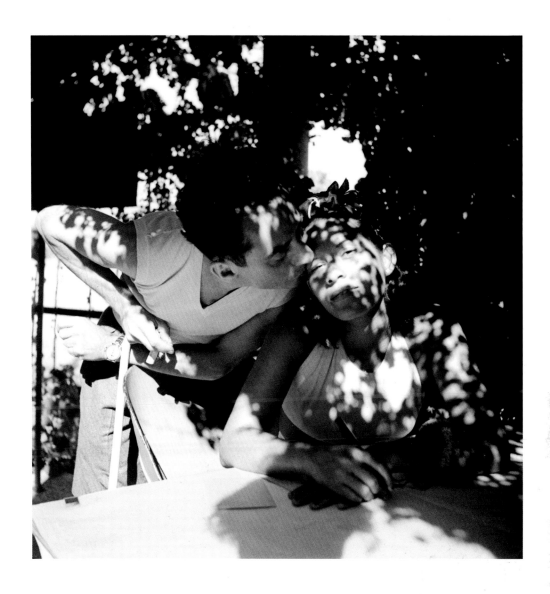

Nusch Éluard, Mougins, France, 1937

Maria Éluard (known as 'Nusch'), a dancer from
Alsace, became a Surrealist muse and artist after her
marriage to Paul Éluard, a French Surrealist poet. In this
portrait, Miller celebrates Nusch's vitality, strength and
independence. Nusch worked for the Resistance during
the war, an experience that took a heavy toll on her
health. Weakened, she collapsed and died of a stroke
on a Paris street in 1946.

**Ady Fidelin and Man Ray, Mougins,
France, 1937**

Adrienne Fidelin (known as 'Ady'), a dancer from
Guadeloupe, replaced Miller as Man Ray's lover
and muse in 1936. She became the first coloured model
to appear on the cover of a major fashion magazine
when *Harper's Bazaar* published a Man Ray photograph
of her in 1937. Their relationship was terminated
by the war. Man Ray, like Max Ernst (see page 49),
fled to the United States in 1940, while Ady remained
in Paris to care for her family.

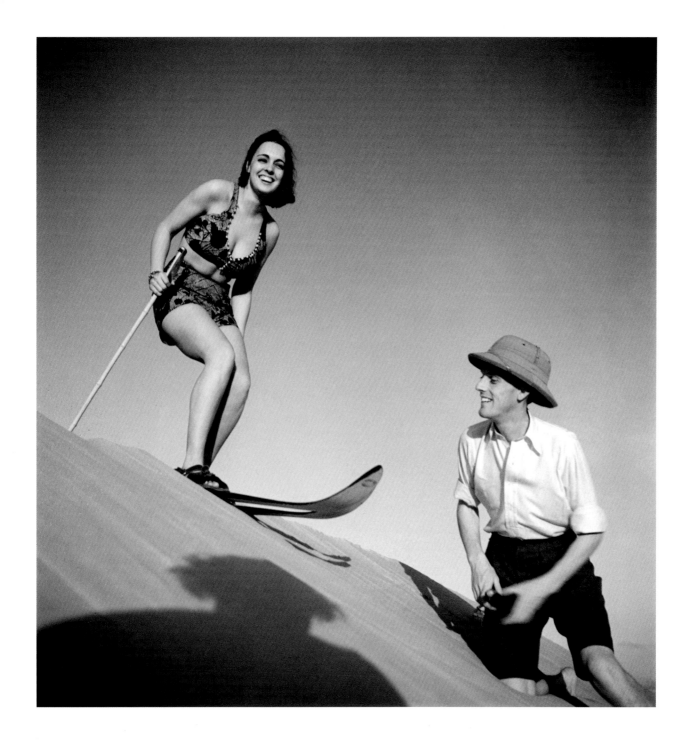

**Mary Anita Loos and Robin Fedden sand-ski
in the desert, Egypt, 1937**

Despite the turmoil in her personal life, Miller
continued to travel within Egypt, documenting the
contrasts in women's lives. Loos and Fedden were two
of her friends and contemporaries. The former was
an American publicist who (like her well-known aunt,
Anita Loos) developed a career as a Hollywood
screenwriter and film producer during the Second
World War. The latter, an English diplomat, university
teacher and writer, was a member of the Cairo
Poets circle, and later became deputy director
of the National Trust.

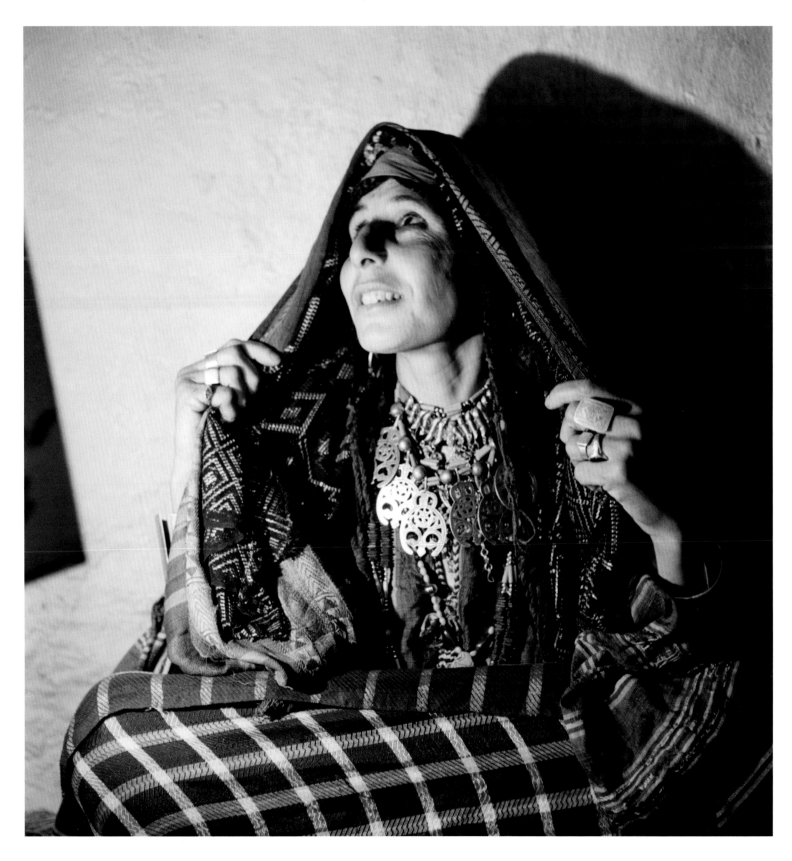

Girls prepare a Caloian (a clay figure) during a traditional folk ritual, Romania, 1938

The Surrealist movement's enduring interest in folk culture prompted Miller and Roland Penrose to tour the Balkans in 1938. While visiting Romania, Miller photographed the Caloian folk ritual, an ancient Romanian fertility and rain-making rite.

Leonor Fini, Saint-Martin-d'Ardèche, near Avignon, France, 1939

With war imminent, Miller and Roland Penrose paid a sombre final visit to Surrealist friends in France. The Surrealists, condemned as degenerate in Germany, were aware that they faced an uncertain future in Europe. Leonor Fini, an Argentinian artist who celebrated female independence and opposed any form of misogyny, would spend the war in Monte Carlo.

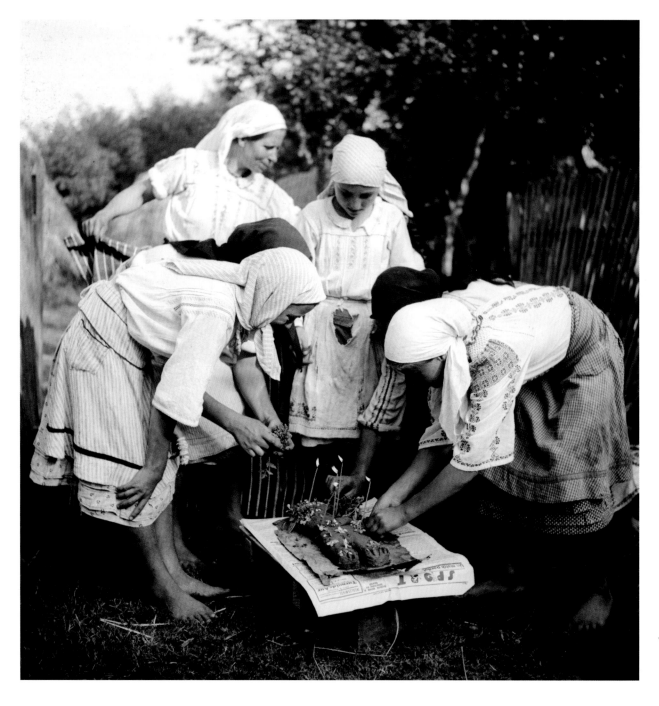

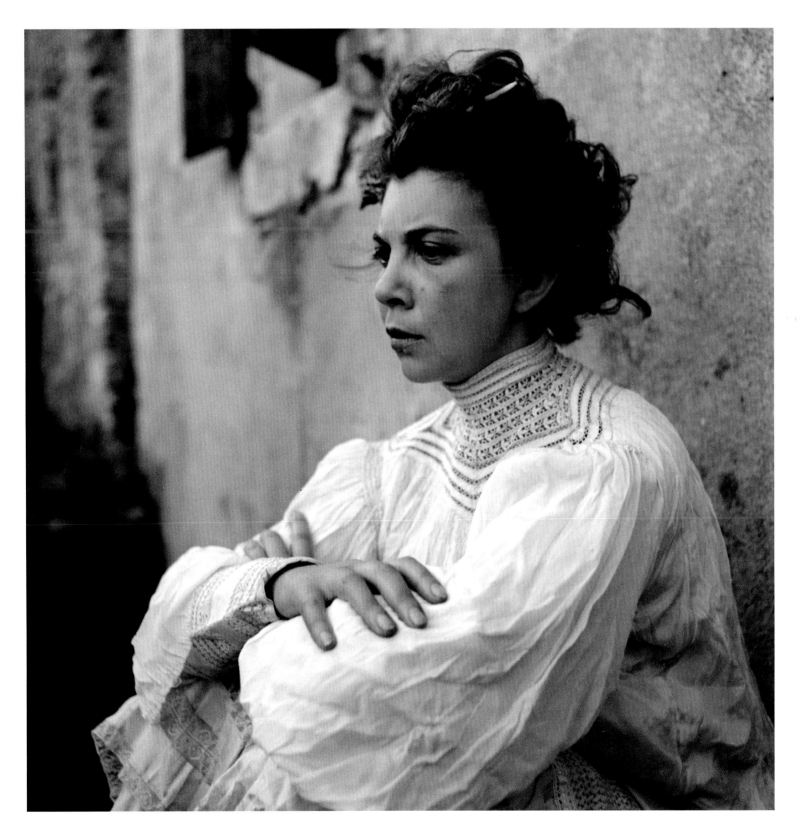

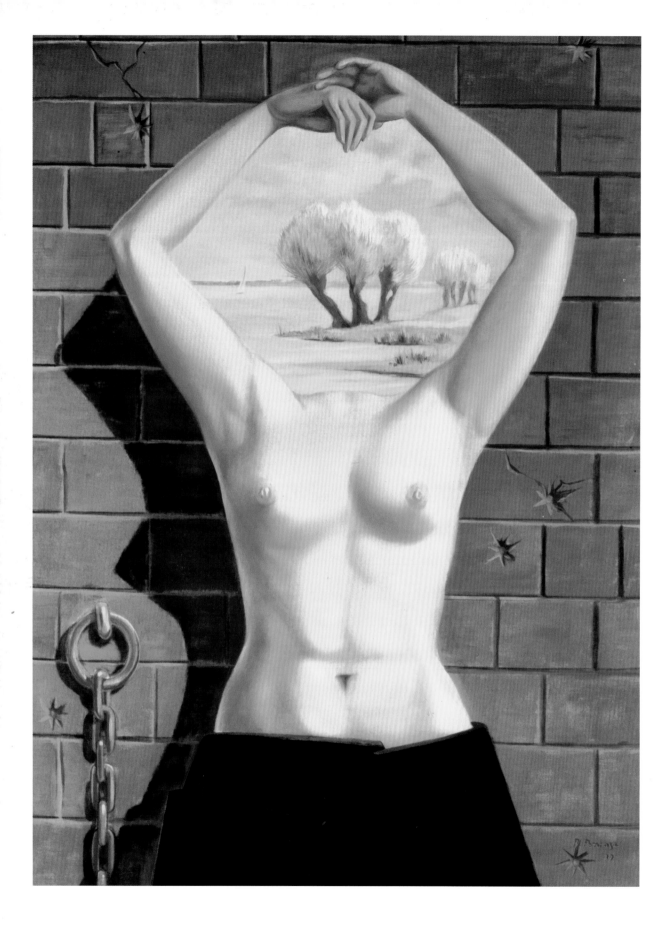

WOMEN IN WARTIME BRITAIN 1939–1944

When war broke out in September 1939, women embarked on a continuous process of change and adaptation. In Britain, men departed for military service and children were evacuated to places of safety, leaving women to sustain the local community. Women found themselves acting as de facto heads of the domestic household, often accommodating temporary or permanent visitors displaced by war. In some areas, large influxes of refugees and foreign servicemen replaced the absent male population, giving rise to social tension.

Wartime regulations, such as air-raid precautions, rationing, recycling and censorship, were quickly introduced. Female auxiliary branches of the armed forces (which had been disbanded after the First World War) were re-established. They were supplemented by civilian services, such as the Women's Voluntary Service and Women's Land Army. Women led increasingly regulated lives, but their contribution to the war effort remained essentially voluntary until the introduction of female conscription in December 1941. As in the First World War, women found that conflict offered them a form of emancipation and personal fulfilment, but its many privations caused stress, exhaustion, anxiety and depression.

Women's magazines played an important part in guiding their readers' responses to wartime demands, a fact recognized by national governments, which saw them as a key outlet for propaganda and information. *Vogue* magazine (which boasted multiple foreign editions tailored towards a readership of affluent and influential women) aspired to remain relevant and offer leadership. But its staff faced diverse challenges, dictated by the impact of war on their countries. Audrey Withers (who took over as editor of British *Vogue* when her predecessor returned to the United States in 1940) transformed the magazine into an influential wartime publication, commissioning major and occasionally radical features on wartime issues, which were adapted for use in *Vogue*'s other editions.

Lee Miller's photography for British *Vogue* between 1939 and 1944 was informed by the magazine's close working relationship with the Ministry of Information. Although it could be termed soft propaganda, it nonetheless offers a genuine account of the evolution of women's lives in wartime Britain and an equally important account of Miller's personal transformation from fashion photographer to war correspondent. A heavy focus on portraiture, fashion and lifestyle gives way to reportage and photojournalism, culminating in major projects documenting the lives of women in uniform. This evolution was facilitated by David E. Scherman, an American photojournalist for *Life* magazine, who became Miller's wartime mentor. As Britain and her allies prepared for the liberation of Europe in 1944, Miller, now an official war correspondent accredited to the US armed forces, prepared to take British *Vogue* in a radical new direction.

Roland Penrose, *Good Shooting (Bien visé)*, London, England, 1939

After separating from her husband in June 1939, Miller made her home in London with Roland Penrose. This painting by Penrose was created as Britain moved to a war footing. It portrays Miller as a woman pinned down by war and her sexuality.

Self-portrait: London, England, January 1940

Miller took this self-portrait to re-establish and demonstrate her professional studio technique after a break of five years. Condé Nast, owner of *Vogue*, felt her technique was lacking in her early assignments (a point confirmed by a disproportionate number of 're-shoots' in 1940) but wisely advised patience. Shortly before his death in 1942, Nast congratulated Miller on the quality and freshness of her photography, noting her ability to overcome problems posed by wartime restrictions 'despite some of the deadliest studio situations'.

WARTIME FASHION AND LIFESTYLE, BRITAIN 1939–1944

'WE SHALL NOT BE UNMINDFUL OF THE CHANGING TIMES. IF THE NEW ORDER IS TO BE ONE OF SACKCLOTH AND ASHES, WE THINK SOME WOMEN WILL WEAR THEIRS WITH A DIFFERENCE! VOGUE WILL CUT THE PATTERN FOR THEM'

Edna Woolman Chase, Editor-in-Chief, American Vogue, *1940*

LEE MILLER: A WOMAN'S WAR

Wartime Fashion and Lifestyle: London, England, January 1940

This elegant photograph of an evening dress was taken during one of Miller's first wartime assignments for British *Vogue*, and was commissioned for the magazine's regular 'Bargain Fashion' feature. The conservative staging draws heavily on Miller's own experience as a fashion model, reflecting her need to establish herself as a photographer at British *Vogue*.

Wartime Fashion and Lifestyle: London, England, April 1940

This photograph, taken for a seasonal feature on hats, ignores any suggestion that Britain has been at war for six months. Throughout the so-called Phoney War, British *Vogue* encouraged women to maintain peacetime standards of dress for the sake of morale and the struggling fashion industry.

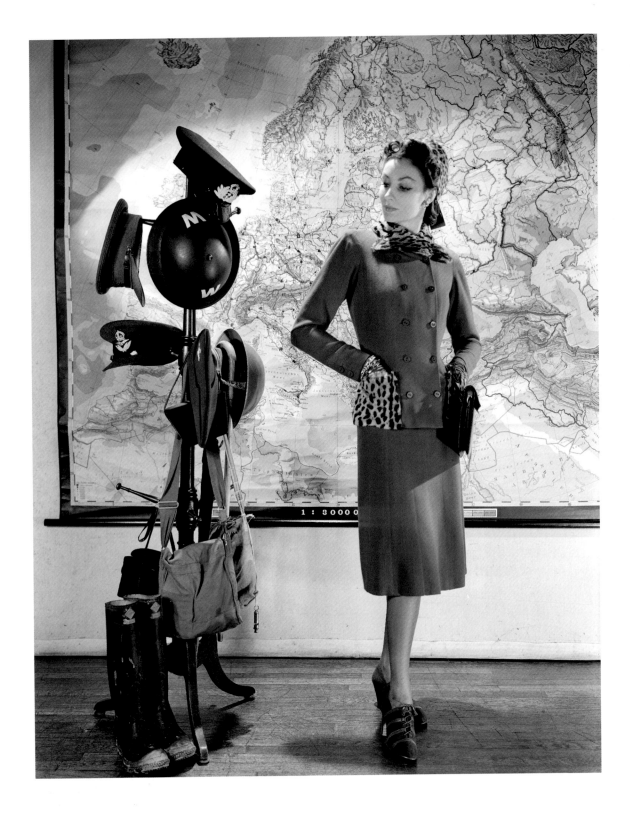

Wartime Fashion and Lifestyle: London, England, November 1939

Staged for British *Vogue*'s 'High Fashion' feature, this is one of Miller's first photographs to make a deliberate reference to the war. Miller's careful selection of hats and accessories combines high fashion with a patriotic tribute to Britain's armed forces in France and the auxiliary services of the home front.

Wartime Fashion and Lifestyle: London, England, June 1941

The widespread destruction and disruption caused by the Blitz offered new opportunities for fashion photography. Here, a *Vogue* model wearing a Digby Morton suit is posed in front of a London bomb site.

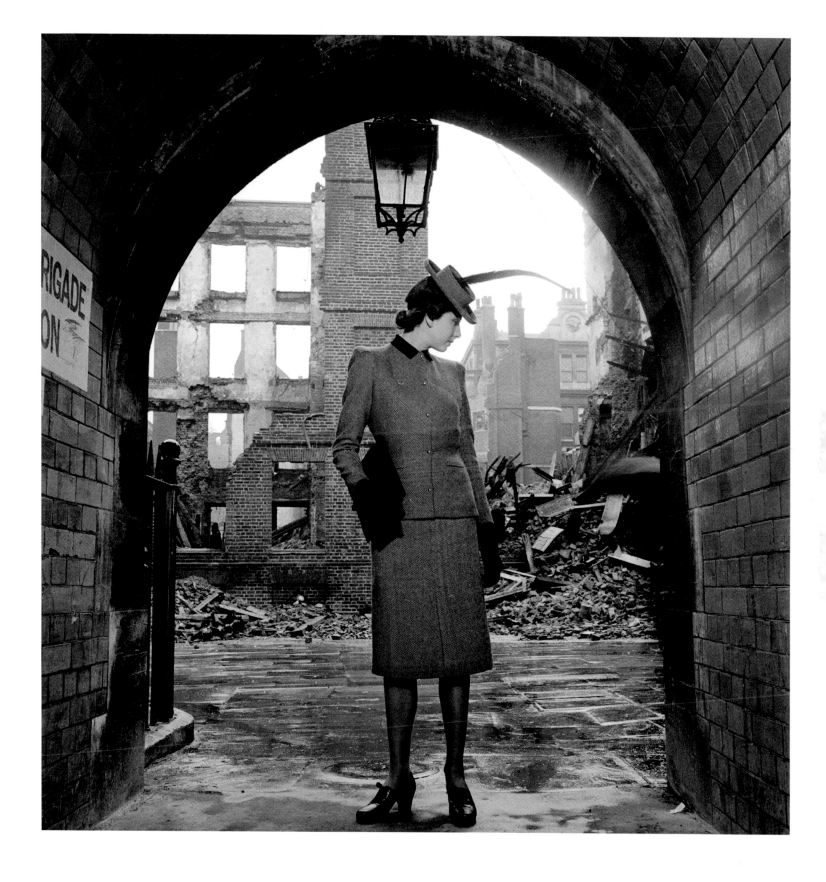

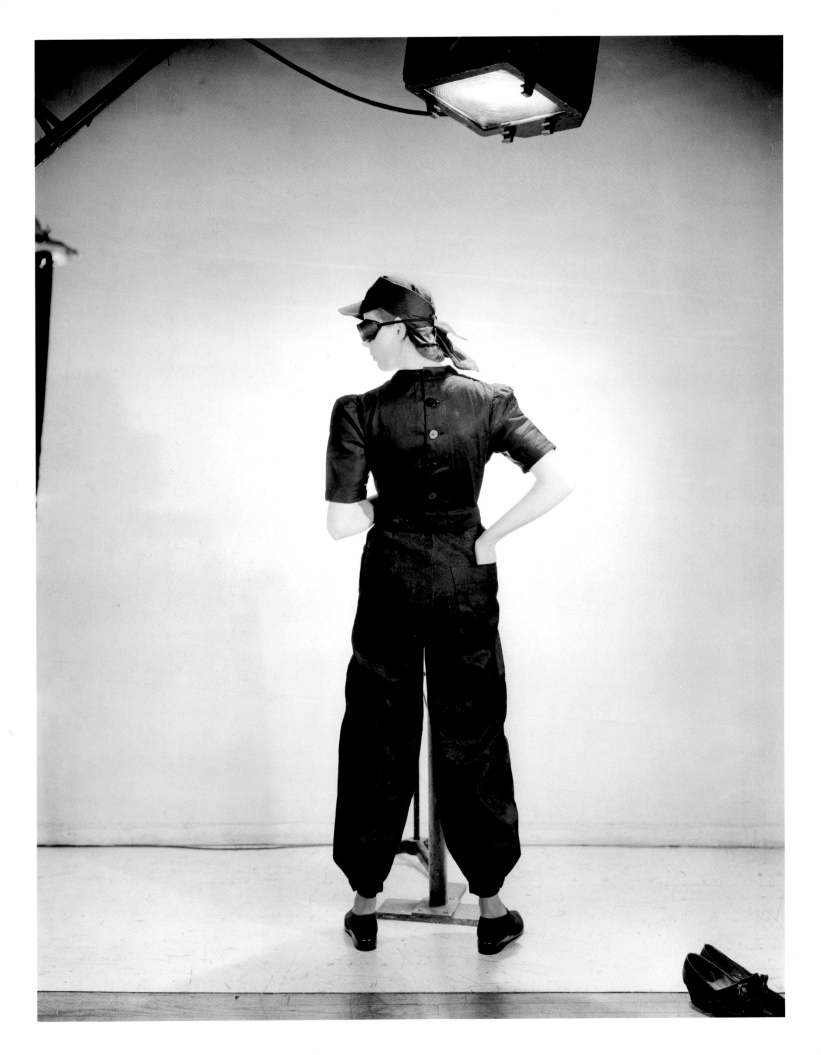

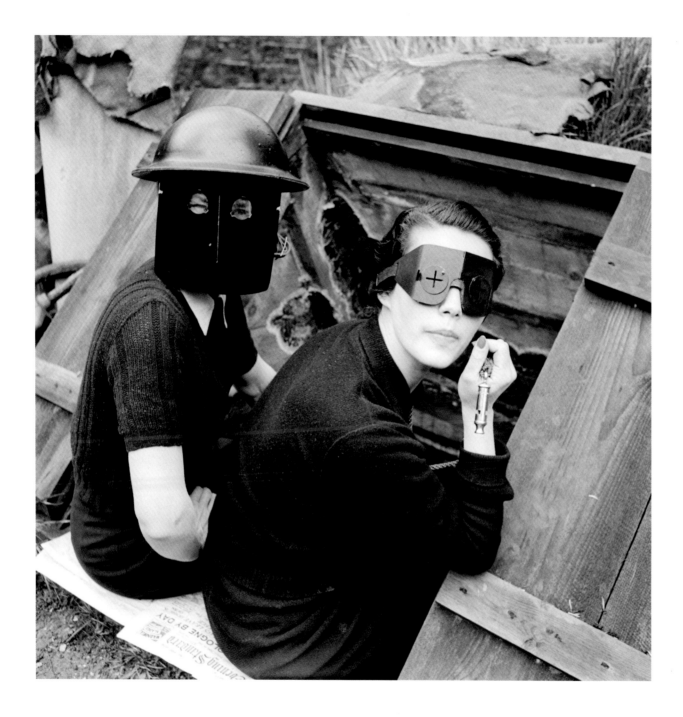

Wartime Fashion and Lifestyle: London, England, May 1941

Miller's fashion photography quickly became more confident. This reworking of a pre-war portrait of Miller by George Hoyningen-Huene formed part of British *Vogue*'s 'Fashion for Factories' feature, which suggested that well-presented women performed better at work. The feature, devised in collaboration with the Ministry of Information, was informed by the government's desire to improve safety in the workplace and recruit women for factory work.

Wartime Fashion and Lifestyle: Hampstead, London, England, May 1941

In a characteristic blend of glamour and Surrealist humour, one of Miller's best-known wartime photographs shows *Vogue* models wearing protective fire masks at the entrance to the air-raid shelter at Miller's home in Hampstead, north London.

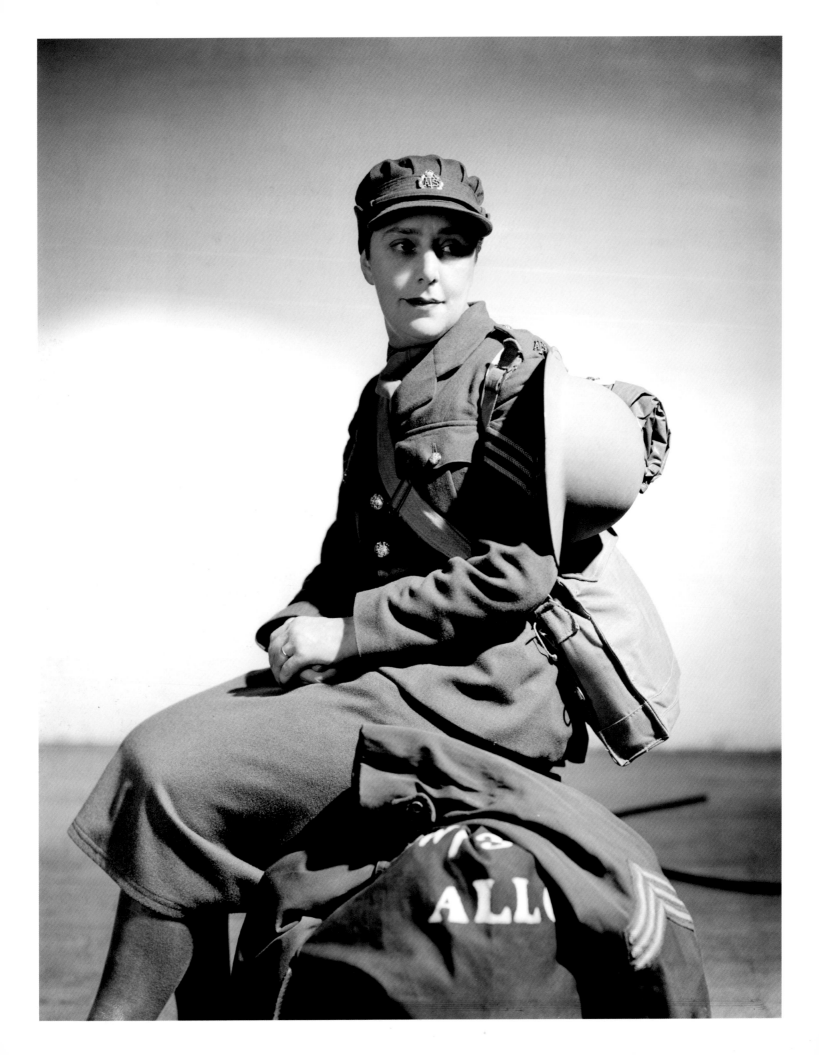

Wartime Fashion and Lifestyle: London, England, July 1940

Miller successfully applies the techniques of fashion photography to this portrait of an unidentified sergeant of the British Army's Auxiliary Territorial Service (ATS). British *Vogue* commissioned the portrait at a time when the ATS was suffering a serious recruitment crisis. Disillusioned by menial duties, poor conditions and unglamorous uniforms, 26 per cent of women who volunteered for the ATS in 1939 left the service in 1940.

Wartime Fashion and Lifestyle: London, England, August 1941

The prevailing British fashion for long hair, inspired by Hollywood actresses, was at odds with wartime requirements. Miller's elegant photograph of *Vogue* model Margaret Vyner, her hair styled by Raymond of Grafton Street, formed part of a British *Vogue* feature entitled 'Short Hair Is News Again'.

Wartime Fashion and Lifestyle: London, England, October 1941

British *Vogue* attempted to help women deal with the stress and anxiety of war. This photograph was taken for a feature on headaches and migraines.

Wartime Fashion and Lifestyle: London, England, June 1942

This interesting multiple exposure was taken for 'Limbering Up for the Big Push', a British *Vogue* feature which argued that attention to personal fitness was essential if women were not to be a liability in wartime.

LEE MILLER: A WOMAN'S WAR

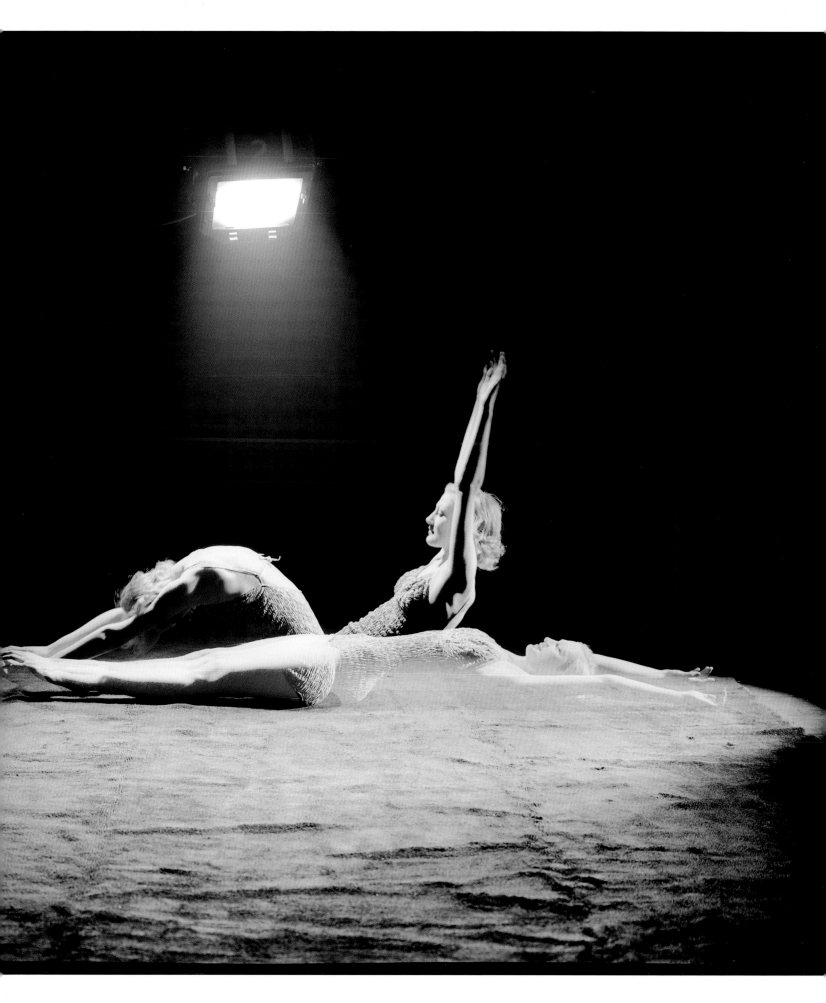

Wartime Fashion and Lifestyle: London, England, 1942

Social convention, as well as the tenets of British *Vogue*, dictated that underwear should be photographed attractively but discreetly. Here, Miller employs the solarization technique for a feature on corsetry.

Wartime Fashion and Lifestyle: London, England, 1942

This composite image, inspired by George Hoyningen-Huene's photograph of Miller from 1932 (see page 35), was accepted for a British *Vogue* feature called 'Good and Bad Posture'.

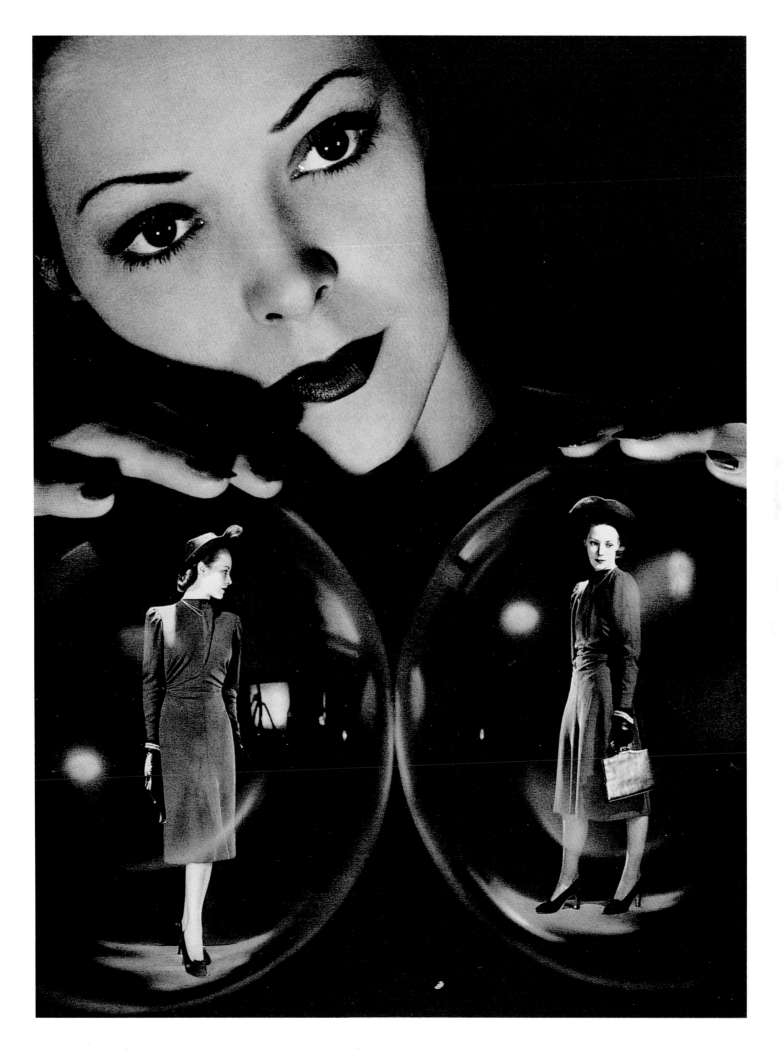

Wartime Fashion and Lifestyle: London, England, February 1944

By 1944, shortages and rationing affected all aspects of British *Vogue*'s fashion coverage. Lively staging could offset the austerity of Utility wartime fashions, but careful lighting is the sole device used to showcase this elegant couture suit.

Wartime Fashion and Lifestyle: London, England, January 1944

Miller's emerging role as an official war correspondent did not leave her much time for fashion photography, which by 1944 held little appeal for her. The staging of this unpublished photograph, featuring a striped Utility summer dress, is perhaps an inadvertent reflection of Miller's mood.

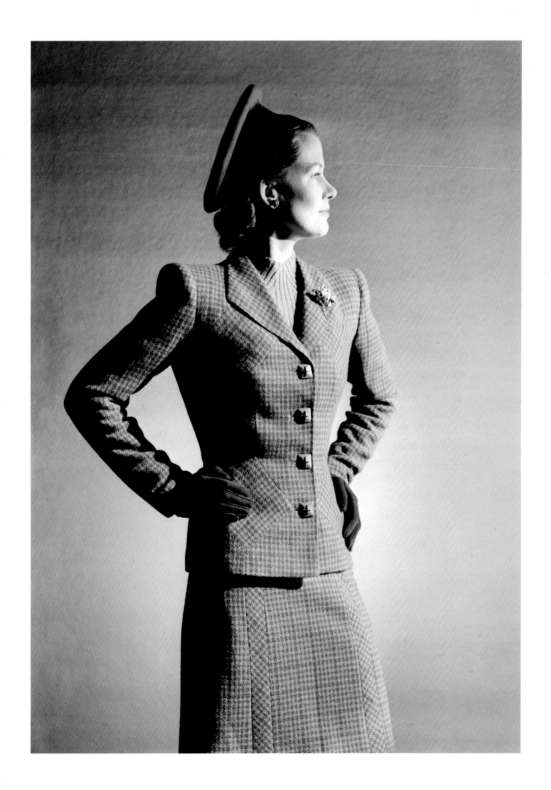

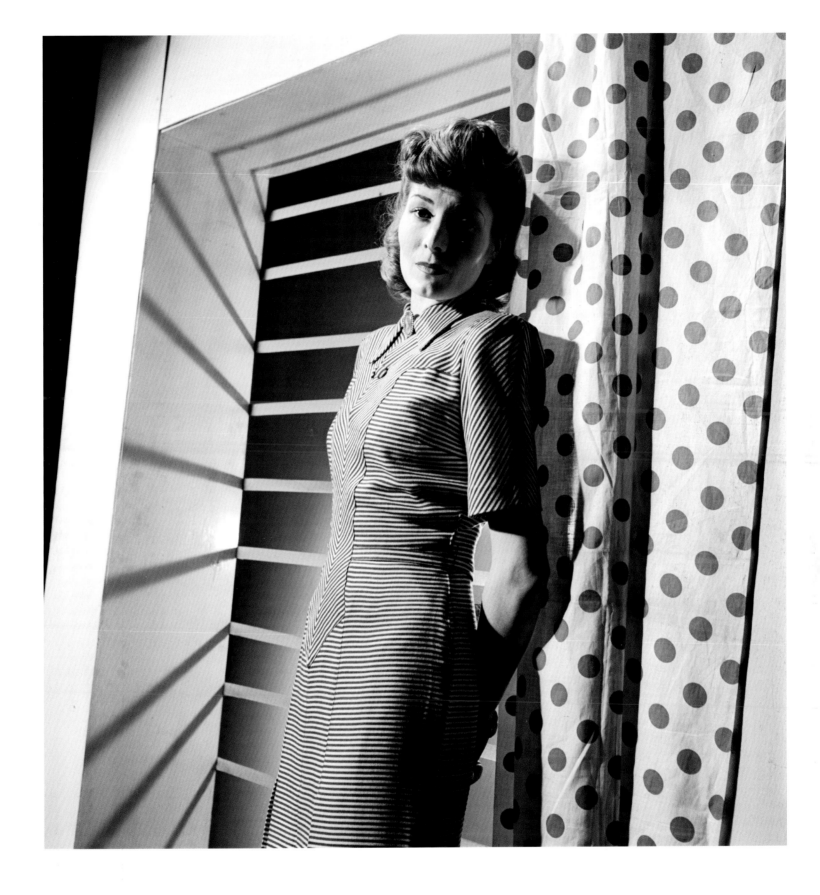

English ballerina Margot Fonteyn wears a black felt Chinese hat designed for her by Aage Thaarup, a Danish milliner, for British *Vogue*'s 'Reflections of Personality' feature. Fonteyn (who had spent her early childhood in China) wore the hat in a subtle tribute to her father, at that time interned by the Japanese in Shanghai.

Miller's later wartime portraits highlight the sitter's personality and wartime contribution. Martha Gellhorn, an American journalist and war correspondent, is shown writing at her dressing table, overlooked by a photograph of her husband, Ernest Hemingway, for a British *Vogue* feature entitled 'Newsmakers and Newsbreakers'. Gellhorn reported on the Spanish Civil War, as well as many key episodes of the Second World War. Hemingway's competitive opposition to her work caused their marriage to fail in 1944.

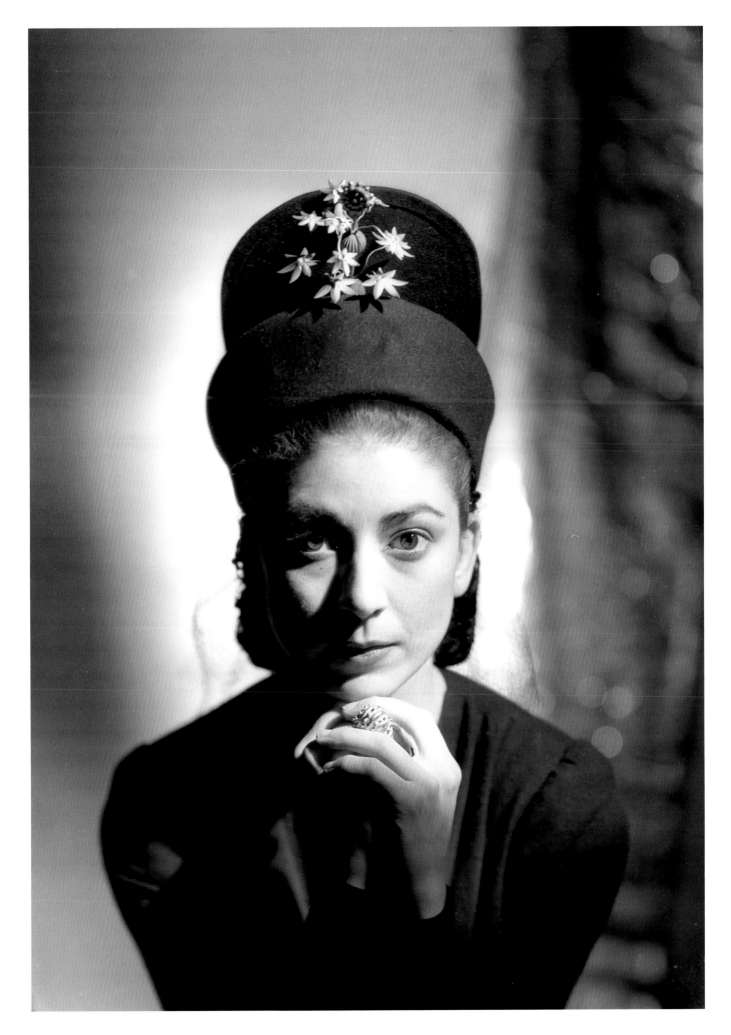

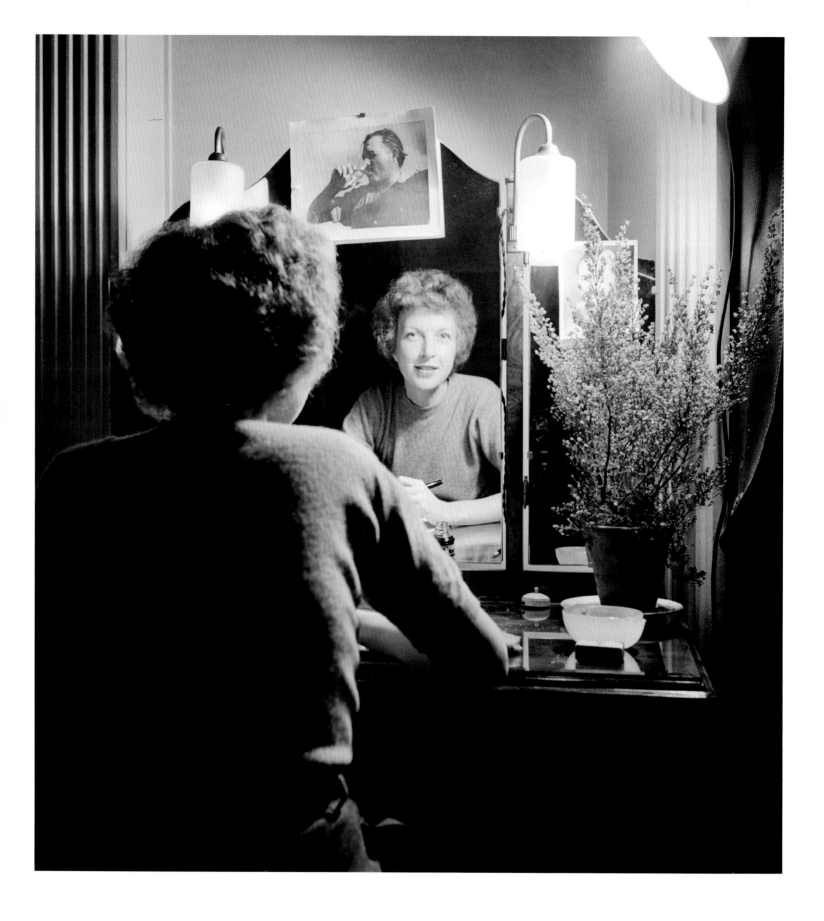

WOMEN AND THE HOME FRONT, BRITAIN 1939–1944

'THE SIRENS HAVE BEEN RINGING AND UNRINGING THEMSELVES IN THE MOST NEW AND FANCY FASHION AGAIN ... EVERYONE HAS VERY ELABORATE THEORIES ABOUT NEW SECRET WEAPONS WHICH ARE SENDING THE BOMBERS HOME AGAIN – BUT MY OWN IS SIMPLER AND PROBABLY MORE TRUE ... THE CHIEF SIREN WARDEN WANTS TO TELEPHONE HIS GIRLFRIEND'

Lee Miller to Roland Haupt, October 1940

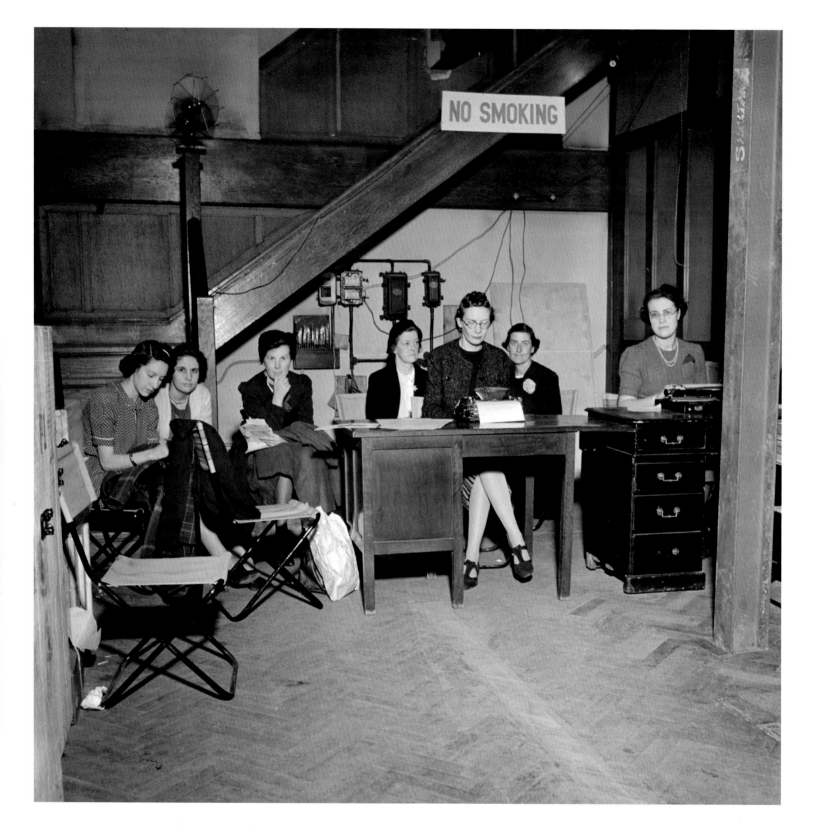

**Women and the Home Front: London,
England, September 1940**

Miller supplemented her fashion photography with
documentary projects detailing the impact of the Blitz,
which began on 7 September 1940. Her photographs
sought to inform the United States while supporting
British morale. In this photograph, British *Vogue* staff are
shown working in the cellar of their Bond Street office
on a feature entitled 'Here is *Vogue*, in Spite of All!'

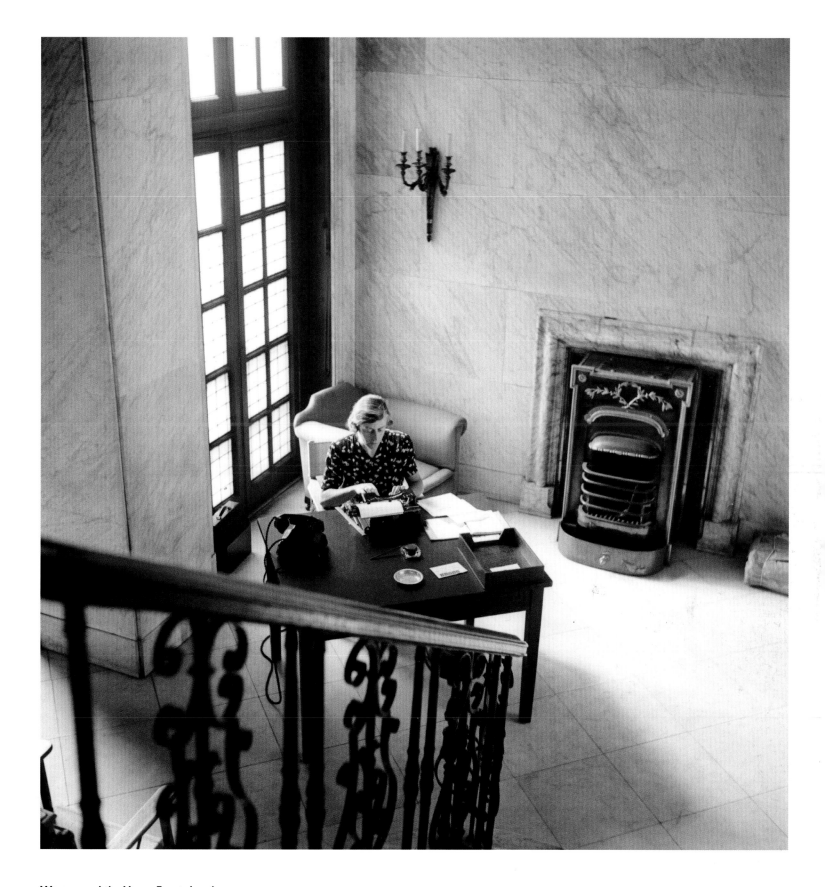

**Women and the Home Front: London,
England, July 1941**

British *Vogue* did its best to highlight the unglamorous
but essential war work carried out by office staff up and
down the country. Here, a typist works in a stairwell at
the British Red Cross headquarters in Cadogan Square.

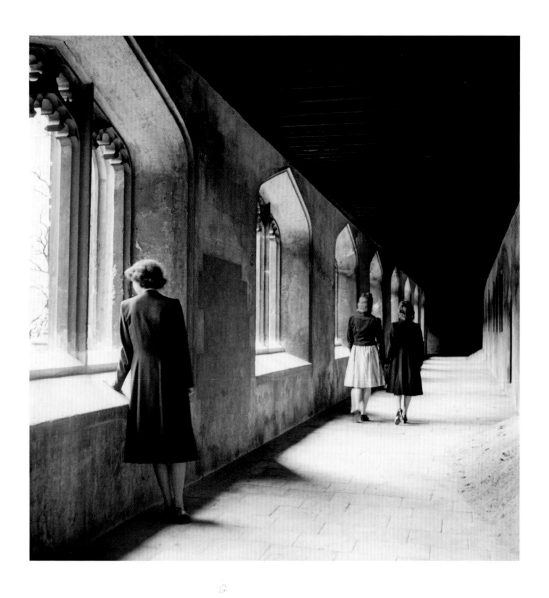

Women and the Home Front: Oxford, England, May 1941

A study of life in wartime Oxford formed one of Miller's first documentary photoessays for British *Vogue*. The absence of male students on war service offered women more opportunities to study, but Miller's photographs also convey the isolation and emptiness of college life in wartime.

Women and the Home Front: Eversholt, Buckinghamshire, England, July 1941

Miller's portrait of Lady Mary Dunn at Castle Farm was one of many photographs commissioned by British *Vogue* to illustrate the multitude of roles undertaken by women on the home front. Lady Mary ran the family farm, cared for a young evacuee and hosted country breaks for traumatized and exhausted Civil Defence workers. Her husband, Sir Philip Dunn, was serving with the army, while her daughters (the future Serena Rothschild and writer-to-be Nell Dunn) had been evacuated to the United States. The war took its toll on the Dunns' marriage, which was dissolved in 1944. However, the couple remarried twenty-five years later.

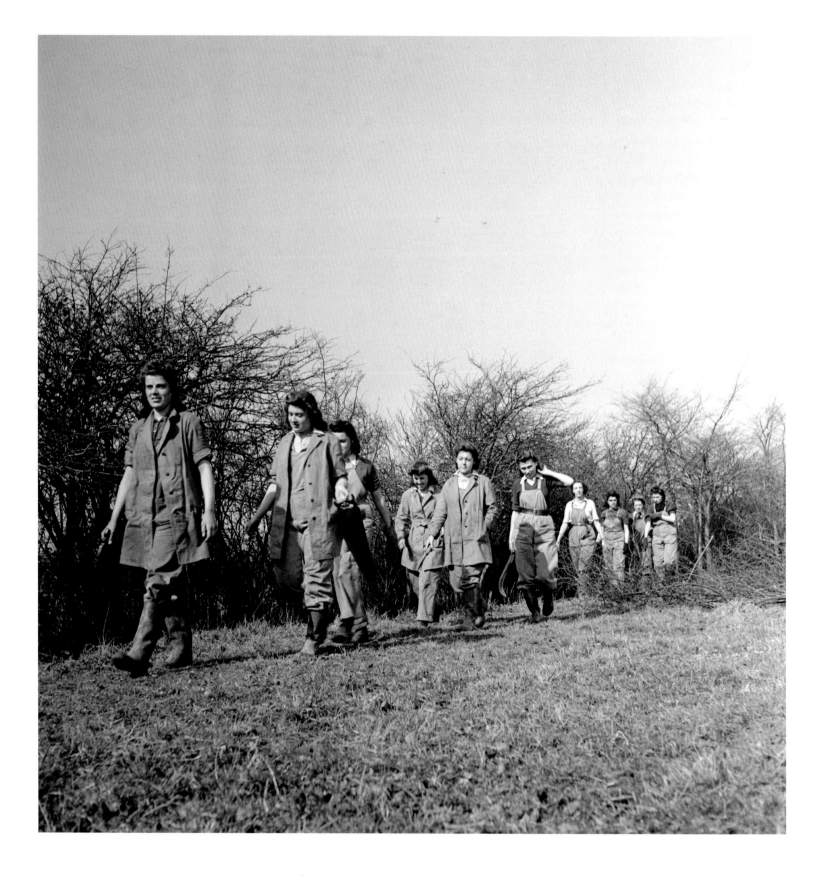

LEE MILLER: A WOMAN'S WAR

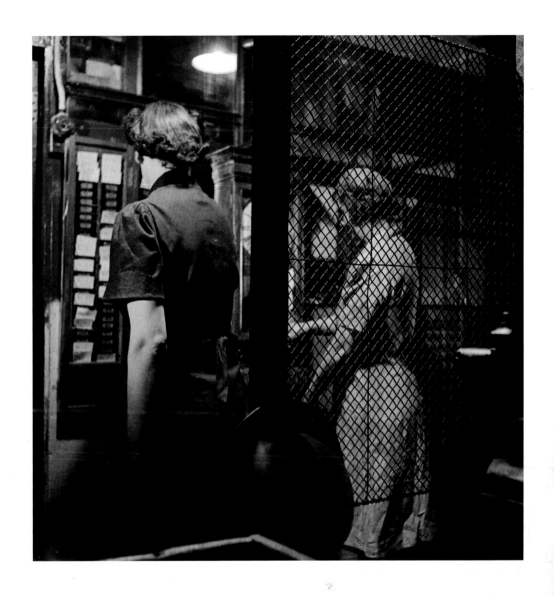

**Women and the Home Front: Chessington
area, Surrey, England, March 1943**

Land girls prepare to maintain a hedge. The Women's
Land Army (WLA), a civilian service, helped maintain
wartime agriculture in Britain, but land girls' lives were
exhausting and far from glamorous. British *Vogue*'s
feature 'The Lay of the Land' stressed the WLA's ability
to master rural crafts involving heavy manual labour.

**Women and the Home Front: London,
England, July 1941**

Factory workers clock in at the start of a twelve-
hour shift. Factories producing war materials were
in continuous operation. Most women worked
a six-day week.

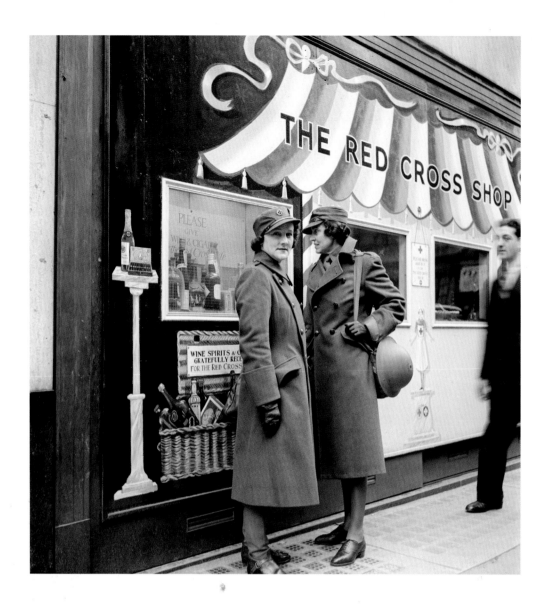

Women and the Home Front: London, England, March 1941

Voluntary civilian services presented women with various opportunities to contribute to the war effort. The Mechanised Transport Corps (MTC) provided female drivers for government use. MTC drivers Mrs Pat MacLeod (left) and Miss Winifred Ashford (a former fashion designer, known professionally as 'Olga') are shown outside a Red Cross charity shop, shortly before undertaking a tour of the United States in aid of British War Relief charities.

Women and the Home Front: London, England, August 1942

Members of the Women's Home Defence Corps (WHD) arrive for evening training. Women were expected to undertake additional voluntary work in support of the war effort in their leisure time, but political and public opinion was firmly opposed to the idea of female combatants. The WHD, an unofficial unit established in support of the Home Guard in 1941, was one of the few British military or civilian organizations that permitted women to handle firearms.

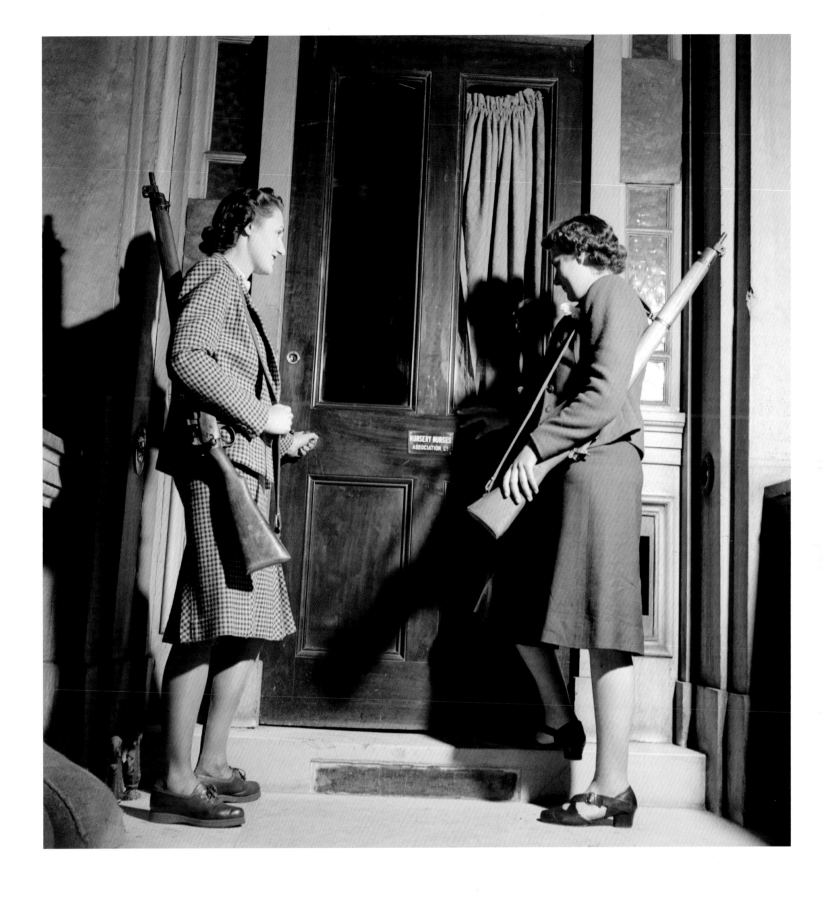

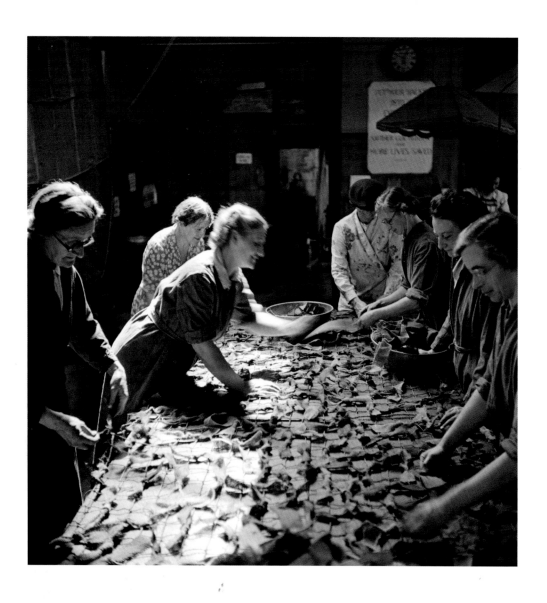

ABOVE AND RIGHT
Women and the Home Front: Cambridge,
England, May 1943

A Women's Voluntary Service (WVS) camouflage
workshop, photographed for British *Vogue's*
feature on wartime life in Cambridge. The WVS
was established to support the emergency air-
raid and Civil Defence services. Its activities were
many and diverse but few chose to wear the WVS
uniform (designed by Norman Hartnell).

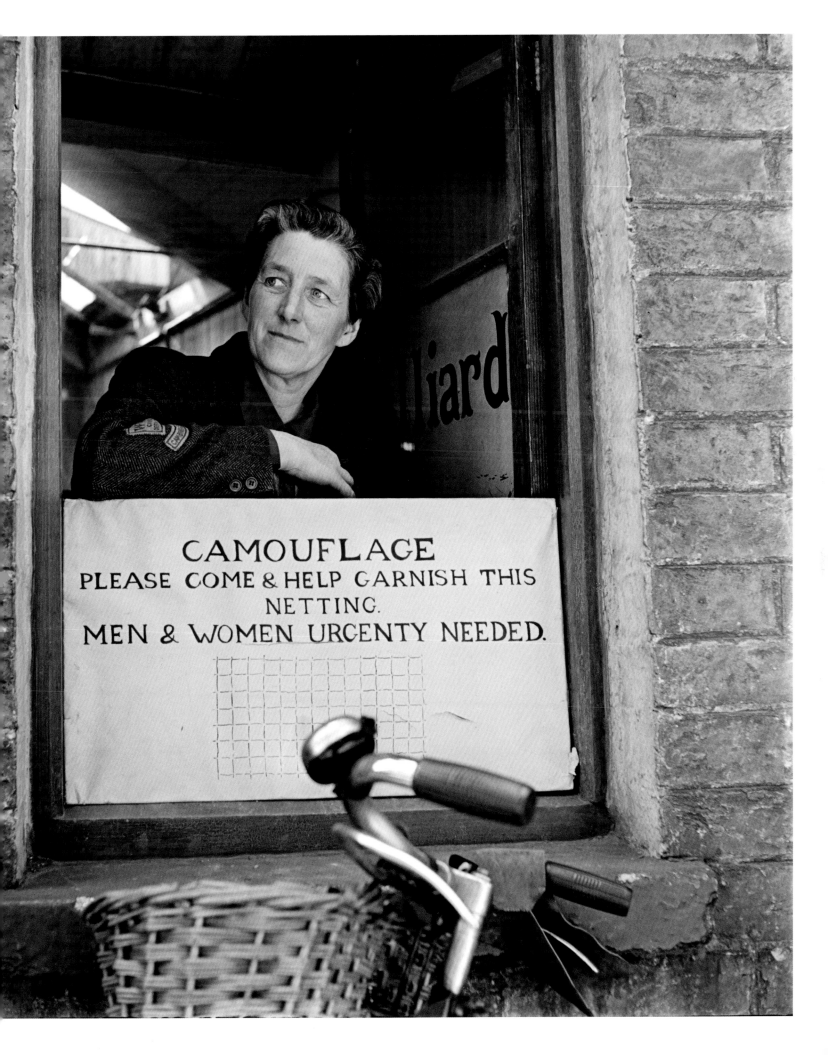

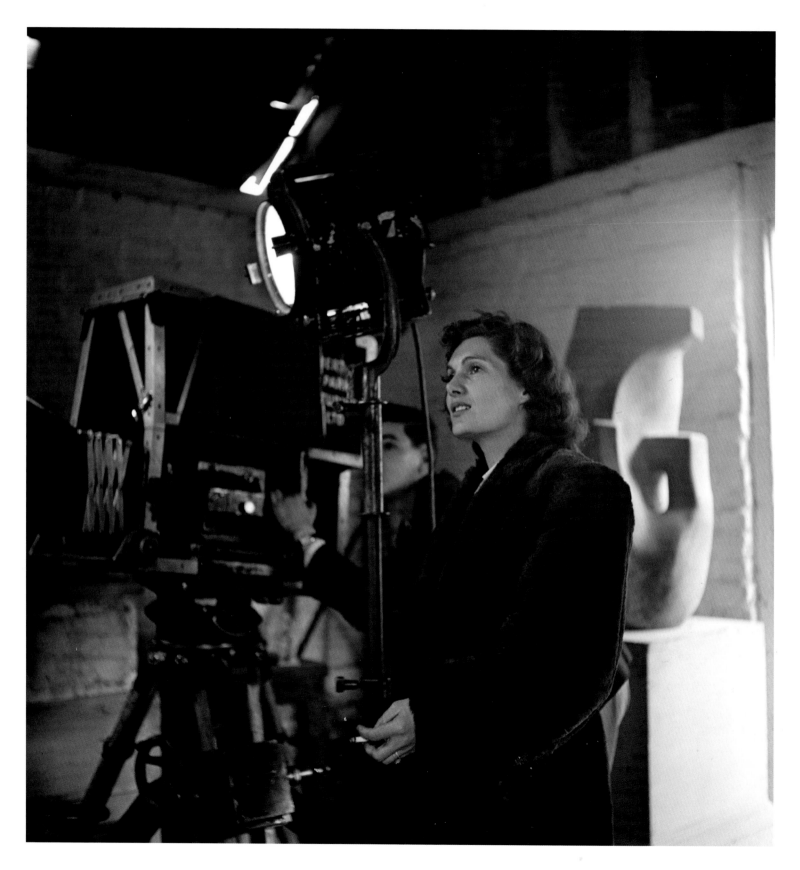

LEE MILLER: A WOMAN'S WAR

Women and the Home Front: Hertfordshire, England, October 1943

Jill Craigie directs proceedings at Henry Moore's studio in Much Hadham for her first film, *Out of Chaos* (1944), a short documentary exploring the impact of war on British artists. The war brought significant disruption to the creative arts, but also offered new opportunities. Craigie, a documentary scriptwriter, went on to enjoy a successful career as a director and producer before marrying Labour politician Michael Foot. Her films included *To Be a Woman* (1951), which examined the issue of equal pay for women.

David E. Scherman and Roland Penrose,
Lee Miller in Camouflage, **Highgate, London, England, 1942**

The Surrealist movement was scattered by the war but not entirely dormant. Creative activities were informed by wartime priorities. Roland Penrose, now serving with the British Army as a camouflage instructor, collaborated with David E. Scherman (who was living with Miller and Penrose in a wartime *ménage à trois*) to create this striking colour portrait of Miller in a friend's garden. Penrose coated Miller with an experimental green camouflage cream developed by Elizabeth Arden's cosmetics firm. He later noted that the photograph proved very popular in camouflage-training lectures.

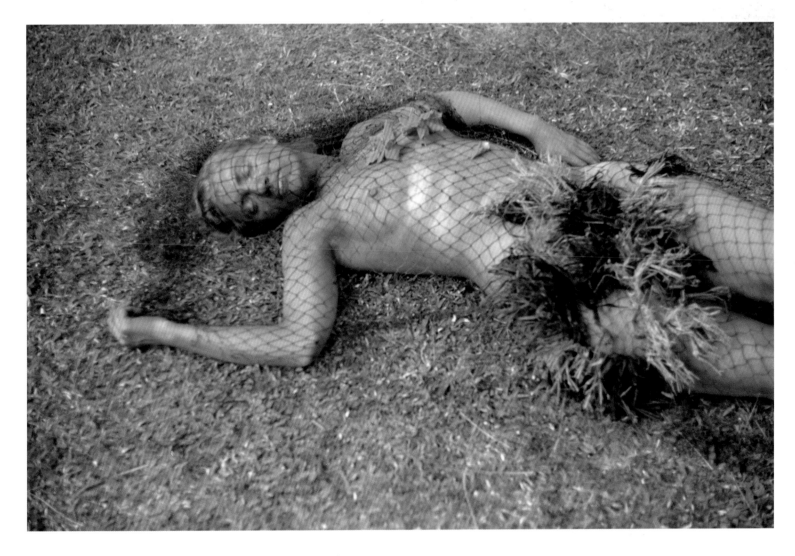

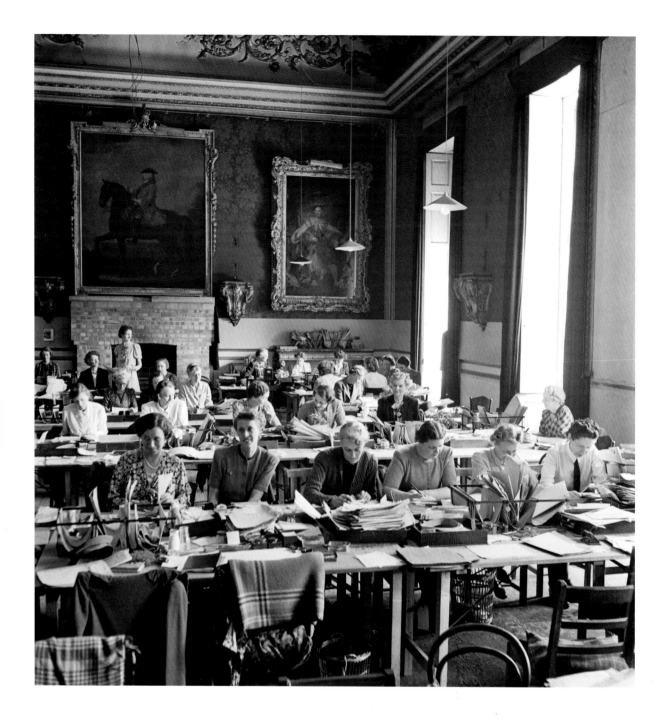

Women and the Home Front: London, England, July 1944

Volunteers at work in the Parcels Office of the British Red Cross Prisoners of War Department on Wellington Street. British POWs in Germany and elsewhere were allowed to receive aid parcels from their families and the Red Cross. By the end of the war, Red Cross Parcels Office volunteers had despatched more than 20 million parcels containing food, medical supplies and recreational items.

Women and the Home Front: London, England, July 1944

Volunteers of the British Red Cross and Order of St John played a vital role in supporting prisoners of war and their families. Here, the wife of a British prisoner of war, accompanied by her young child, seeks information about her husband from a volunteer at the British Red Cross Prisoners of War Department.

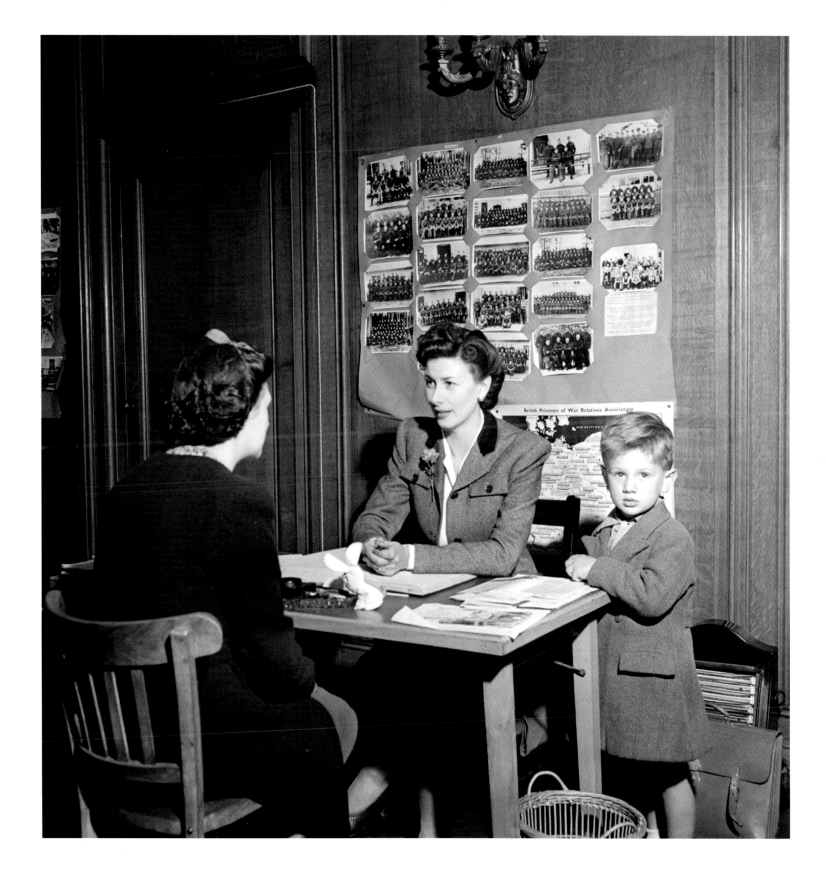

WOMEN IN UNIFORM, BRITAIN 1939–1944

'NOW I WEAR A SOLDIER SUIT ON ACCOUNT OF I'M WAR CORRESPONDENT FOR CONDÉ NAST PRESS. YOU OUGHT TO SEE ME ALL DONE UP AND VERY SERIOUS LIKE IN OLIVE DRAB AND FLAT HEELED SHOES'

Lee Miller to her parents, May 1943

Lee Miller as an official US war correspondent for Condé Nast press, London, England, 1944 (photo: David E. Scherman)

The British government's decision to introduce female conscription and the arrival of American forces on British soil did much to liberate Miller from the frustrations of fashion photography. British *Vogue*, at the behest of the Ministry of Information, commissioned a series of features showcasing the work of women in uniform. Miller's growing interest in photojournalism, fostered by David E. Scherman, led to her securing accreditation as an official US war correspondent in December 1942. In 1943 Miller began to write as well as photograph for *Vogue*.

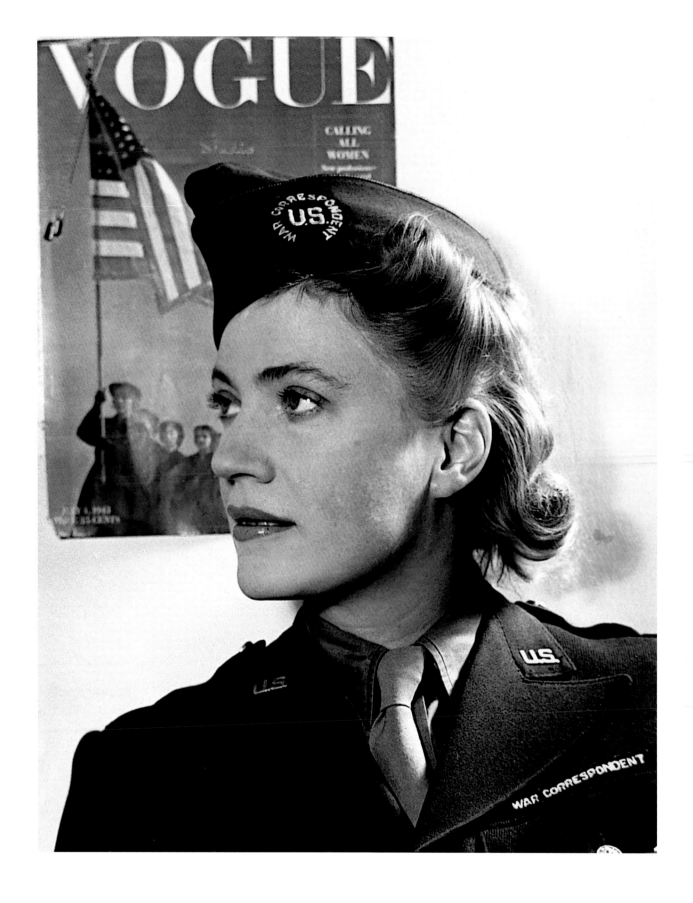

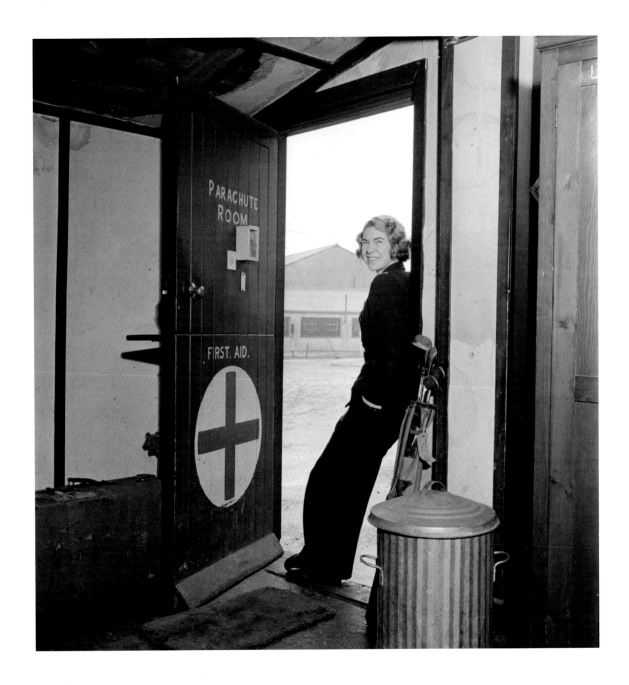

**Women in Uniform: White Waltham,
Berkshire, England, March 1942**

Anne Douglas (later Anne Welch), a pilot with the
Air Transport Auxiliary (ATA), poses with her golf clubs
at White Waltham Airfield. The ATA was a small civilian
unit controlled by the Ministry of Aircraft Production.
Its pilots ferried military aircraft, ranging from small
fighters to heavy bombers, between factories and
maintenance units. Despite the risk of enemy attack,
the aircraft were unarmed. Fifteen female pilots lost
their lives serving with the ATA. Douglas, a highly
experienced pilot who had flown with aviation pioneer
Alan Cobham before the war, flew more than a hundred
different types of aircraft during the conflict.

**Women in Uniform: White Waltham,
Berkshire, England, March 1942**

Flight Lieutenant Anna Leska, one of three Polish
women to serve as ferry pilots with the ATA,
is photographed in the cockpit of a Spitfire fighter
aircraft at White Waltham Airfield. Flt Lt Leska,
a serving officer in the Polish air force, flew more
than ninety different types of aircraft while serving
with the ATA. She returned to Poland after the war.

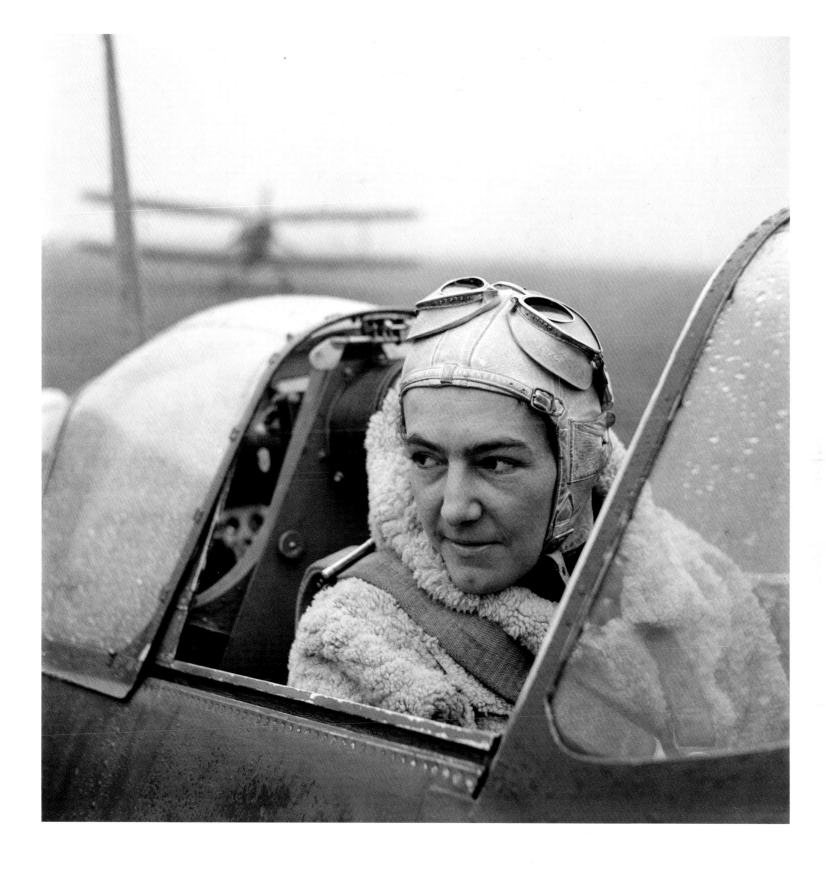

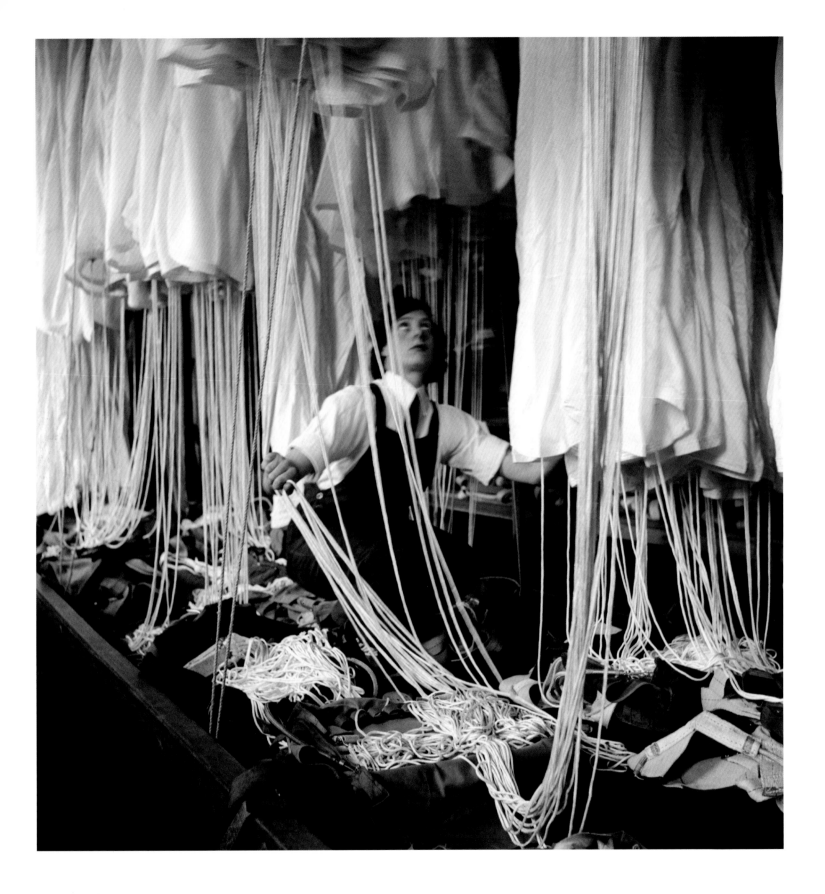

LEE MILLER: A WOMAN'S WAR

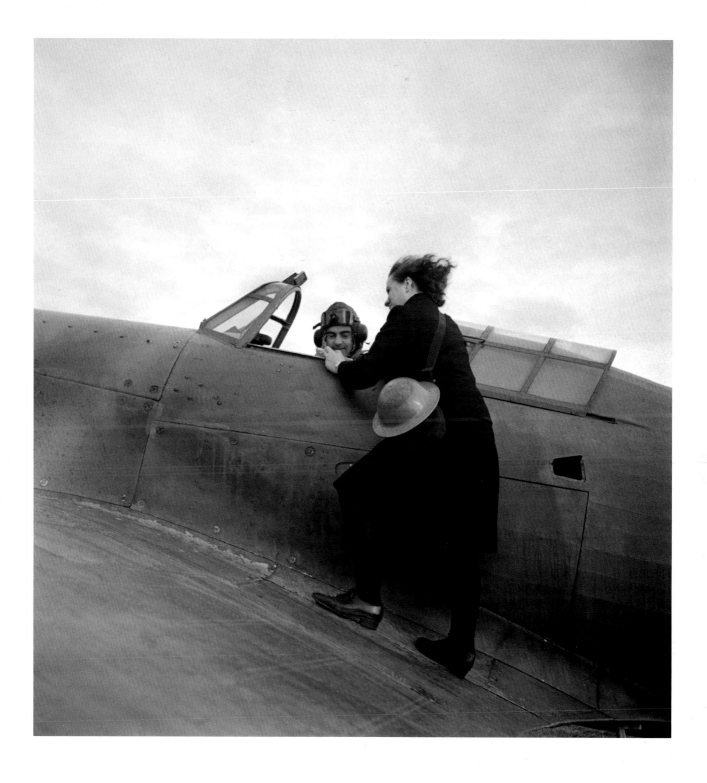

**Women in Uniform: RNAS Yeovilton (HMS
Heron), Somerset, England, September 1941**

A WRNS parachute packer at HMS *Heron*. The
Women's Royal Naval Service, popularly known as 'the
Wrens', was the smallest branch of the women's armed
forces but carried out a broad range of duties on land,
in the air and in coastal waters. Although some duties,
such as parachute packing and codebreaking, required
specialist skills, the majority of Wrens carried out more
mundane work.

**Women in Uniform: RNAS Yeovilton (HMS
Heron), Somerset, England, September 1941**

A WRNS messenger confers with the pilot of a Sea
Hurricane at HMS *Heron*. Miller photographed the
Wrens extensively for features in British *Vogue* and for
her second wartime book, *Wrens in Camera* (1945).

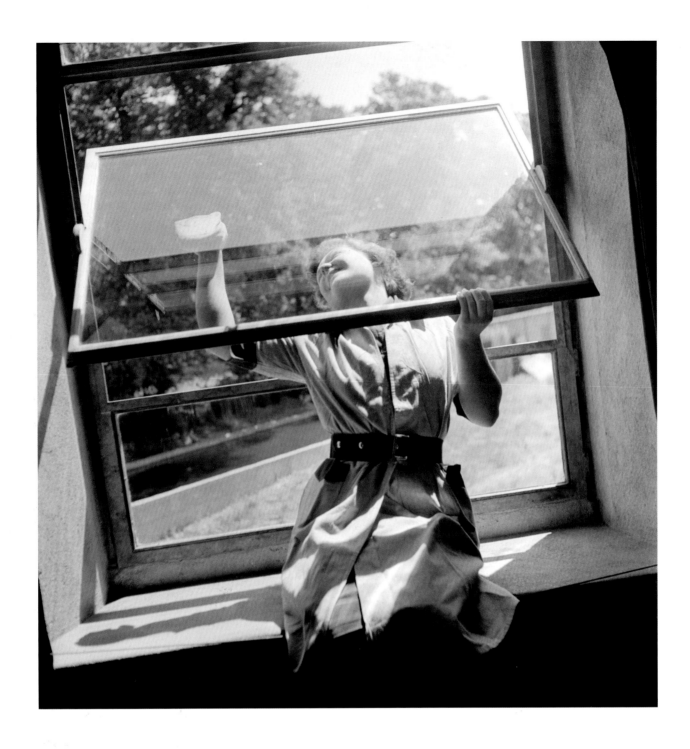

Women in Uniform: HMS *Pembroke*, Mill Hill, Barnet, London, England, June 1944

A WRNS probationer cleans a plate-glass window at HMS *Pembroke*, the WRNS training establishment. Each probationer was required to complete a week of domestic duties as part of her preliminary training.

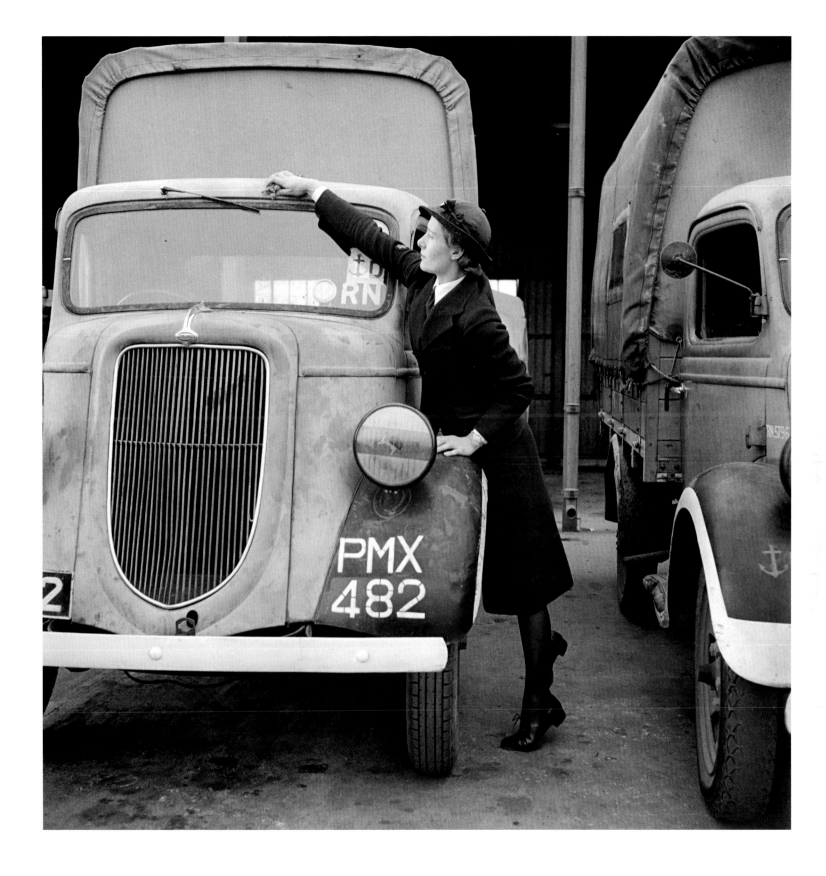

**Women in Uniform: RNAS Yeovilton (HMS
Heron), Somerset, England, September 1941**

A WRNS driver at HMS *Heron*.

Women in Uniform: RNAS Yeovilton (HMS *Heron*), Somerset, England, September 1941

Reminders of home in the WRNS living quarters at HMS *Heron*. Miller's intimate photography of servicewomen's living quarters conveys a sense of feminine empathy.

Women in Uniform: Churchill Hospital, Headington, Oxfordshire, England, January 1943

Laundry belonging to a US Army nurse dries in the window of her living quarters.

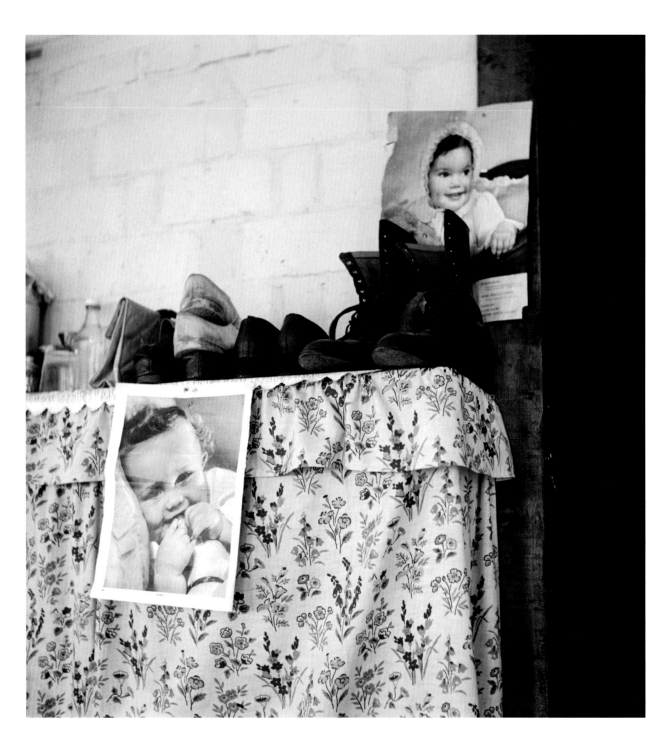

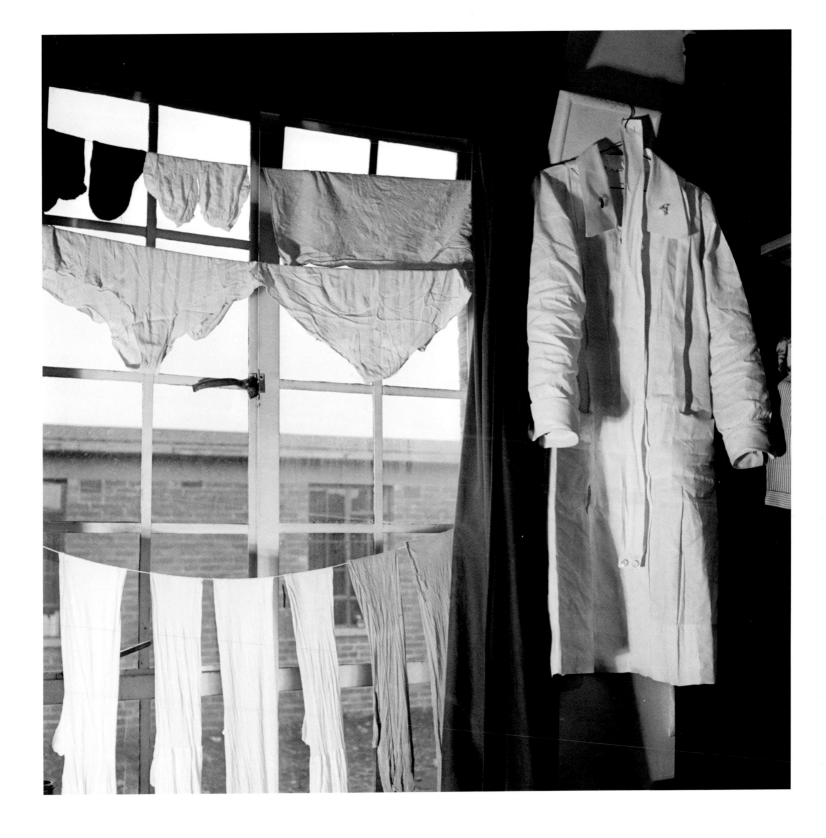

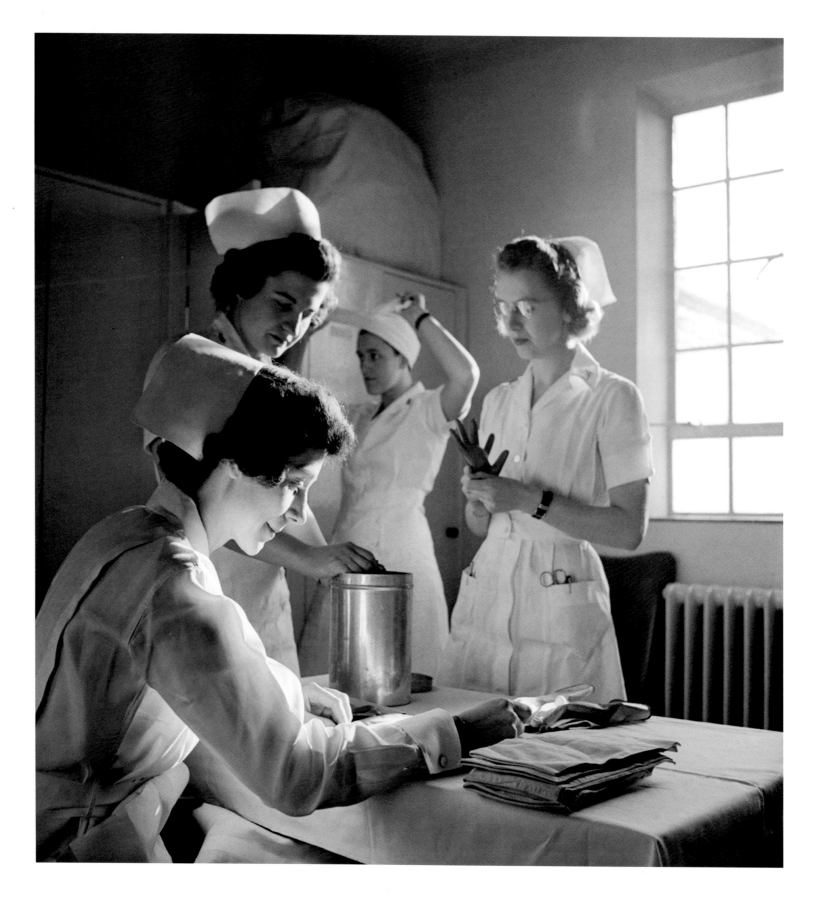

LEE MILLER: A WOMAN'S WAR

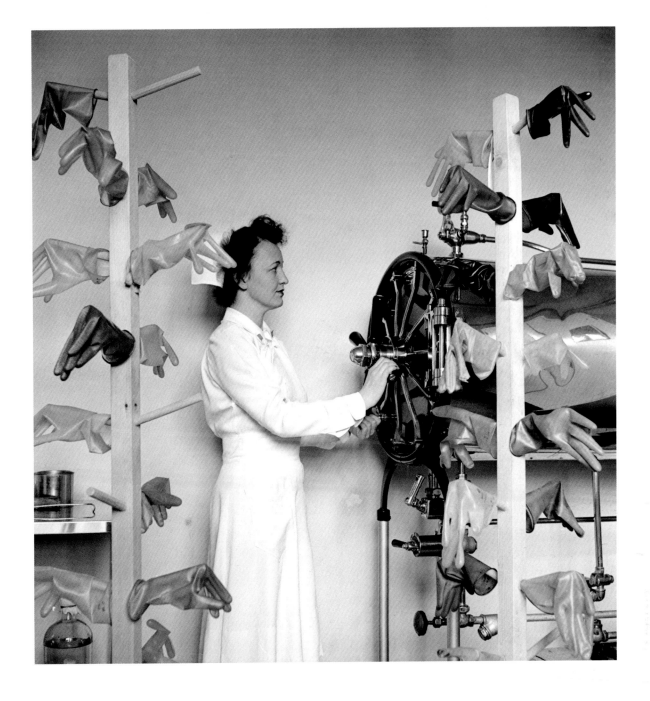

**Women in Uniform: Churchill Hospital,
Headington, Oxfordshire, England,
January 1943**

American nurses of the 2nd US Army General
Hospital photographed for 'American Army Nurses',
one of Miller's first pieces of photojournalism for
Vogue. The Churchill Hospital, near Oxford, was
assigned to the 2nd US Army General Hospital in
1942. With a capacity of more than 1,000 beds, the
hospital was one of the largest and best-equipped
facilities of its kind. It initiated the use of penicillin
by US armed forces.

**Women in Uniform: Churchill Hospital,
Headington, Oxfordshire, England,
January 1943**

A nurse dries sterilized surgical gloves in
a Surrealist-inspired photograph taken at the
2nd US Army General Hospital.

Women in Uniform: Churchill Hospital, Headington, Oxfordshire, January 1943

An off-duty couple at the 2nd US Army General Hospital photographed for Miller's 'American Army Nurses' feature. Life in the armed forces brought men and women into regular contact, both on and off duty. Miller's article noted that American nurses 'may only go out with officers and civilians. They *don't* get a ration of silk stockings.'

Women in Uniform: Woking, Surrey, England, April 1943

Firewomen of No. 32 Fire Force, National Fire Service (NFS), maintain a fire tender. Approximately 80,000 women served with the NFS. Although they received some basic training in firefighting techniques, firewomen did not fight genuine fires during the war.

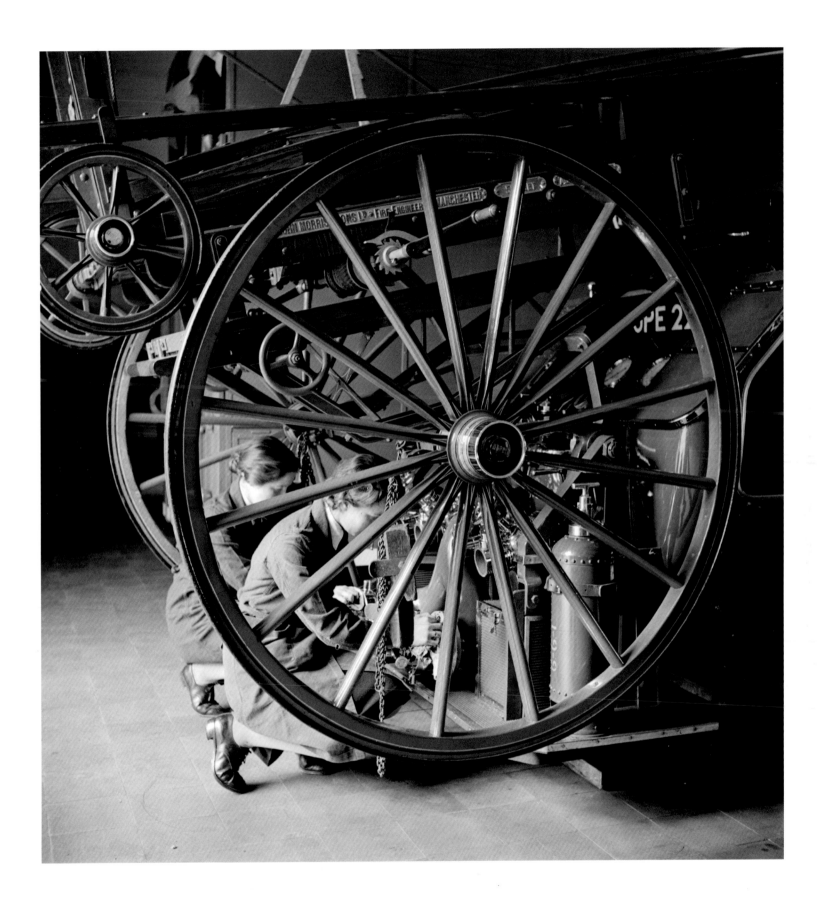

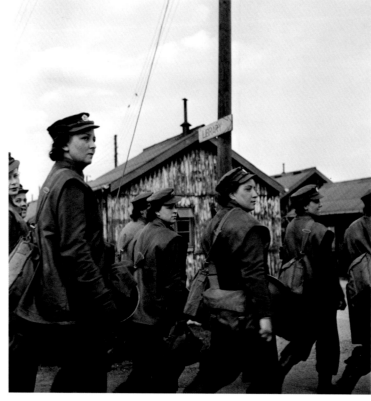

Women in Uniform: Shoeburyness, Essex, England, May 1943

ATS gunners from a mixed heavy anti-aircraft artillery battery return to barracks after gunnery practice. General Sir Frederick Pile, commander-in-chief of the British Army's Anti-Aircraft Command, established mixed anti-aircraft units to address a recruitment crisis in 1941. As non-combatants, the ATS were allowed to perform every function except fire the guns. Their battledress, the first to be specifically designed for women, used lighter material that was less irritating to female skin.

Women in Uniform: Camberley, Surrey, England, January 1943

An officer cadet of the Auxiliary Territorial Service (ATS) issues orders on the parade ground in a photograph for British *Vogue*'s feature 'What It Takes to become an Officer'. The ATS officer cadre had been established in 1941 as part of a reorganization in response to ATS recruitment problems. By 1943, the ATS numbered more than 200,000 women.

Women in Uniform: London, England, March 1943

ATS searchlight operators of Anti-Aircraft Command photographed for British *Vogue*'s 'Nightlife Now' feature. Searchlights were often deployed on isolated and exposed sites. General Pile wrote: 'The girls lived like men, fought their lights like men and, alas, some of them died like men.'

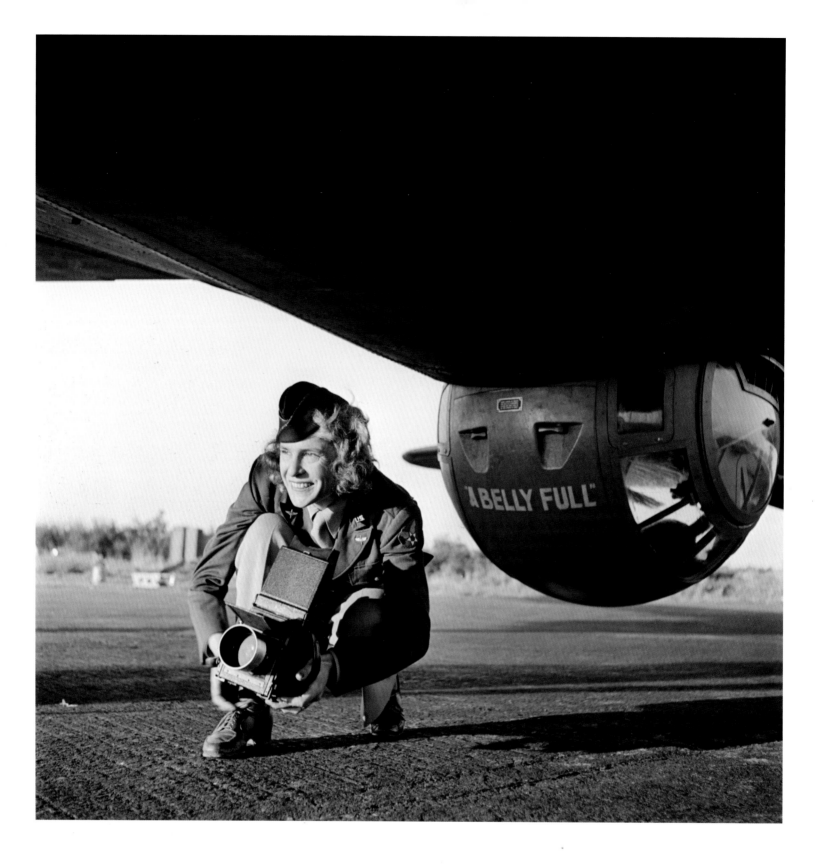

LEE MILLER: A WOMAN'S WAR

Women in Uniform: RAF/USAAF Polebrook, Northamptonshire, England, October 1942

Margaret Bourke-White, *Life* magazine photojournalist and official US war correspondent, photographs an American B-17 bomber of 97th Bomb Group (the first operational American heavy bomber unit) at RAF/USAAF Polebrook for *Life* magazine. Bourke-White was the most experienced member of a very small group of female war correspondents accredited to the US armed forces. Her determination to get the story would inspire Miller's coverage of the war in Europe. In 1943 Bourke-White became the first woman to fly on a US Army Air Force combat mission.

Women in Uniform: RAF Waddington, Lincolnshire, England, May 1943

A Women's Auxiliary Air Force (WAAF) darkroom assistant processes a negative in the darkroom at RAF Waddington. Although barred from combat photography, WAAFs played a crucial role in processing and interpreting aerial photographs of enemy targets. They also maintained the camera equipment carried by every RAF bomber. The work was routine but demanding. Speed was essential.

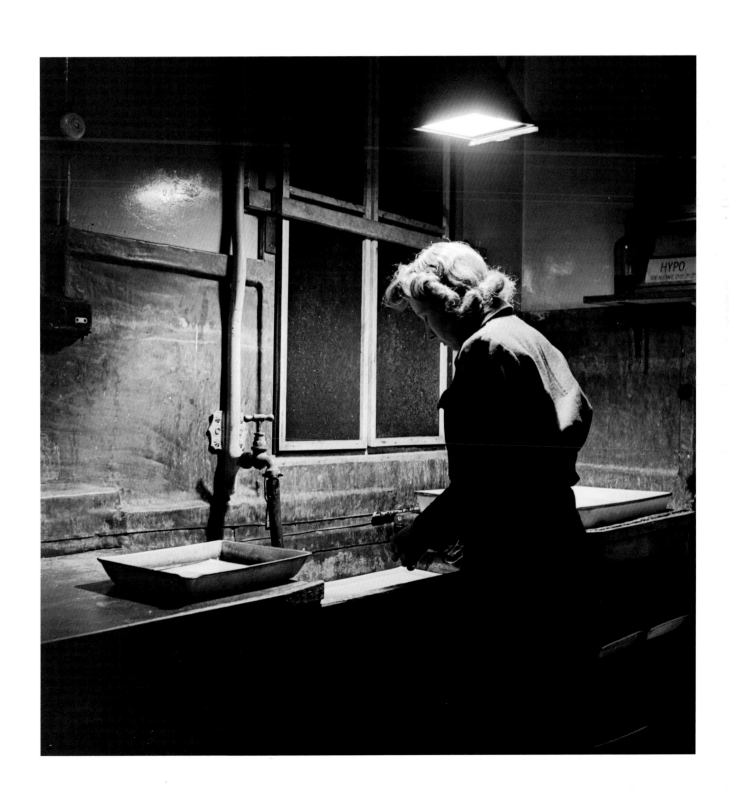

Women in Uniform: Camberley, Surrey, England, January 1944

After performing drills in muddy conditions, ATS officer cadets change quickly into clean uniforms in preparation for their next assignment.

Women in Uniform: England, June 1944

WRNS stewards take a moment to relax in the sun while off duty at a naval training establishment. With Admiralty support, Miller was in the final stages of compiling material for a book on the Wrens when her plans were disrupted by the Normandy landings. *Wrens in Camera* was finally published in 1945, as the war in Europe came to an end.

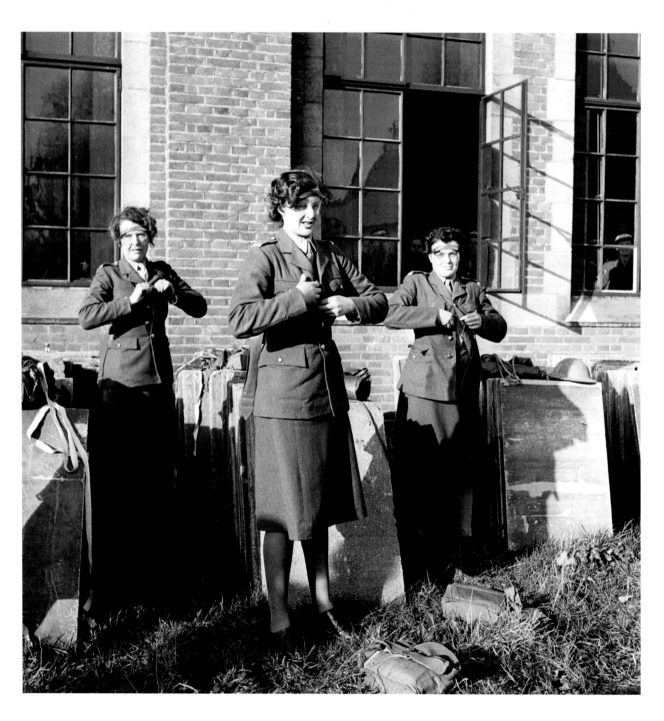

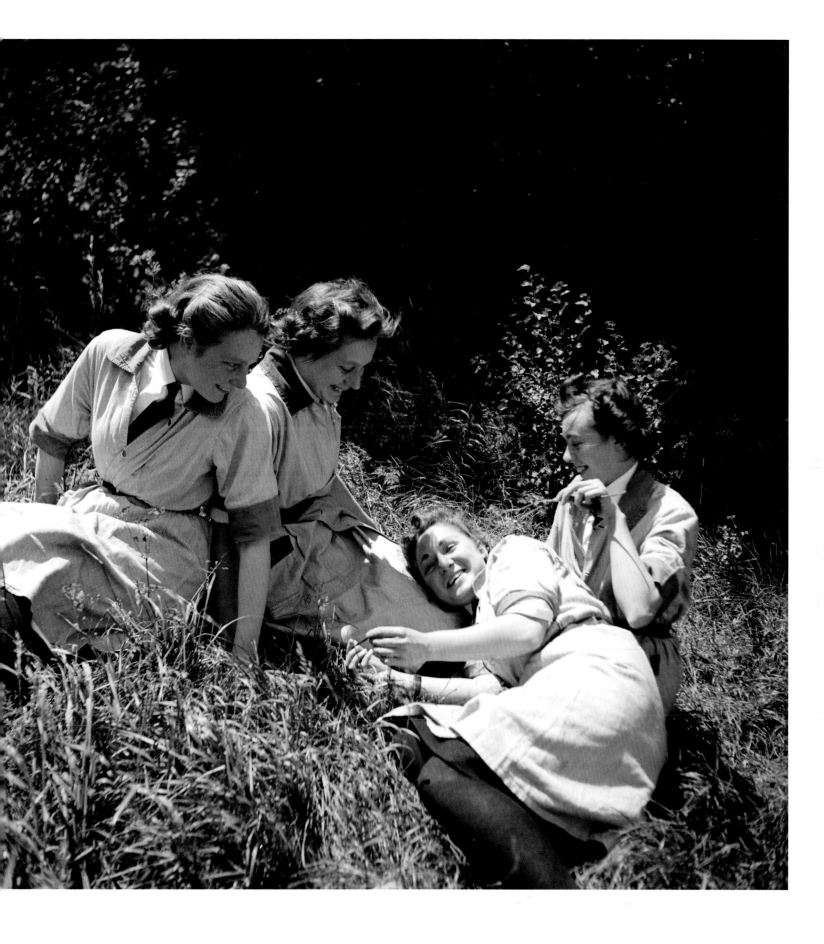

Women in Uniform: England, June 1944

A WRNS radio mechanic works to diagnose a fault
in an aircraft radio set.

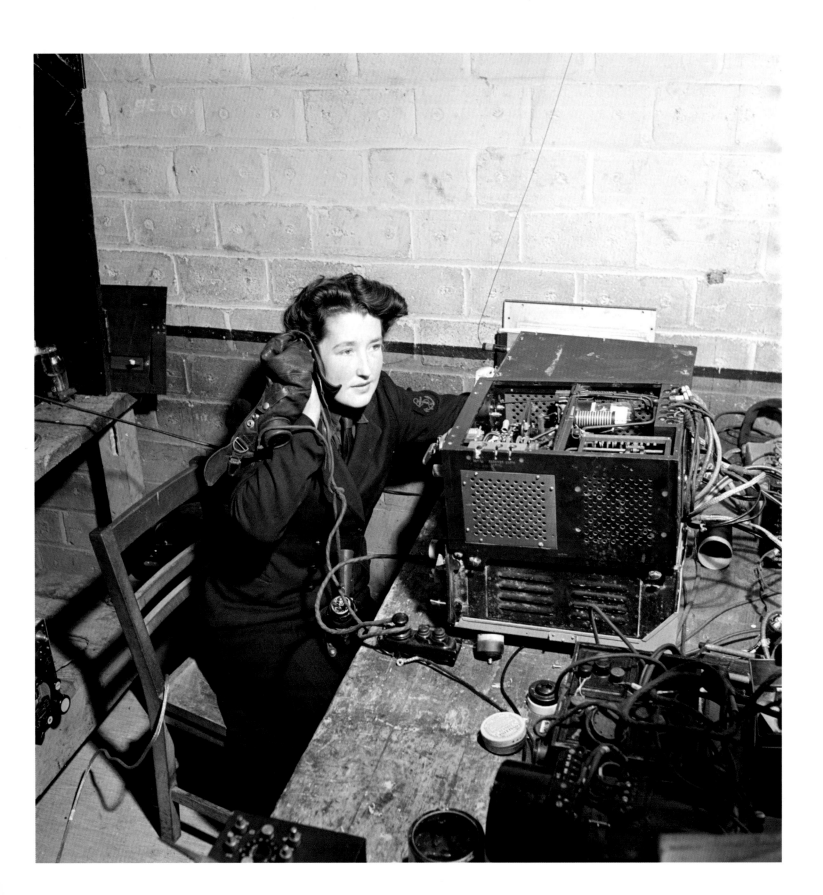

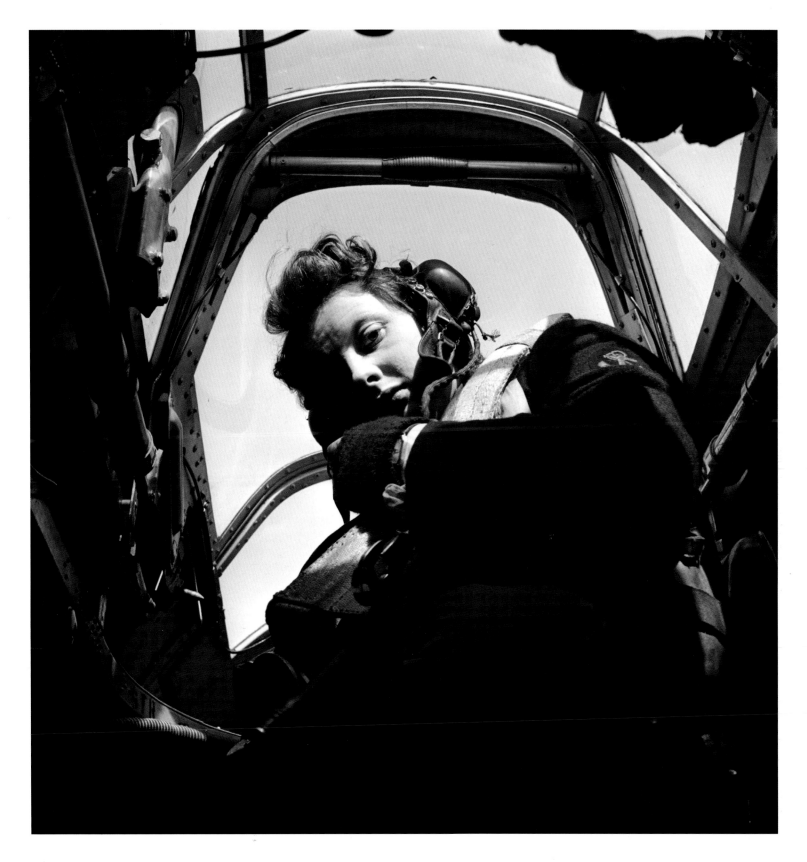

Women in Uniform: England, June 1944

Service women of the auxiliary forces took on
increasingly sophisticated duties during preparations for
the Normandy landings. WRNS radio mechanics were
members of a small group of Wrens attached to the
Fleet Air Arm whose regular duties included non-
operational flights in naval aircraft to test equipment.

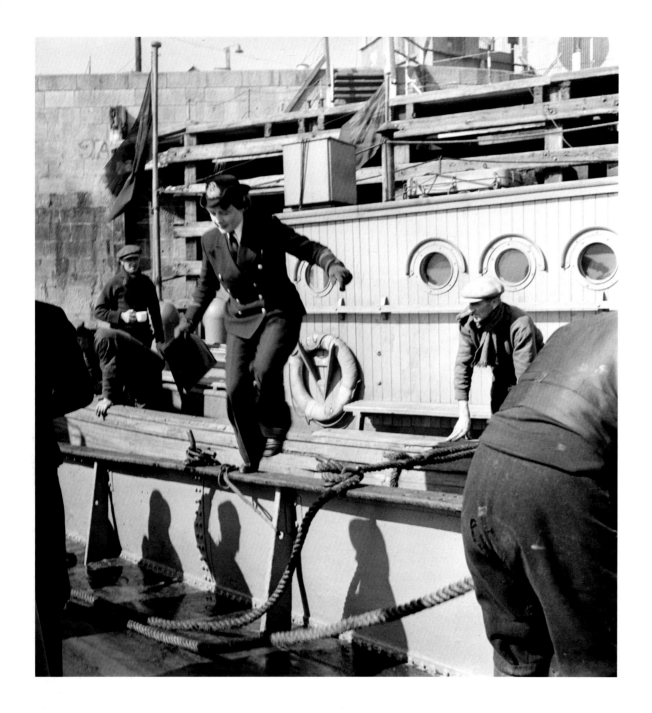

Women in Uniform: England, March 1944

A WRNS boarding officer of the Naval Control
Service brings convoy briefing orders on board
a merchant vessel.

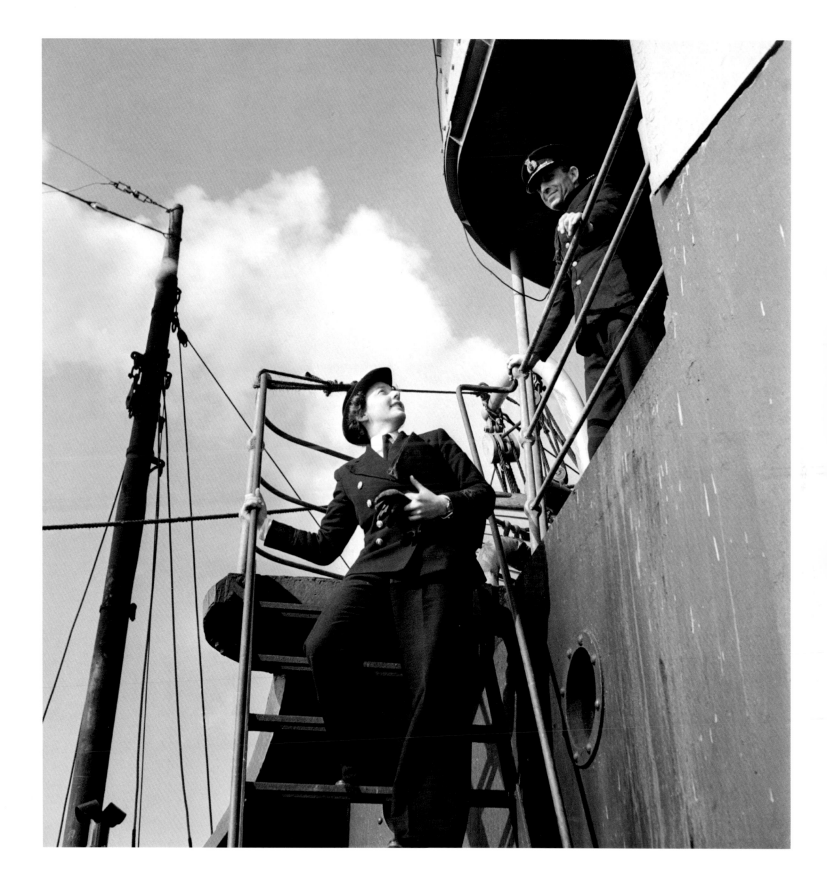

Women in Uniform: England, March 1944

Having checked that all papers are in order, a WRNS
boarding officer of the Naval Control Service wishes
the captain of a merchant vessel a safe voyage
as she disembarks.

'THE PATTERN OF LIBERATION IS NOT DECORATIVE. THERE ARE THE GAY SQUIGGLES OF WINE AND SONG. THERE IS THE BEAUTIFUL OVERALL COLOUR OF FREEDOM, BUT THERE IS RUIN AND DESTRUCTION. THERE ARE PROBLEMS AND MISTAKES, DISAPPOINTED HOPES AND BROKEN PROMISES'

Lee Miller, 'Pattern of Liberation', British Vogue, *January 1945*

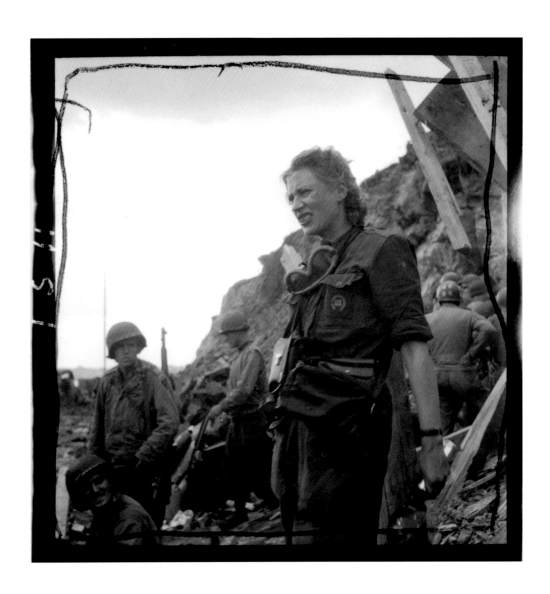

WOMEN IN WARTIME EUROPE 1944–1945

The Allied Expeditionary Force (AEF) launched its campaign to liberate Western Europe from German occupation on 6 June 1944. By the end of that year, most of France, Belgium and Luxembourg was free. In the east, Soviet forces had occupied Romania and were advancing into Hungary. Savage fighting on both fronts throughout the winter enabled Allied forces to advance into Germany in early 1945. Here, they discovered unprecedented horror in the form of the German concentration camps. The forces of east and west met at the River Elbe on 25 April 1945. Two weeks later, the Allies celebrated victory in Europe.

Military nurses were the first women permitted in the war zone by the AEF. They were soon followed by women from the auxiliary branches of the armed forces and civilian relief workers. For European women, the final stages of the war brought joy and relief, but also considerable suffering. Many, displaced by the fighting and associated destruction, experienced serious deprivation. Thousands were killed, injured or raped. Fear and bitterness compounded the suffering. In occupied countries, women, like men, had been forced to choose between collaboration and resistance. Their choices informed their treatment and status after liberation. In enemy nations, women faced the consequences of defeat and military occupation. These included both collective and individual punishment for atrocities perpetrated by the Nazi regime. However, the exigencies of desperate fighting, conquest and defeat weakened traditional wartime barriers between the genders. Lee Miller's photographs suggest a closer, more equal collaboration between men and women than at any other stage of the war.

Planning for the Normandy landings included sophisticated arrangements for media coverage. But no women war correspondents were allowed to accompany the invasion force in June 1944. American journalist Martha Gellhorn (who stowed away on a hospital ship) was the sole woman to witness the D-Day landings. Accredited female war correspondents, including Miller, were finally given access to the war zone in July 1944. From this point until the end of the war, Miller supplied *Vogue*'s various editions with photojournalism on a par with that of such current-affairs publications as *Life* magazine and *Picture Post*. Audrey Withers struggled to do justice to Miller's work within the confines of a fashion magazine that paper rationing had reduced to 18 per cent of its normal size.

Miller's photographs and written dispatches reflect her unique insight as a professional photojournalist and as a woman. Sharp observation, accompanied by compassion and outrage, is expressed in terms that are highly feminine. Miller, again assisted by David E. Scherman, documented everything from front-line combat to the revival of the French fashion industry. She also helped relaunch French *Vogue* (which had suspended publication during the German occupation). But she faced the realities of war without the protective cushion of formal training, practical experience and editorial guidance. By VE Day, Miller was exhausted and emotionally fragile. Her photographs reflect her encroaching depression.

Lee Miller at the entrance to the fortress of St Malo, Brittany, France, August 1944 (photo: David E. Scherman)

David E. Scherman (who highlighted this photograph in ink to ensure that it caught the attention of *Vogue* magazine and Roland Penrose), met Miller by chance in the ruins of St Malo on 17 August 1944. He later described his shock at seeing Steichen's former fashion model looking like 'an unmade, unwashed bed'.

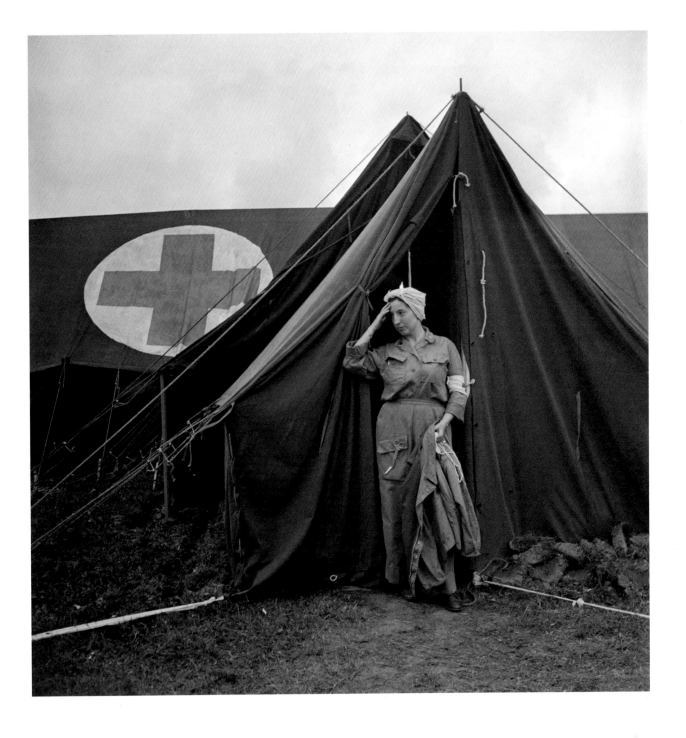

**Liberation: Bricqueville, Normandy,
France, July 1944**

An exhausted nurse at the end of a long shift
during the Battle of St Lô. The nurse was one of
forty US Army nurses attached to the semi-mobile
44th US Army Evacuation Hospital, 13 km (8 miles)
south of Omaha Beach. Versions of Miller's report,
her first from Normandy, appeared in both the
British and American editions of *Vogue*.

**Liberation: Bricqueville, Normandy,
France, July 1944**

A female anaesthetist works alongside a US Army
surgeon at the 44th US Army Evacuation Hospital.
The hospital treated 4,499 patients between 5 July
and 4 August 1944. All but fifty survived.

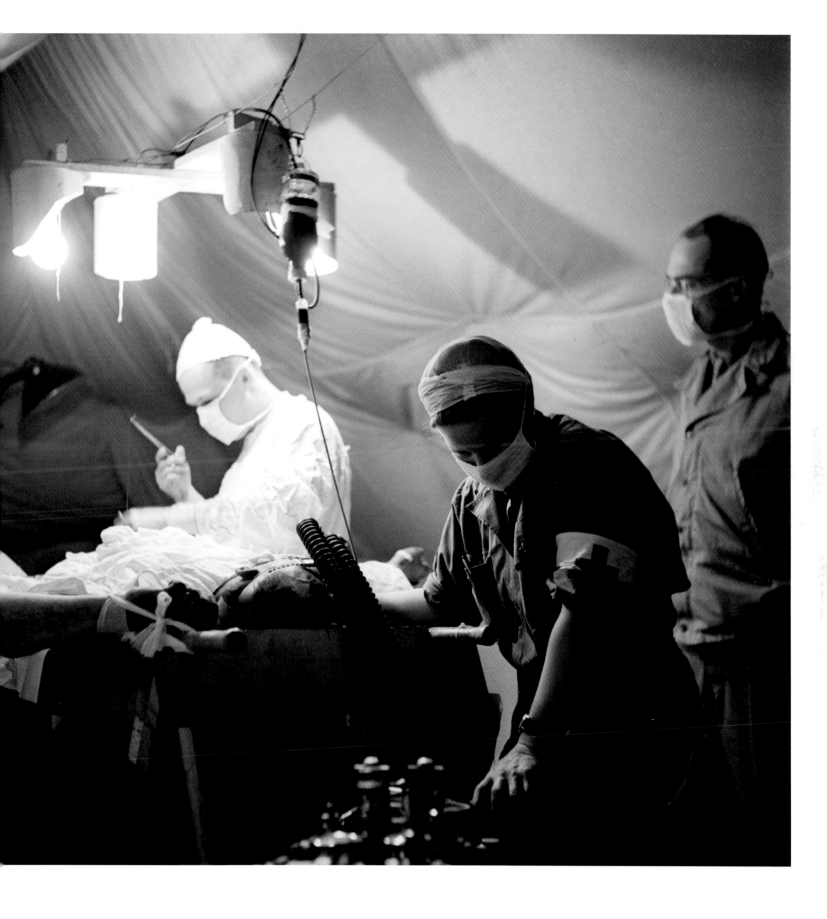

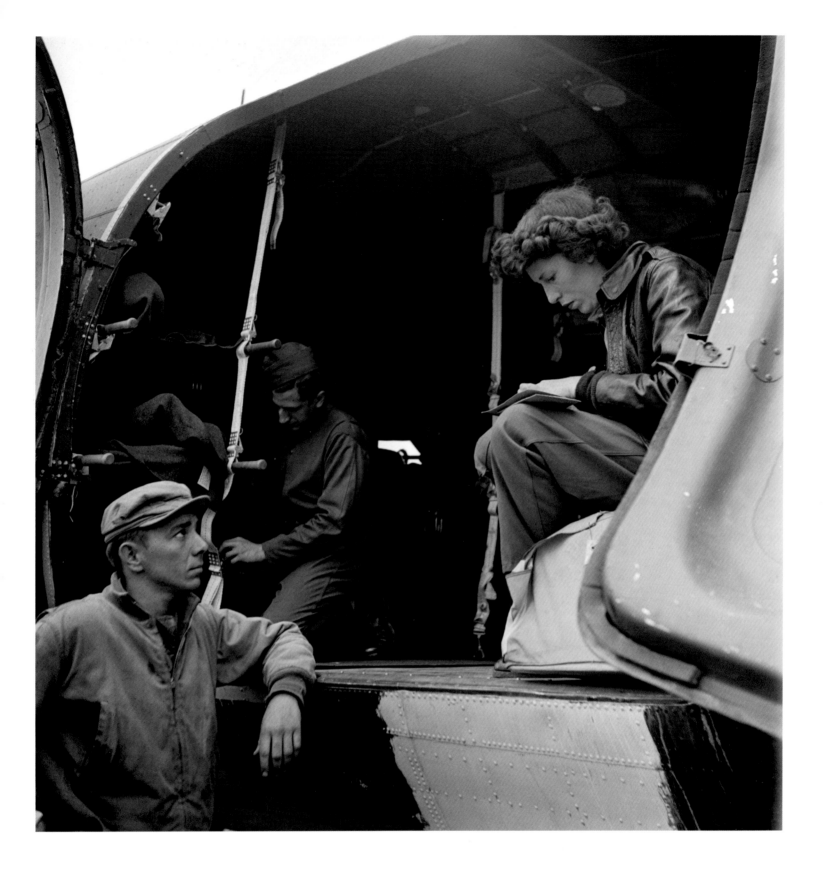

**Liberation: St Laurent-sur-Mer airfield,
Normandy, France, July 1944**

American soldiers and a US Army nurse prepare
casualties for evacuation by a Douglas C-47 transport
aircraft near Omaha Beach.

LEE MILLER: A WOMAN'S WAR

**Liberation: St Malo, Brittany, France,
August 1944**

An elderly French woman peers cautiously from her
doorway after surviving heavy fighting in St Malo.
Portraits of French civilians, framed by newly opened
doorways and windows, became a recurring device
in Miller's photographs of the liberation of France.

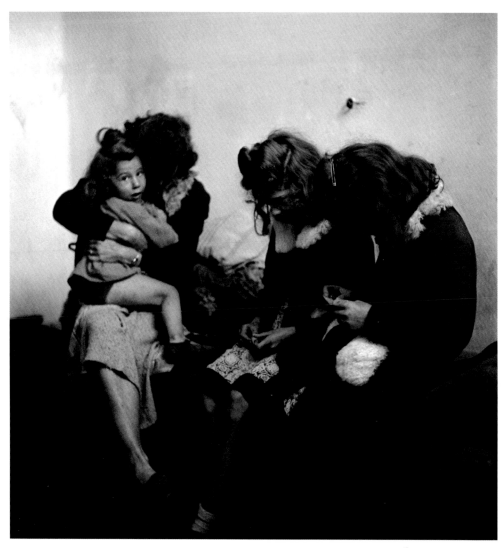

**Liberation: St Malo, Brittany, France,
August 1944**

The French family of a German soldier hide
their faces from the camera after taking refuge
in a former Wehrmacht medical post.

OPPOSITE
Liberation: St Malo, Brittany, France,
August 1944

A French couple work together to salvage their possessions in a ruined street in St Malo. Miller's accompanying article includes an early but telling reference to the emotional cost exacted by her work in Europe: 'It was just another destroyed area, and I couldn't stop to think that here were the places I had spent my last hours in France.'

PAGES 124–5
Liberation: Rennes, Brittany, France,
August 1944

A French woman, accused of collaborating with the Germans, is interrogated prior to being paraded in the street in a public shaming. The shaving of women's heads as a form of retribution was not new or unique to France, but the presence of press cameras gave the spectacle unprecedented power.

LEE MILLER: A WOMAN'S WAR

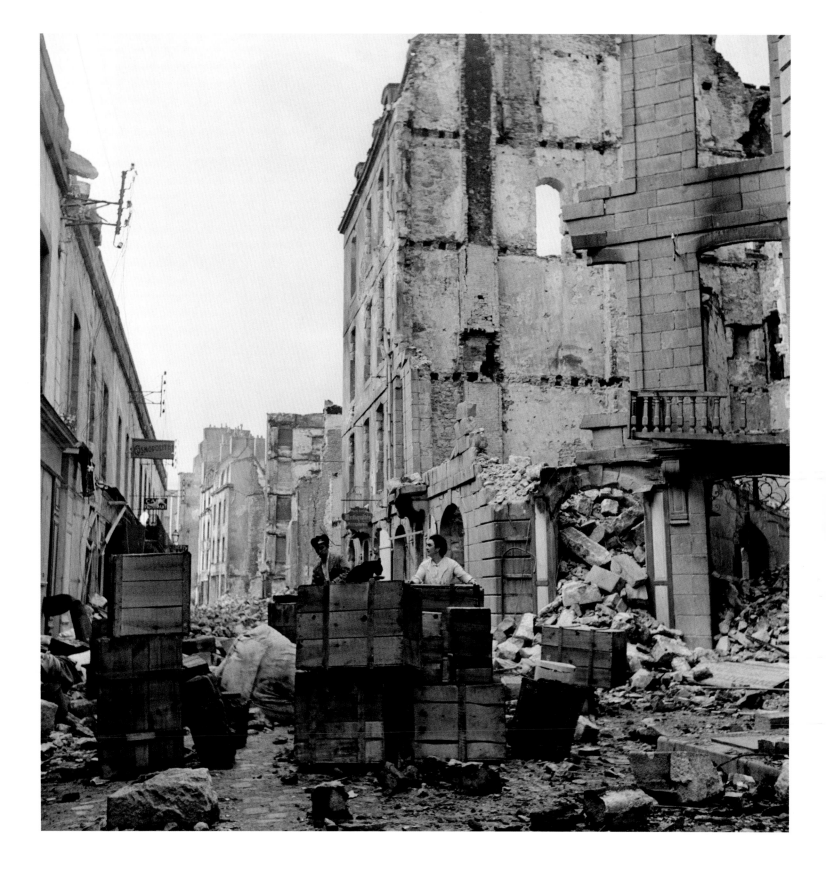

Liberation: Paris, France, August 1944

Liberation celebrations at the Maison Paquin couture house. Some Parisian fashion houses closed during the occupation of France, but the majority continued to function in deliberate defiance of German wartime rationing. Some saw this as a form of collaboration, but the move protected the industry's highly skilled workers during the occupation.

Liberation: Paris, France, August 1944

A stylish Parisian resistance worker of the Forces Française de l'Intérieur (FFI). Her deliberately extravagant full-skirted dress and pompadour hairstyle were recognized French forms of resistance during the German occupation, but later caused resentment among British women. British *Vogue* was forced to mediate public opinion.

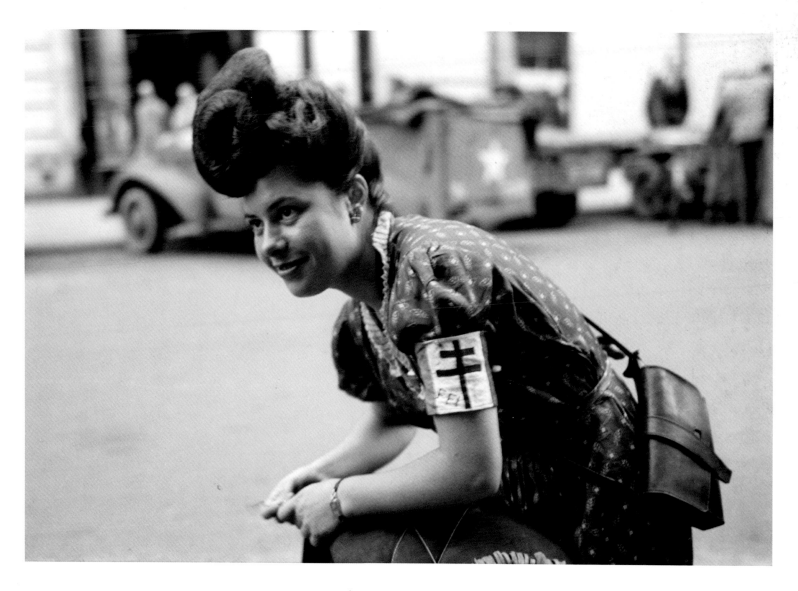

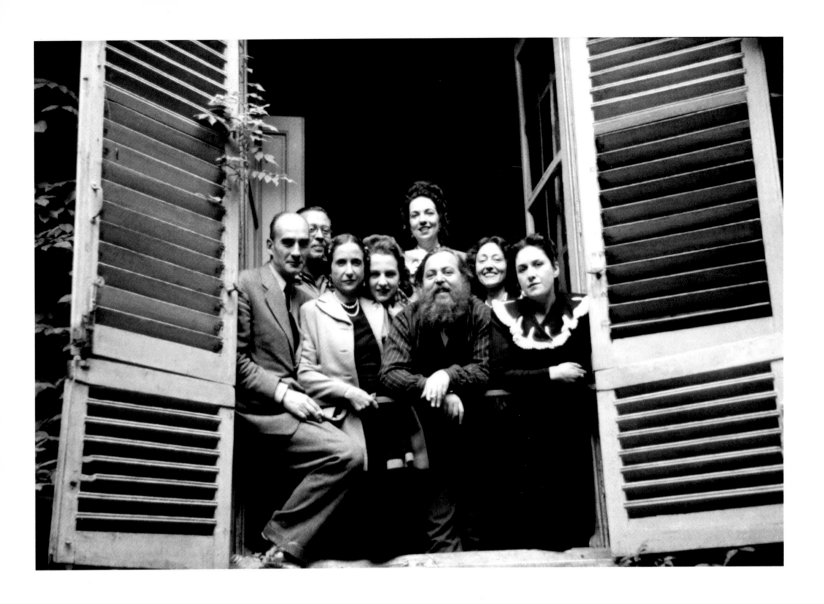

Liberation: Paris, France, August 1944

French Surrealists gather in the window of Jean
Cocteau's apartment in the Palais-Royal for
a celebratory photograph to mark their emotional
reunion following the liberation of Paris. Nusch Éluard
and Dora Maar (Picasso's former partner) can be
seen to the right of Christian (Bébé) Bérard, a French
artist and designer (front row, with beard).

Liberation: Paris, France, September 1944

Christine Poignet, a French law student, photographed
beside the bullet-scarred window of a Parisian café
for British *Vogue*'s feature 'The Way Things Are in Paris'.
The feature highlighted the difficulties faced by Parisian
women in a deliberate response to British resentment
of their perceived extravagance.

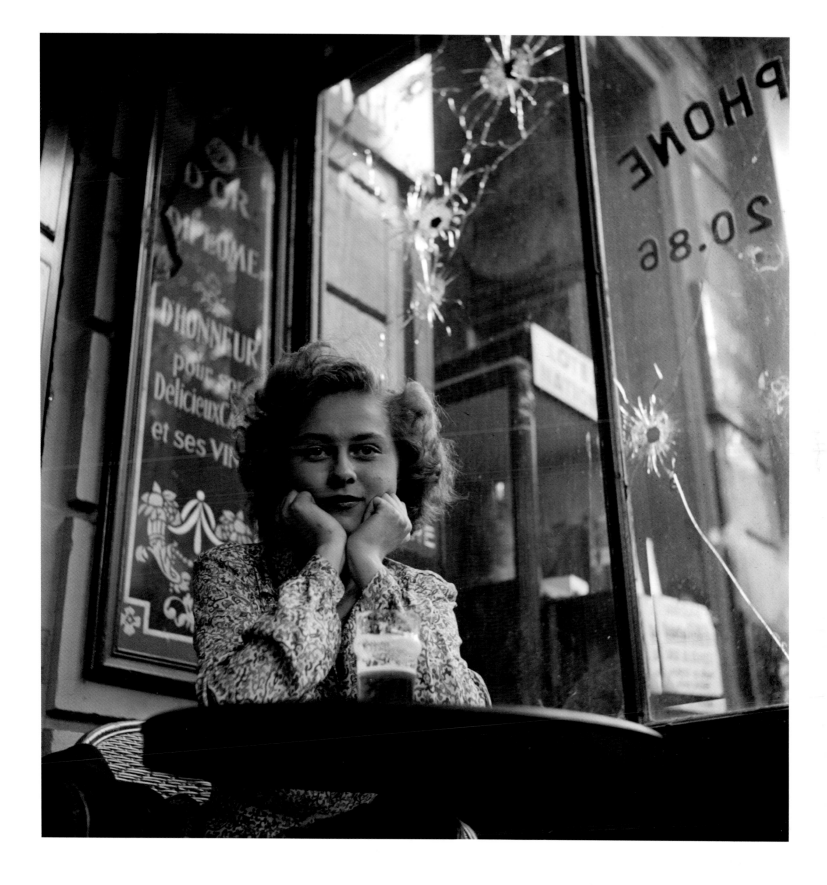

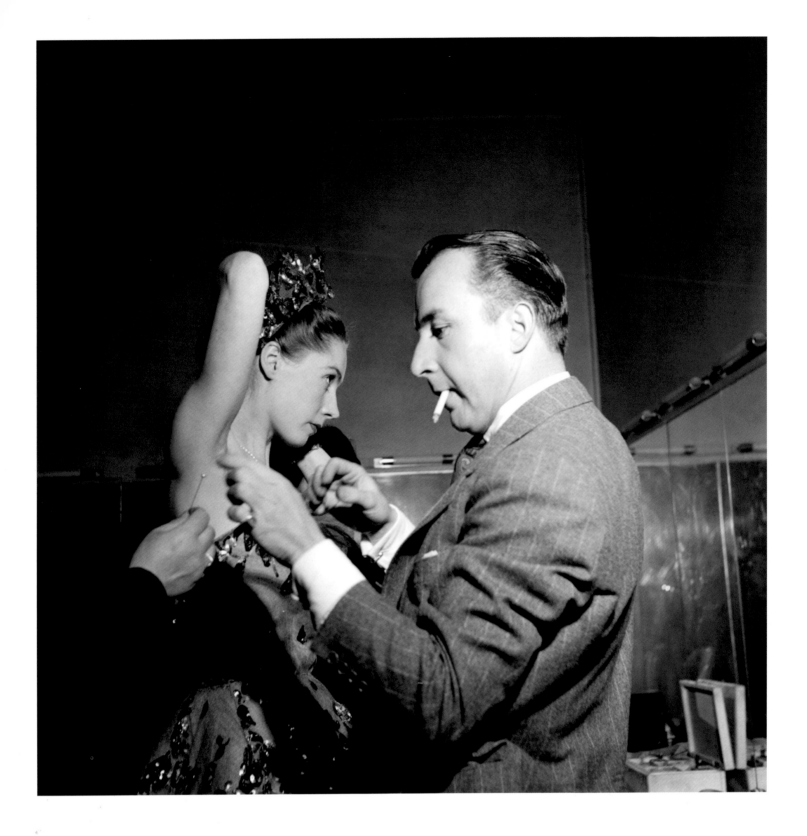

Liberation: Paris, France, October 1944

Spanish designer Antonio Castillo adjusts the fitting
of a dress on a French model during preparations
for the showing of Maison Paquin's first collection
following the liberation of Paris. At *Vogue*'s request,
Miller briefly (and reluctantly) abandoned her role
as a war correspondent to cover the international
revival of Parisian haute couture.

Liberation: Paris, France, September 1944

Parisian women take advantage of working hairdryers and a manicure service at Salon Gervais. The salon was the only hairdressing establishment in Paris to have its own source of power – a tandem in the basement.

Liberation: Paris, France, September 1944

Cyclists in the basement of Salon Gervais generate electricity for the salon's hairdryers.

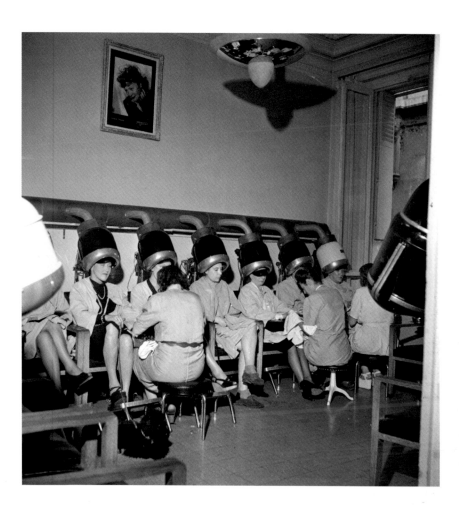

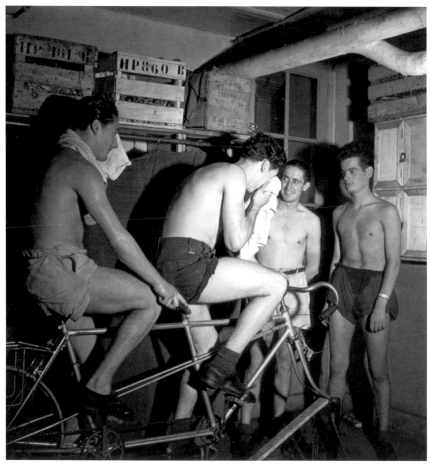

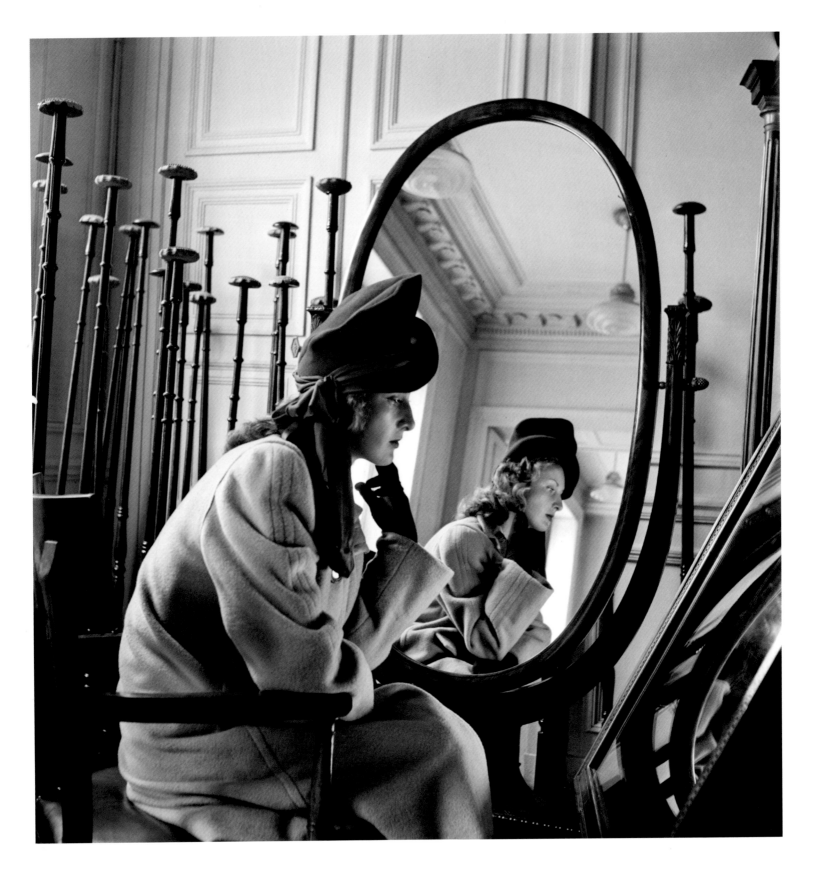

LEE MILLER: A WOMAN'S WAR

Liberation: Paris, France, September 1944

A millinery model at Salon Rose Descat. Parisian milliners were among the first of the city's fashion concerns to launch a new collection after the liberation of Paris. Large, elaborate hats, which made generous use of materials and featured patriotic references, were a Parisian form of resistance during the German occupation.

Liberation: Paris, France, October 1944

Fashion models rest as best they can before a millinery show at Salon Rose Descat.

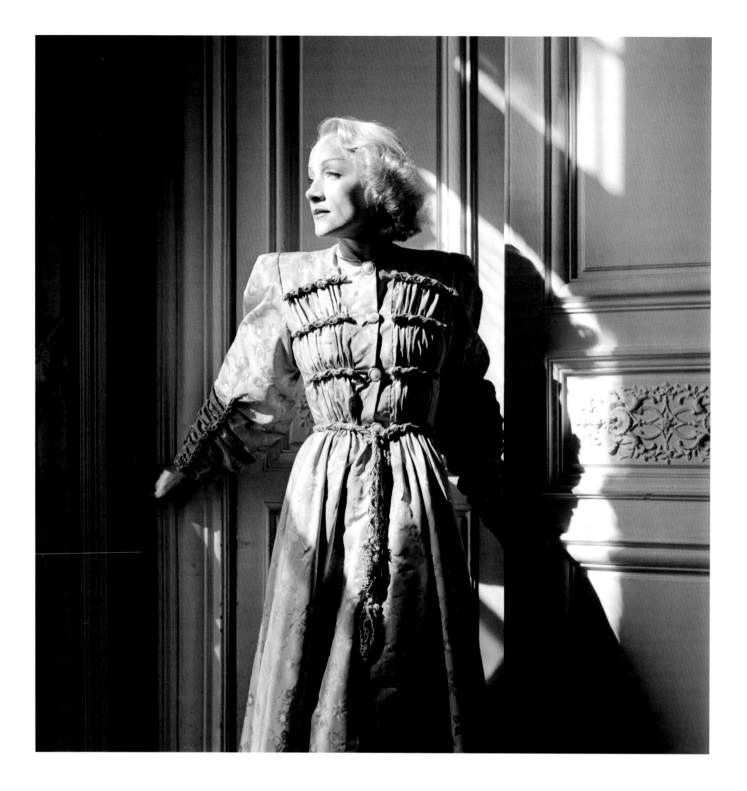

Liberation: Paris, France, October 1944

Marlene Dietrich photographed in her suite at the Hôtel
Ritz wearing an elaborate robe designed by Schiaparelli.
Dietrich rose to fame as a German film actress in the
1920s before pursuing a career in Hollywood. In 1937
she resisted pressure to return to Germany and became
an American citizen. Dietrich worked tirelessly to
entertain Allied troops during the war. This was her
first visit to liberated Paris.

**Liberation: Lee Miller at work in her room
at Hôtel Scribe, Paris, France, September 1944
(photo: David E. Scherman)**

Despite her natural talent as a writer, Miller always
found writing a laborious process. She relied on David
E. Scherman for support when producing the vivid
articles that accompanied her photographs for *Vogue*.
Both reporters kept rooms at Hôtel Scribe until
1946. The Parisian hotel had served as a German press
bureau before being taken over by Allied journalists.

**Liberation: Lee Miller with US Army jeep
in Alsace, France, January 1945 (photo:
David E. Scherman)**

Miller returned to her preferred role of war
correspondent after completing her coverage of
Paris fashion shows. A military jeep was her usual
form of transport, but it offered little comfort on
long journeys.

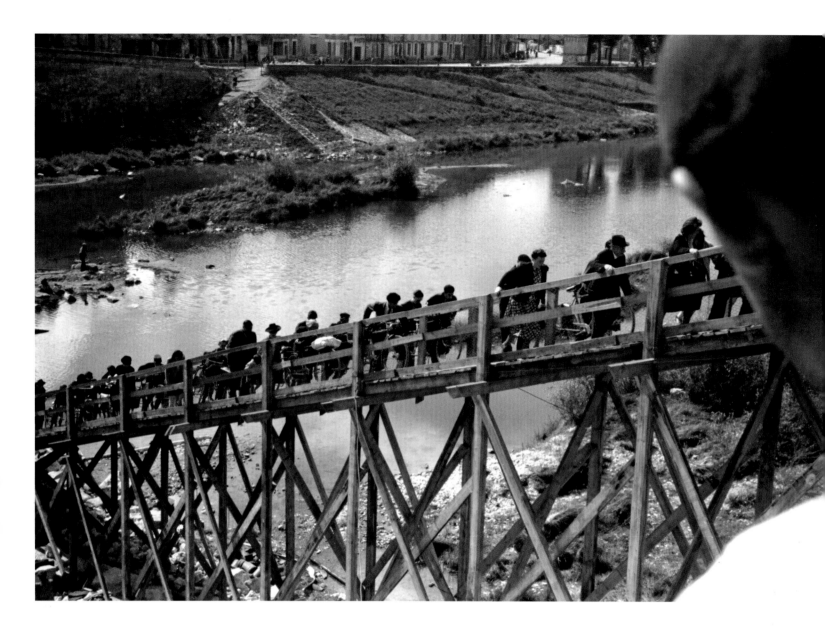

**Liberation: Beaugency, Loiret, France,
September 1944**

Civilian refugees struggle over a temporary
bridge across the River Loire. Miller's reports
highlighted the impact of the war on civilians
as well as military personnel.

LEE MILLER: A WOMAN'S WAR

Liberation: Paris, France, October 1944

Parisians walk to Père Lachaise Cemetery
in Paris for a memorial ceremony in honour
of Resistance fighters and others who died during
the German occupation.

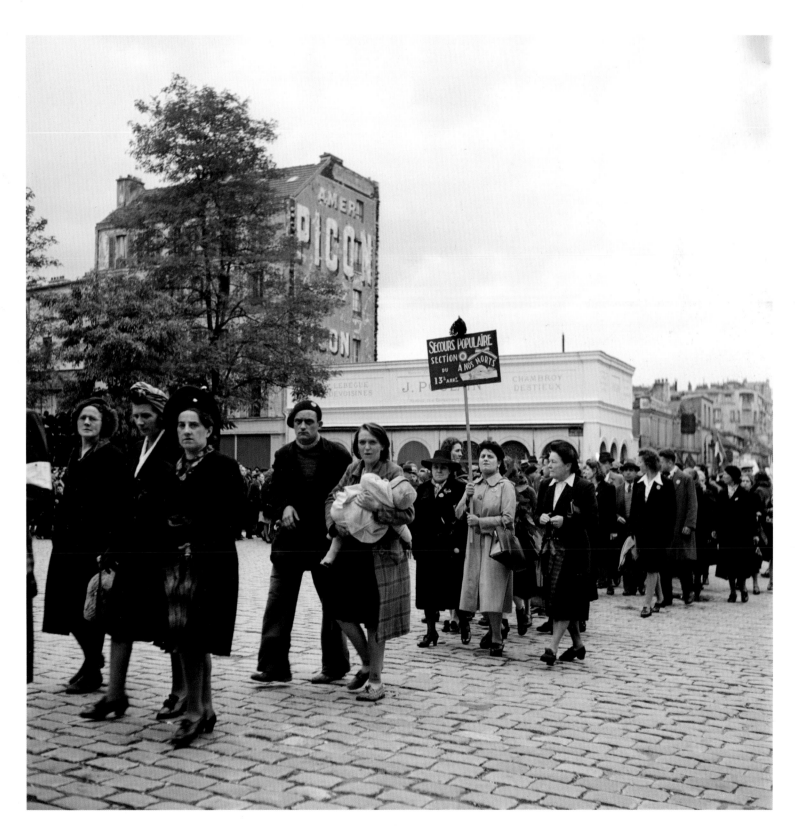

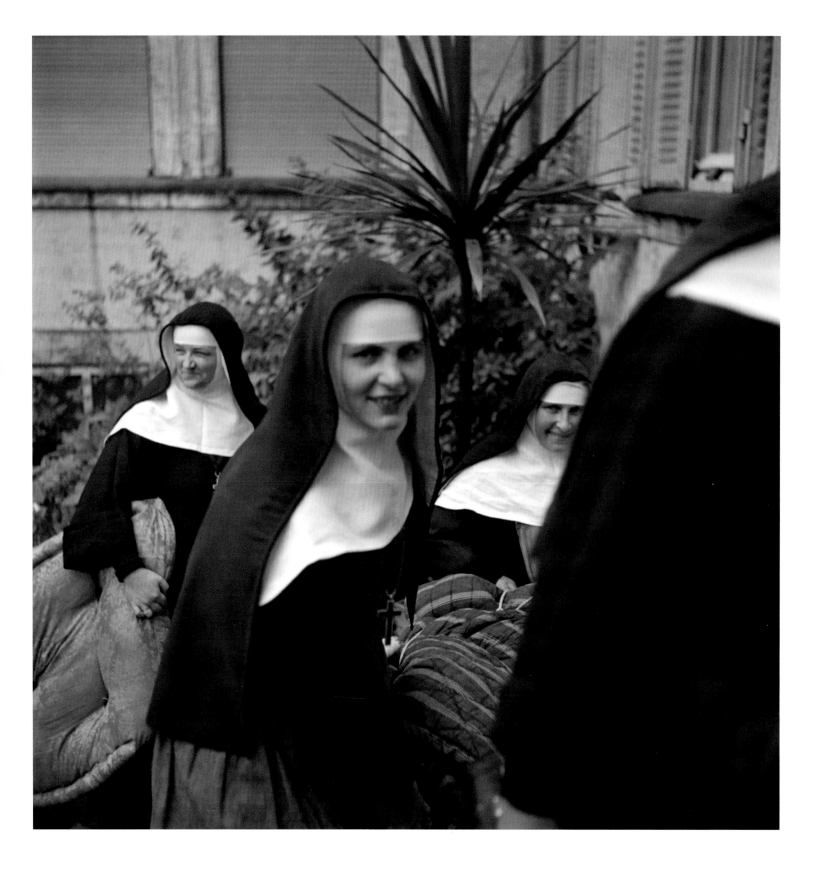

Liberation: Luxembourg, November 1944

Luxembourger nuns evacuate a school for
the blind.

LEE MILLER: A WOMAN'S WAR

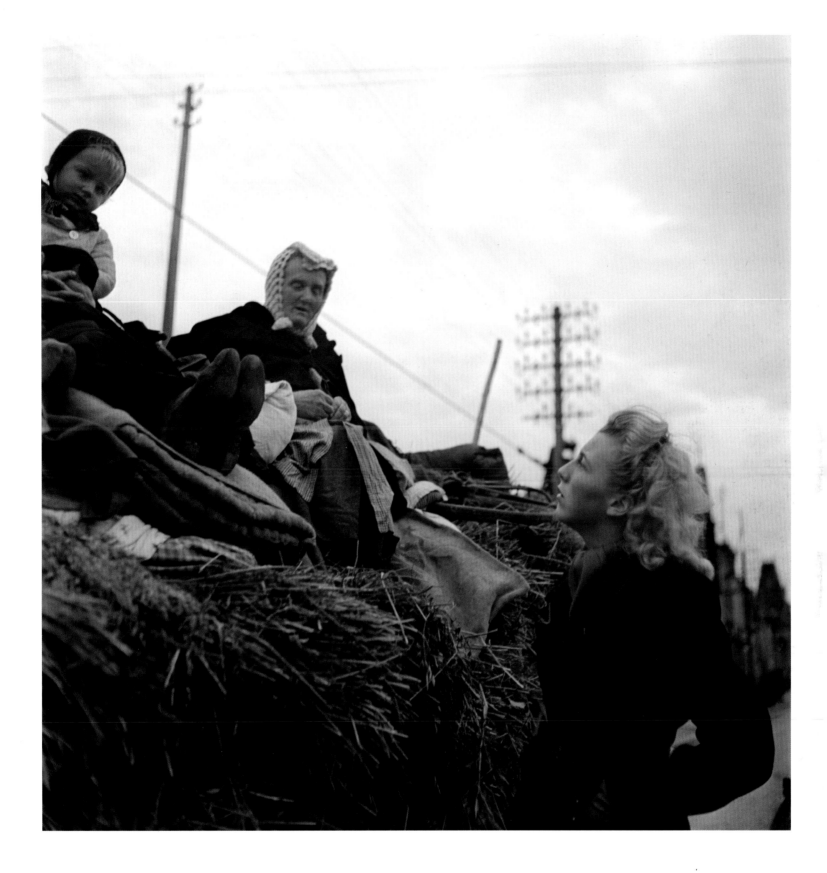

Liberation: Luxembourg, November 1944

Maesy Bastion, a US Civil Affairs Team interpreter, talks
to refugees who have fled the fighting in Luxembourg.

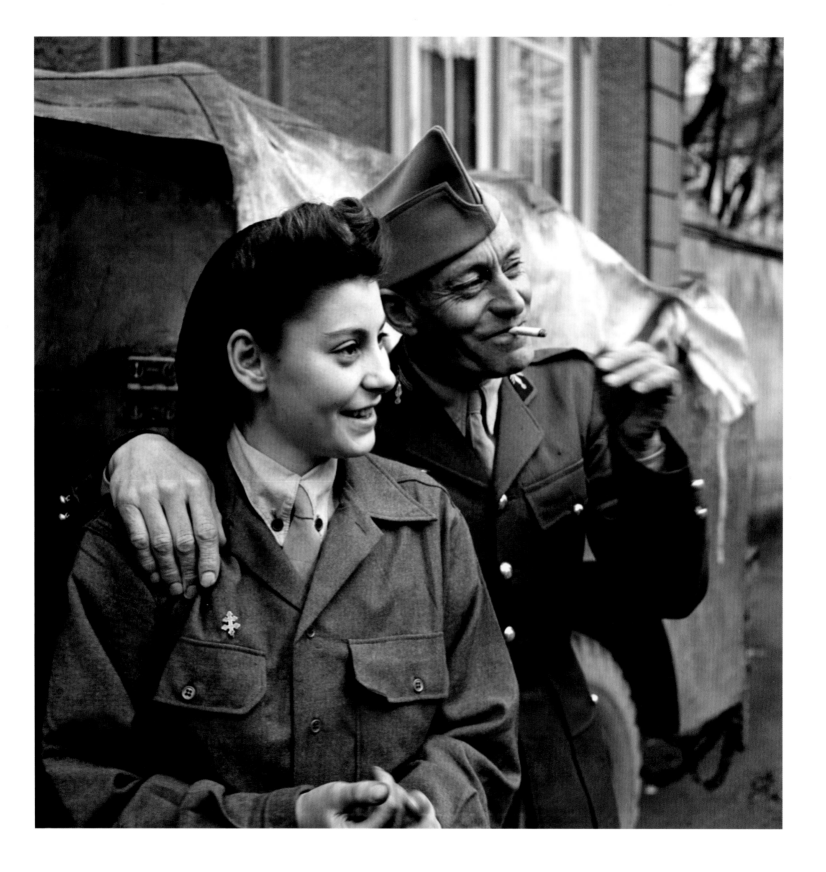

LEE MILLER: A WOMAN'S WAR

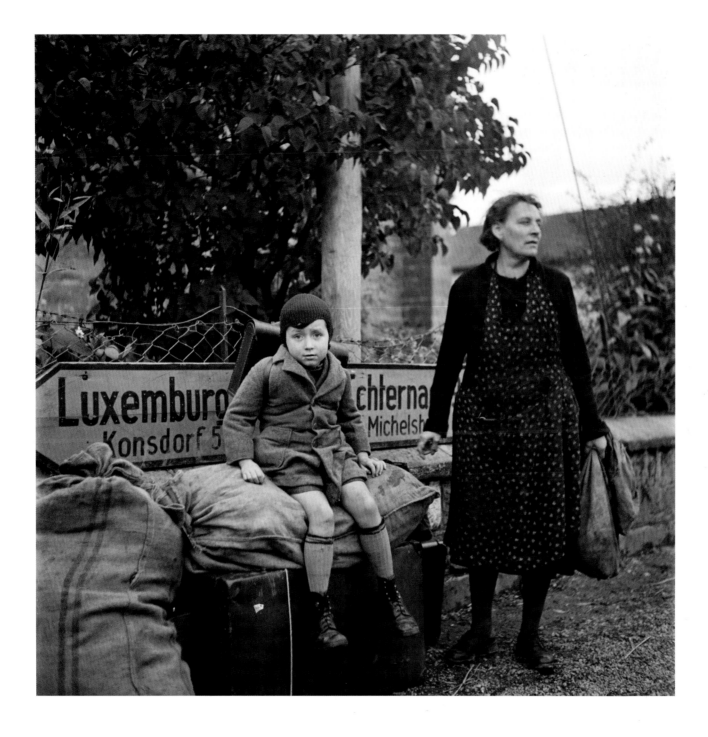

Liberation: Alsace, France, February 1945

Ghislane Schlesser, a French ambulance driver, with
her father, Brigadier General Guy Schlesser, commander
of a French armoured division.

Liberation: Luxembourg, November 1944

A weary mother and child wait for transport at the
roadside after fleeing the fighting in Luxembourg.

Liberation: Alsace, France, February 1945

A lace tablecloth provides incongruous winter camouflage for a French soldier's machine gun as tanks move through a village near Colmar.

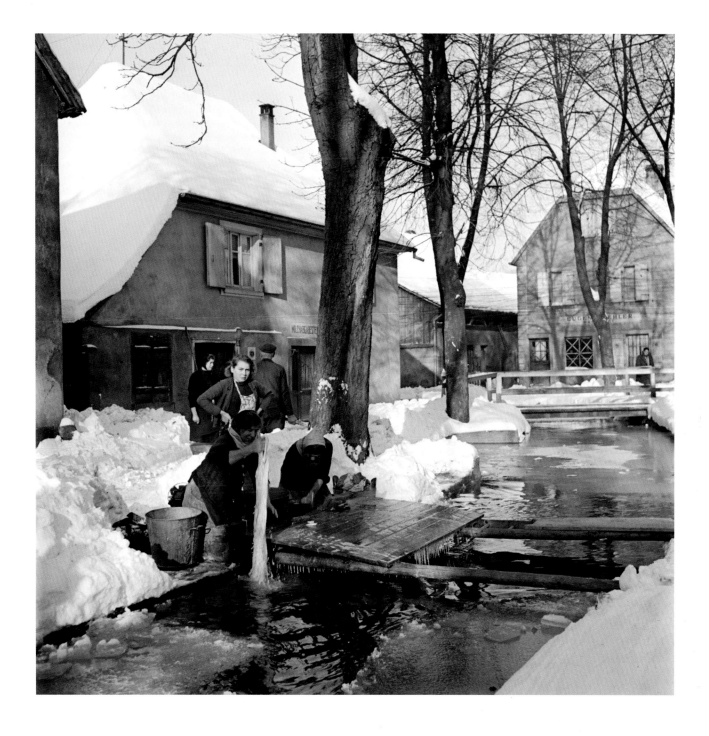

**Liberation: Approaching the German
frontier, France, March 1945**

Women harvest dandelions in an empty potato
field near the Franco-German frontier.

Liberation: Alsace, France, February 1945

French women wash soldiers' laundry in an icy
river near Colmar.

'GERMANY IS A BEAUTIFUL LANDSCAPE DOTTED WITH JEWEL-LIKE VILLAGES, BLOTCHED WITH RUINED CITIES, AND INHABITED BY SCHIZOPHRENETICS ... MOTHERS SEW AND SWEEP AND BAKE, AND FARMERS PLOUGH AND HARROW; ALL JUST LIKE REAL PEOPLE. BUT THEY AREN'T. THEY ARE THE ENEMY'

Lee Miller, 'Germany – the War that is Won',
British Vogue, *June 1945*

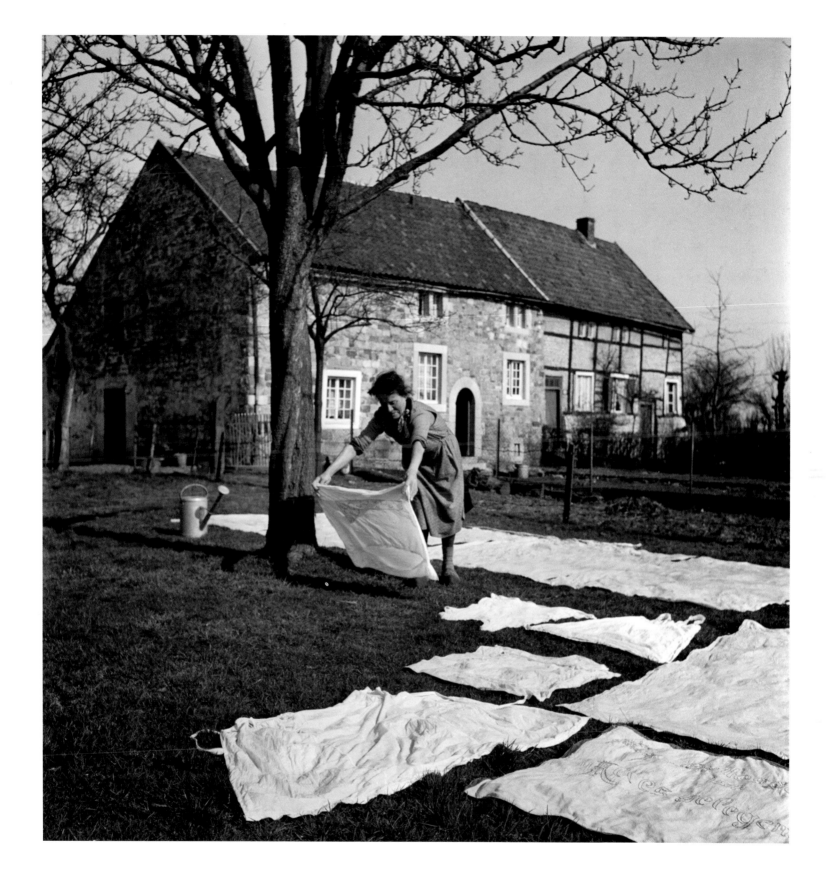

Defeat: Aachen, Germany, March 1945

A German woman spreads out her laundry to dry
on the grass. Miller's first impression of Germany
was of a country untouched by war.

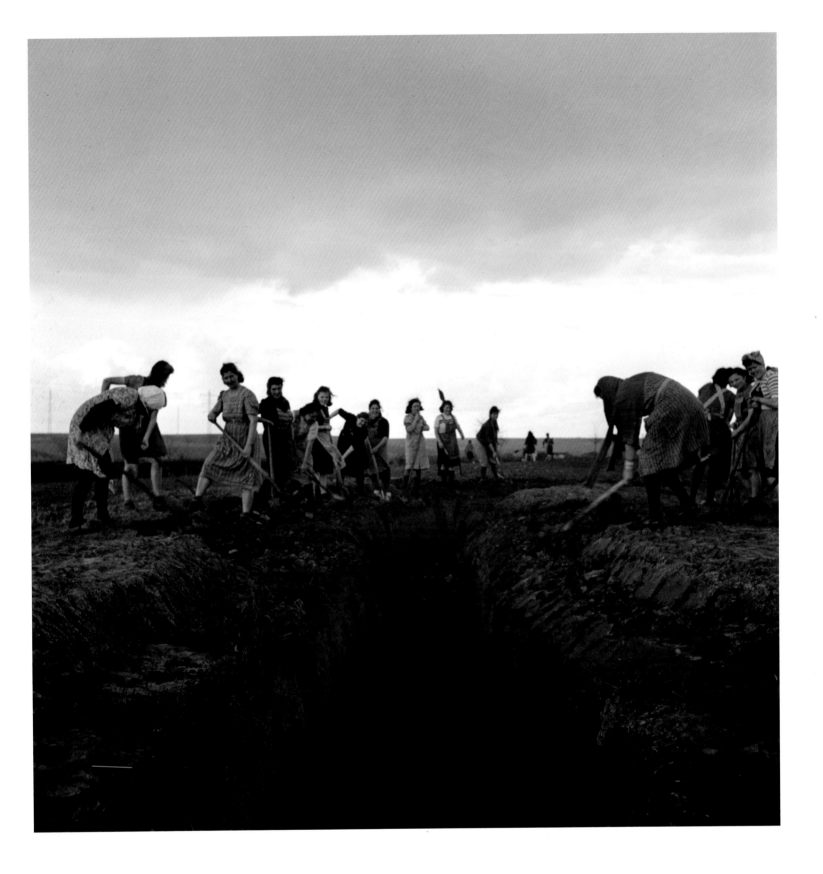

Defeat: Cologne area, Germany, March 1945

German women fill in defensive trenches on the outskirts of Cologne. American forces captured the city on 6 March.

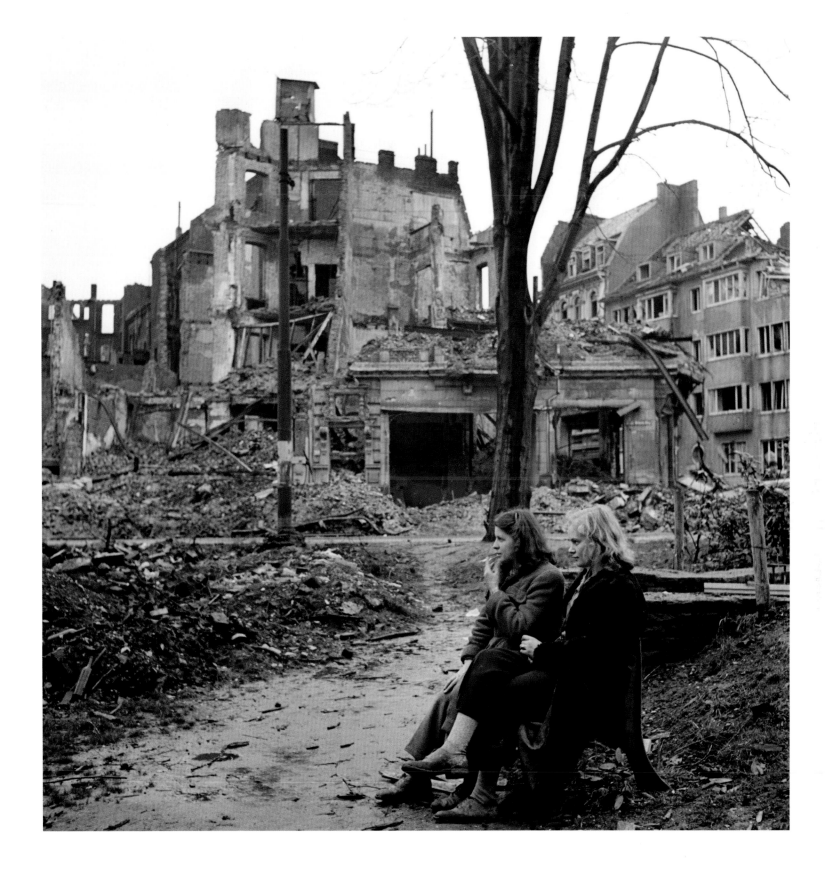

Defeat: Cologne, Germany, March 1945

German women in the ruins of Cologne. Allied bombers
carried out 262 raids on the city, including the RAF's
first 1,000-bomber raid in May 1942. The raids
killed at least 20,000 people. Nearly half of the city
was uninhabitable.

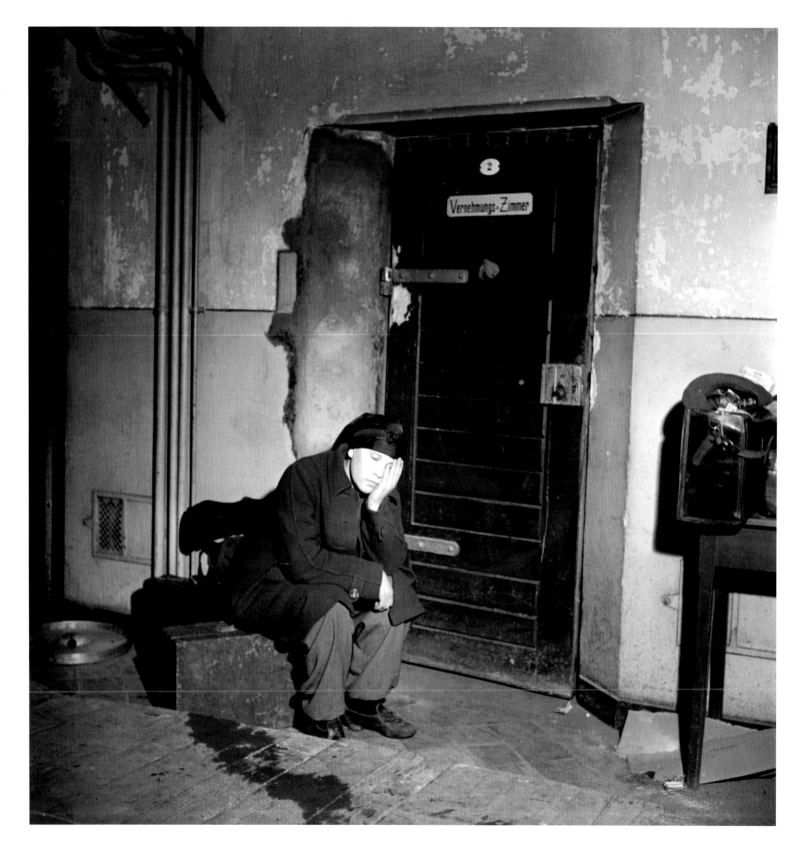

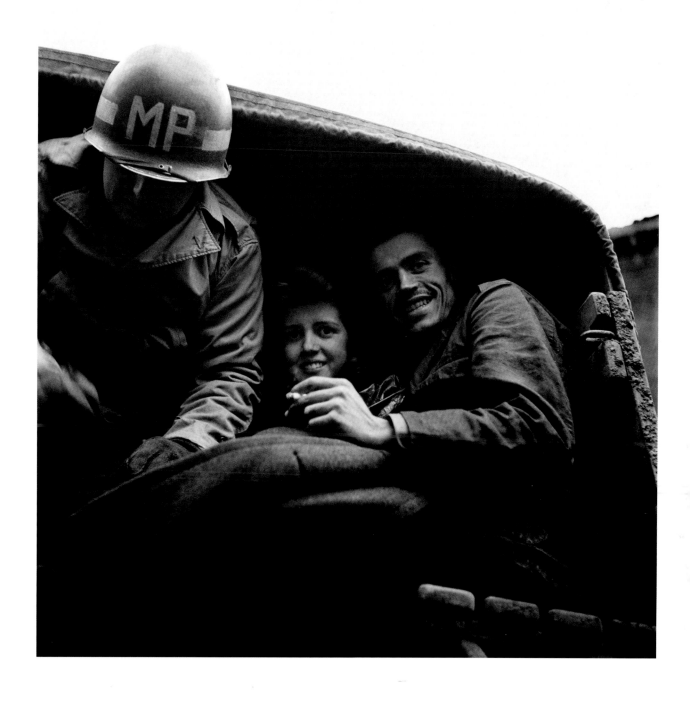

Defeat: Cologne, Germany, March 1945

An exhausted female prisoner waits to be evacuated, shortly after being freed from her cell in the Gestapo wing of Klingelpütz prison in Cologne. More than 10,000 prisoners were held at the notorious prison in the closing stages of the war; 1,000 were executed by guillotine or beaten to death. The prison was Miller's first encounter with the realities of Nazi brutality. Her anger against the Germans grew in the weeks that followed.

Defeat: Cologne, Germany, March 1945

French and Belgian Resistance fighters are evacuated by US military police after being freed from the Gestapo wing of Klingelpütz prison in Cologne. The young woman had been imprisoned for helping RAF aircrew evade capture.

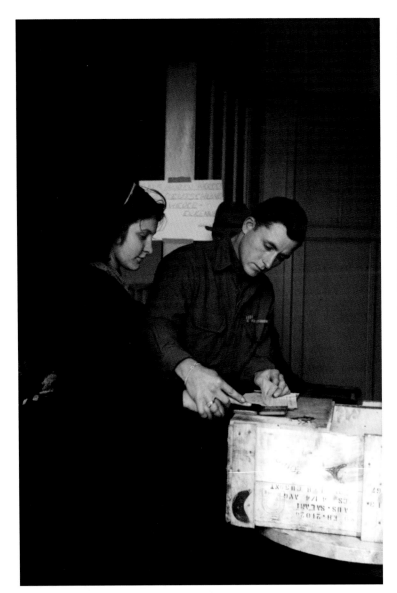

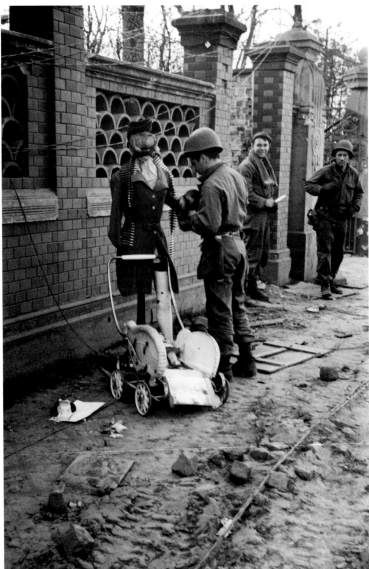

Defeat: Cologne, Germany, March 1945

American soldiers turn a shop mannequin
into an insulting response to German civilians
who fraternized with them by day, but attacked
them by night.

Defeat: Cologne, Germany, March 1945

A German woman is fingerprinted while registering
with Allied military authorities.

German nurses push a cart containing their belongings along a road after being evicted from their accommodation by American troops. German civilians were barred from large parts of their towns in a move designed to subdue the population while establishing military control.

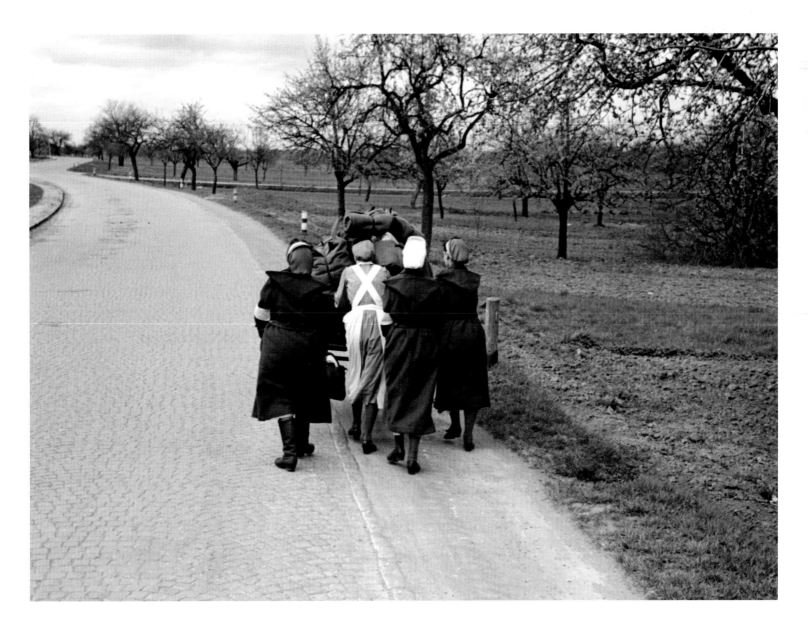

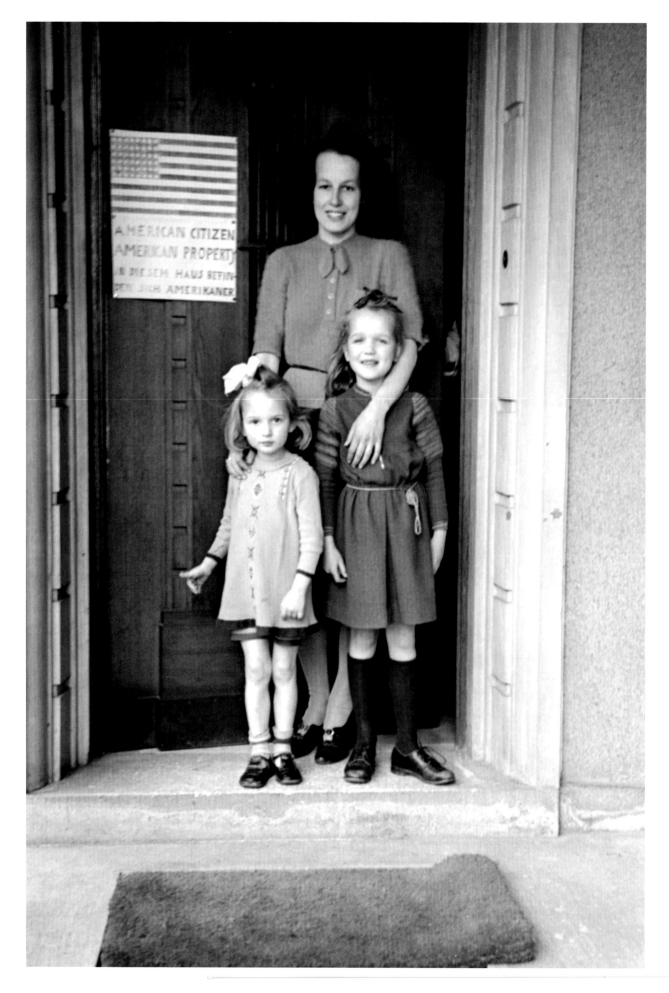

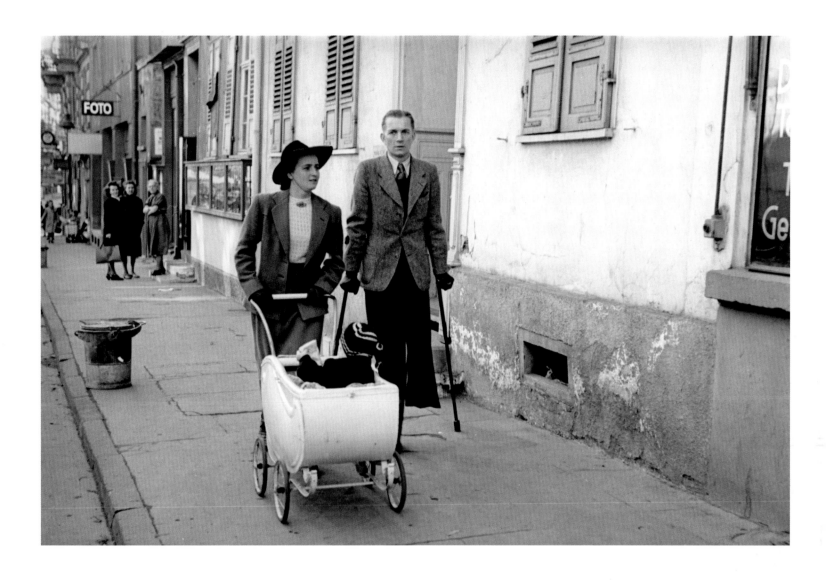

Defeat: Heidelberg, Germany, April 1945

Mrs Doris Lauffs, an American, and her daughters at
the entrance to her home. Mrs Lauffs had married her
German husband before the war, which she spent
in Heidelberg. Because of her nationality, her property
was exempt from being requisitioned by the Allies.

**Defeat: Bad Nauheim, Hesse, Germany,
April 1945**

A former German soldier with crippling war injuries
walks through Bad Nauheim with his family. Numerous
injured soldiers were recuperating in the town, a famous
health spa.

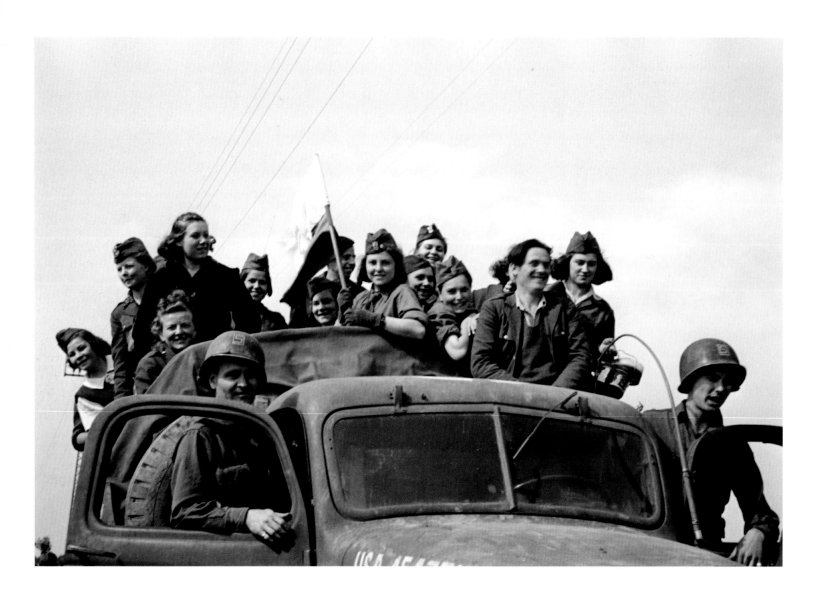

Defeat: Torgau, Saxony, Germany, April 1945

American and Soviet troops celebrate their meeting at Torgau, on the River Elbe, on 25 April 1945. The inclusion of a significant number of camera-friendly female soldiers in the Red Army contingent is explained by the fact that the event was staged entirely for the cameras.

Defeat: Munich, Bavaria, Germany, April 1945

Displaced Russian women and children occupy
the former SS guardhouse next door to Eva Braun's
Munich home in Wasserburger Strasse.

**Defeat: Nuremberg, Bavaria, Germany,
April 1945**

Women cook a carp on an open-air stove constructed
from rubble in the ruins of Nuremberg. The city, which
had been the venue for Hitler's pre-war rallies, was
devastated by Allied air raids and some of the fiercest
street fighting of the war. American forces finally
captured the city on 20 April 1945, Hitler's last birthday.

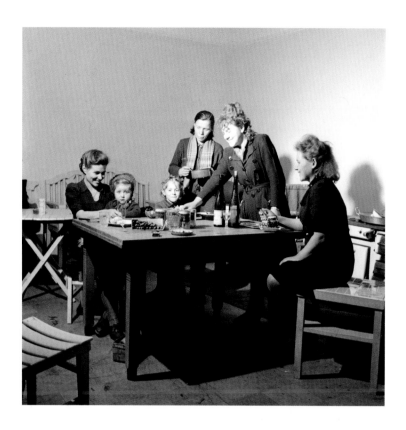

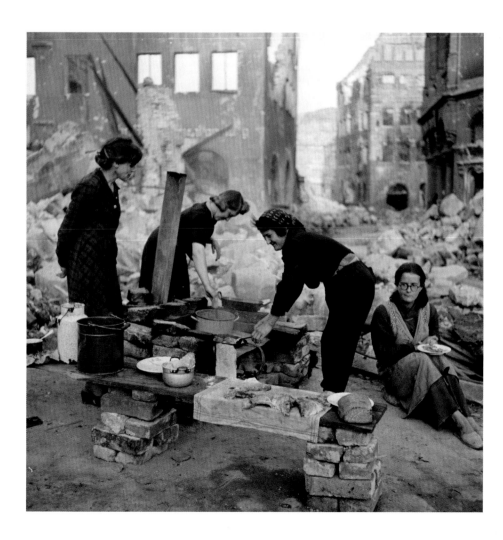

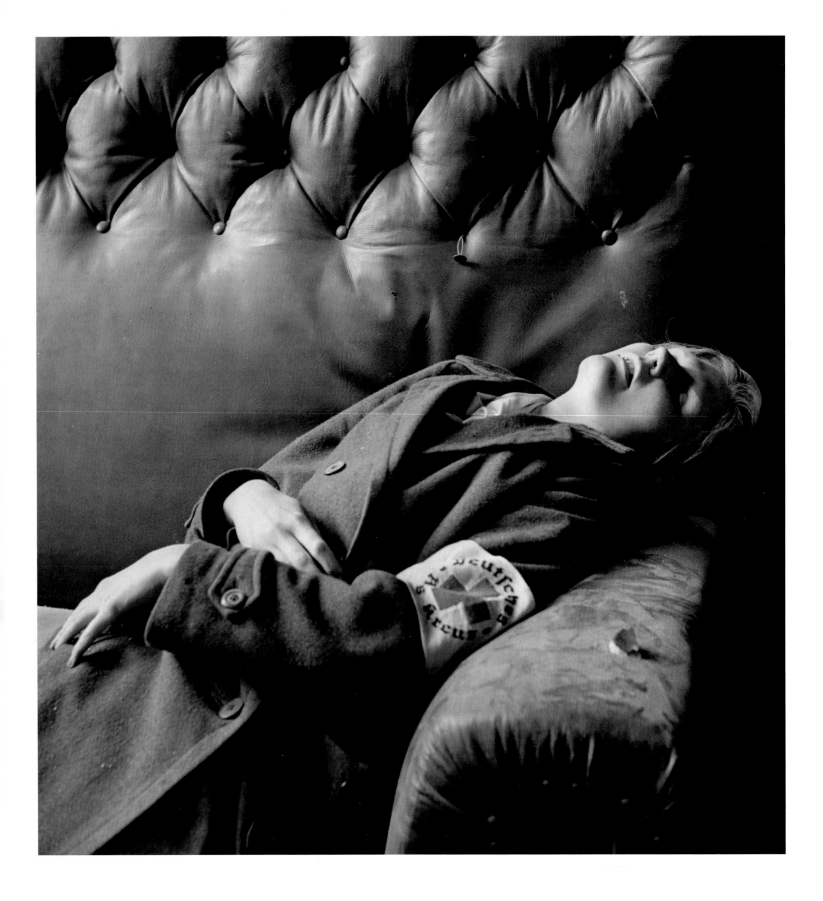

'I DON'T NORMALLY TAKE PICTURES OF HORRORS. BUT DON'T THINK THAT EVERY TOWN AND EVERY AREA ISN'T SICK WITH THEM. I HOPE THAT *VOGUE* WILL FIND THAT IT CAN PUBLISH THESE PICTURES'

Lee Miller to Audrey Withers, quoted in 'Believe It',
British Vogue, *1945*

Defeat: Leipzig, Saxony, Germany, April 1945

Regina Lisso, daughter of Dr Kurt Lisso, city treasurer
of Leipzig, after committing suicide with her parents
in the town hall on 18 April 1945. Some senior
Nazi officials and soldiers chose to commit suicide
rather than face capture or defeat. The Lisso family
staged their deaths carefully, surrounding themselves
with symbols they deemed important. Regina Lisso
opted to die wearing her nurse's uniform. Miller noted
that she had 'extraordinarily pretty teeth'.

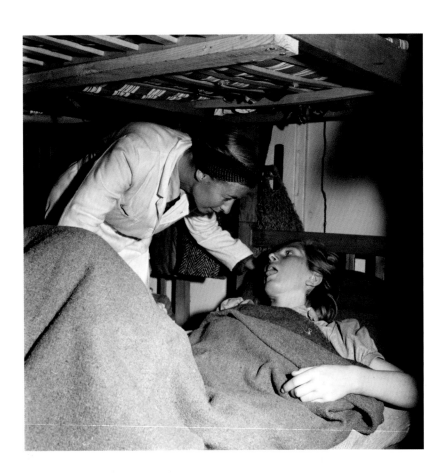

Defeat: Dachau Concentration Camp, Bavaria, Germany, April 1945

Dr Ella Lingens comforts a Hungarian woman (described by Miller as a 'half-crazed Tzigane') suffering from typhus in the camp hospital at Dachau on 30 April 1945. Dr Lingens, from Vienna, had been imprisoned in Auschwitz after being denounced for sheltering Jews. Both women were survivors of an 800-km (500-mile) forced march from Auschwitz to Dachau.

Defeat: Dachau Concentration Camp, Bavaria, Germany, April 1945

Women forced to serve as camp prostitutes await evacuation from Dachau. Miller's searing coverage of the German concentration camps ranks among her finest work but created a legacy that haunted her for the rest of her life.

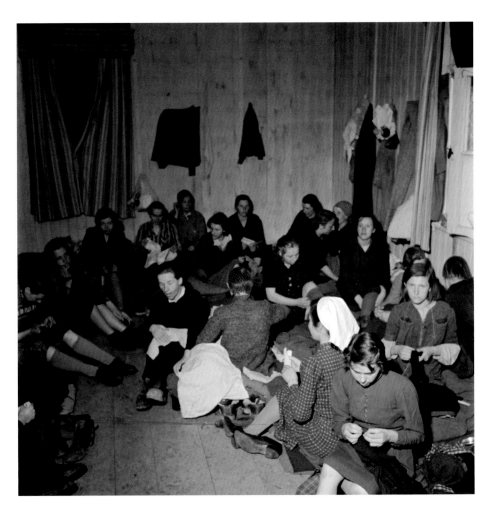

LEE MILLER: A WOMAN'S WAR

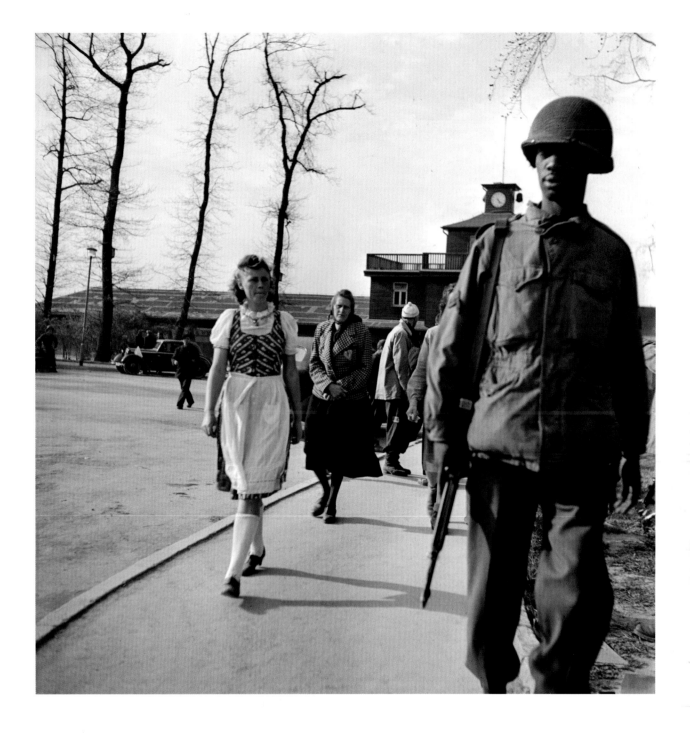

Defeat: Buchenwald Concentration Camp, Thuringia, Germany, April 1945

A German girl wears a dirndl (a traditional German dress) in a mute show of defiance during an enforced visit to Buchenwald Concentration Camp on 16 April 1945. Buchenwald, established in 1938, had housed nearly a quarter of a million prisoners in atrocious conditions. German civilians in Weimar were ordered to visit the camp by General George S. Patton.

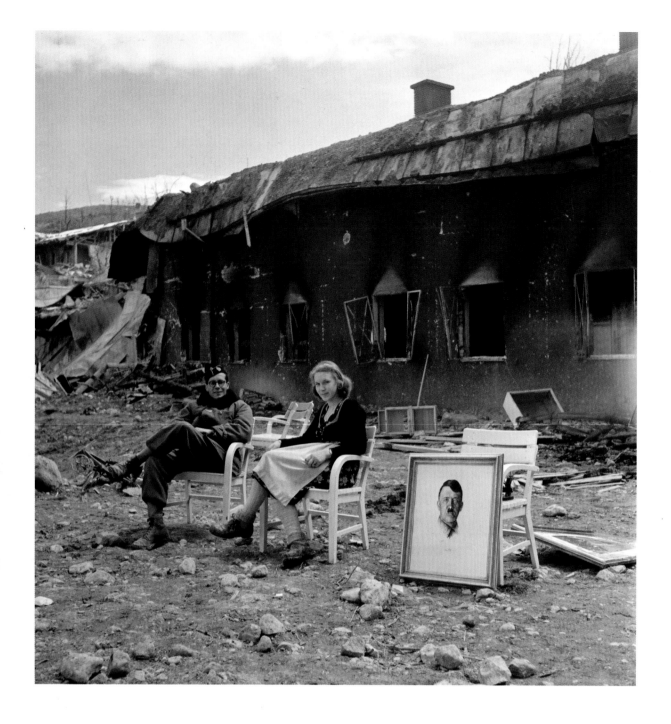

Defeat: Berchtesgaden, Bavaria, Germany, April 1945

A couple pause for a rest while looting Hitler's home, the Berghof near Berchtesgaden. By the end of the war, Miller regarded German men and women as equally immoral.

Lee Miller in Hitler's bath, Munich, Bavaria, Germany, April 1945 (photo: David E. Scherman)

This carefully arranged and highly symbolic photograph was taken in Hitler's Munich home on the day of his death (30 April 1945) within hours of Miller's return from Dachau.

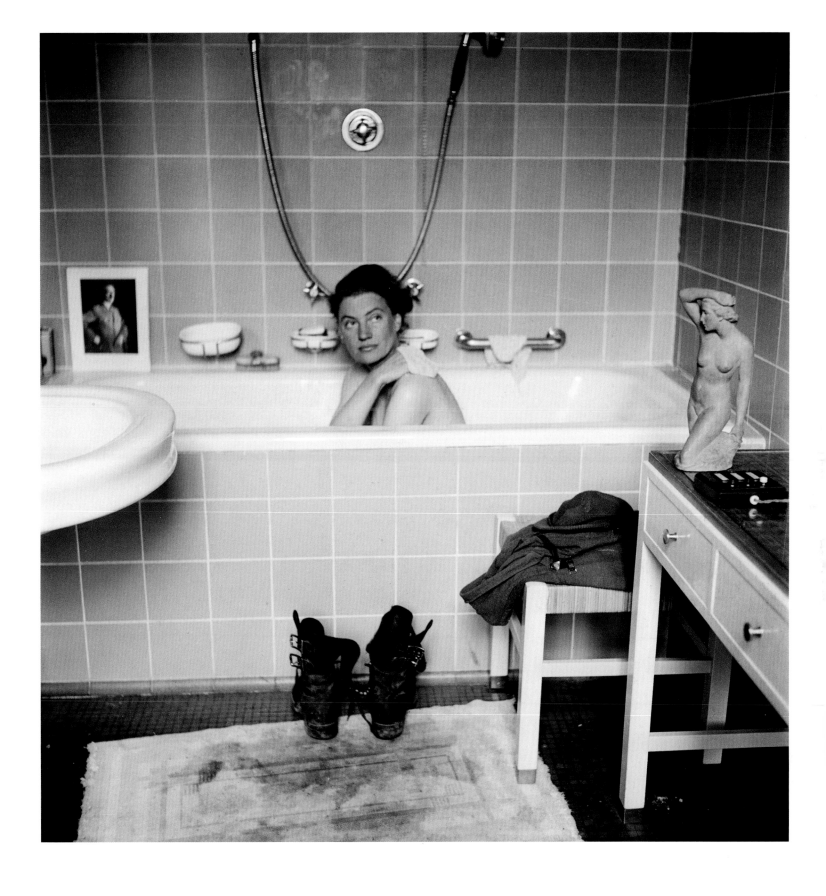

'THIS IS A NEW AND DISILLUSIONING WORLD. WAR WITH ALL THE COMPLICATIONS OF PEACE. PEACE WITH PERFORATIONS, DOG EARED CORNERS AND MARGINAL NOTES'

Lee Miller to Roland Penrose, late 1945

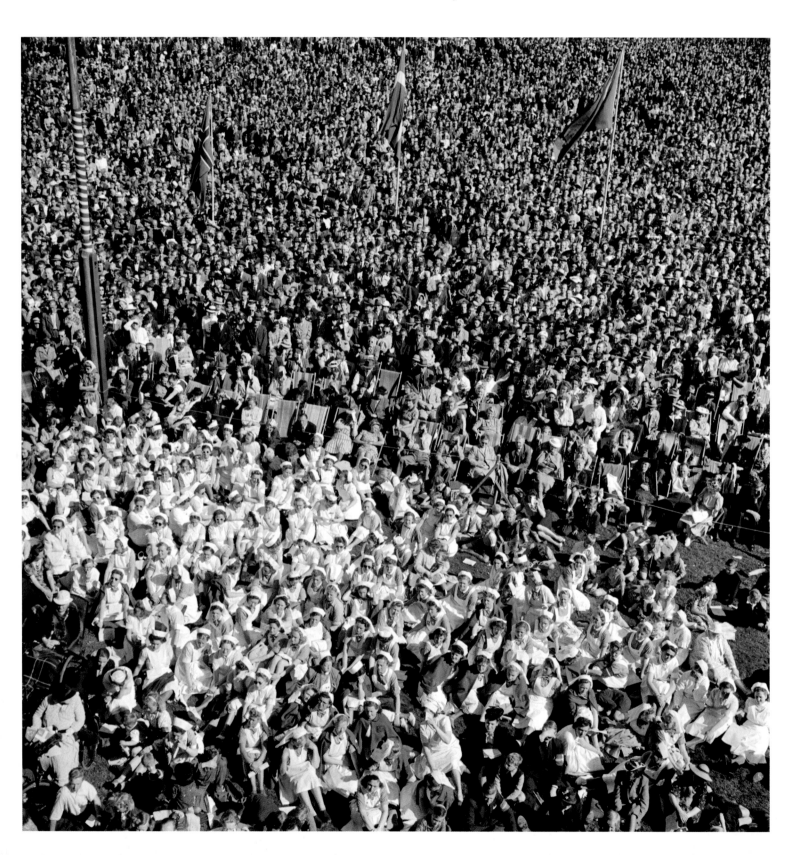

WOMEN AND THE AFTERMATH OF WAR

Life for women during the immediate post-war years was difficult. Wartime austerity continued, and in many instances worsened. Women struggled with an enduring personal legacy of trauma while attempting to restore family relationships that had been undermined by the war. Once again, social and political pressure combined to deprive many of their wartime roles. However, the abilities of women to carry out demanding work, regardless of circumstance, was now generally acknowledged.

British *Vogue* paid its own tribute to the contribution of women in a special issue marking the end of the war, but asked: 'where do they go from here – the Servicewomen and all the others, who without the glamour of uniform, have queued and contrived and queued, and kept factories, homes and offices going? Their value is more than proven ... how long before a grateful nation (or anyway the men of the nation) forget what women accomplished when the country needed them?'

This question was as relevant to Lee Miller as to the thousands of other women to whom it was addressed. After the triumphs of her wartime coverage of Europe, Miller was forced to come to terms not only with the lasting legacy that war had inflicted on her but also with a changed world that offered her little fulfilment as a photographer. Characteristically, she did so on her own terms and in her own unique style. In the last years of her life, Lee Miller adapted domesticity to achieve a new celebrity based in creative cuisine with a Surrealist twist.

War's Aftermath: Copenhagen, Denmark, June 1945

Despite clear signs of personal trauma and exhaustion, Miller opted to continue working in Europe after VE Day. Photographs of sunshine and celebration gradually gave way to a much bleaker style of photojournalism as she documented the grim legacy of war for women in post-war Europe. Miller's work reflected the growing depression that would become the enduring personal legacy of her wartime experiences.

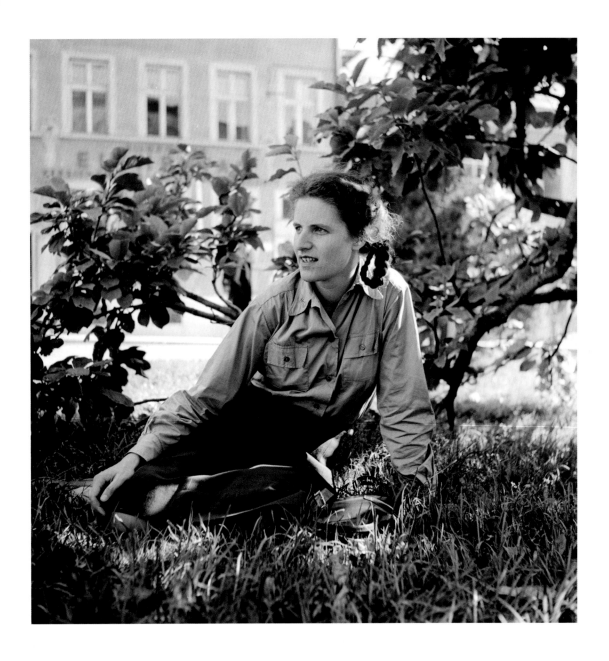

**War's Aftermath: Vienna, Austria,
August 1945**

Portrait of Margot Pinter, Music Officer with the
US Information Services Branch in Vienna. Pinter
was assisting with the post-war revival of the Vienna
Philharmonic Orchestra. Many of the orchestra's most
talented players had been members of the Nazi Party.
Pinter, an American concert pianist, found herself
a reluctant arbiter of their future careers.

**War's Aftermath: Vienna, Austria,
September 1945**

Irmgard Seefried, a German soprano, performs
an aria from Puccini's opera *Madame Butterfly* in the
ruins of Vienna Opera House. Jaded by war, Miller
was unreceptive to the Viennese love of music, writing
irritably: 'There is never silence in Vienna. There
is a madness of music.'

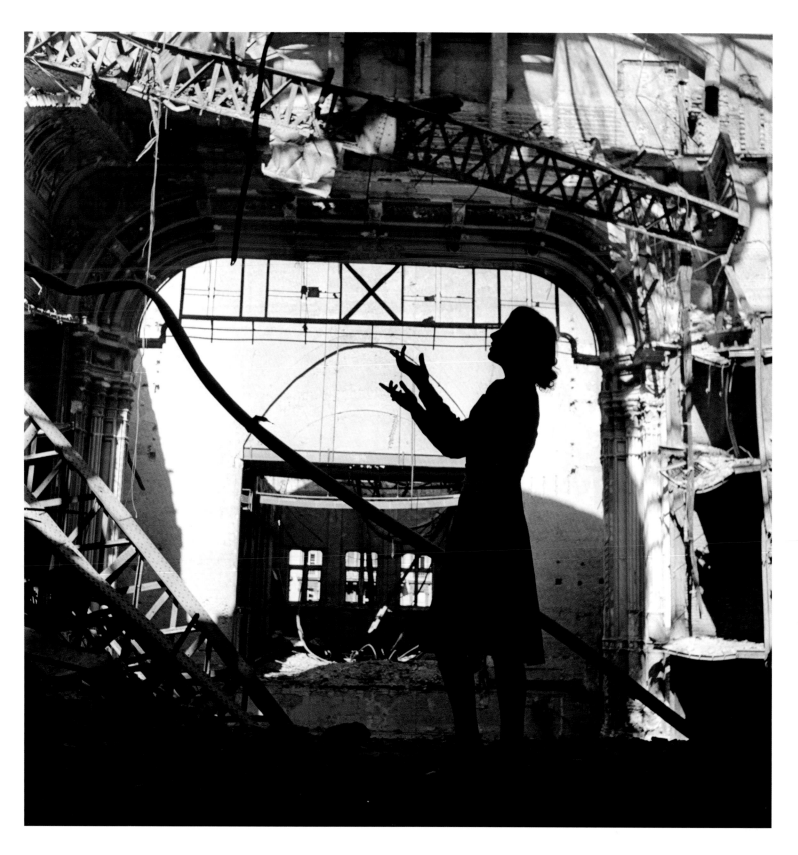

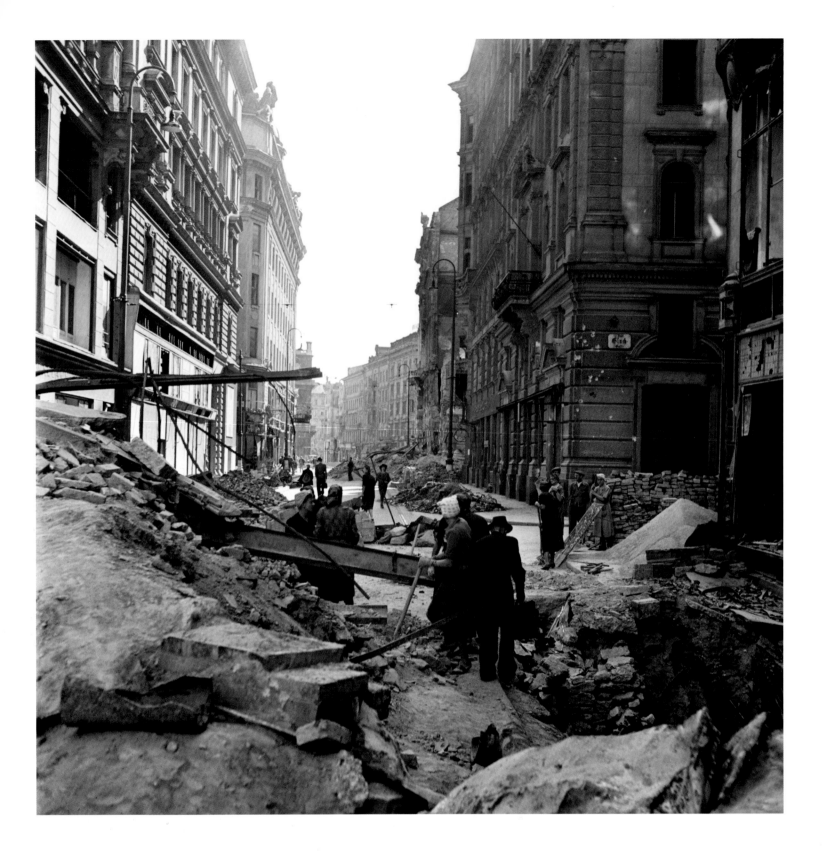

War's Aftermath: Vienna, Austria, August 1945

Austrian women clear rubble from the streets in Vienna. German and Austrian soldiers, now prisoners, would not return home for some time. Women bore the brunt of clearing up war damage. Equipped with buckets, they formed human chains to remove rubble.

War's Aftermath: Vienna, Austria, September 1945

Two Viennese women chat in front of a large Soviet portrait of Lenin in Kärntner Strasse. Vienna had initially been occupied only by the Red Army, but, like Berlin, was subsequently divided into zones of occupation controlled by the four major Allies.

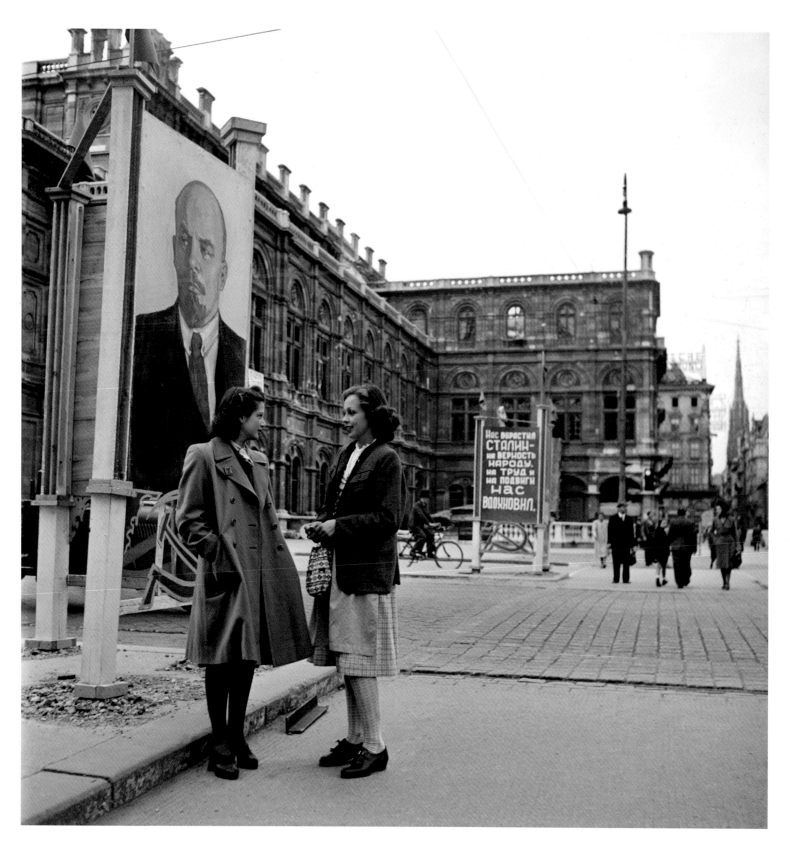

A Viennese nun comforts a dying child, one of many civilian cases of malnutrition in post-war Vienna. Miller found the suffering of children particularly hard to bear, writing: 'This tiny baby fought for his only possession, life, as if it might be worth something.'

War's Aftermath: Budapest, Hungary, Winter 1945

Princess Gabrielle Esterházy in a Budapest street. The Esterházy family had dominated Hungarian society and political life for centuries. Princess Esterházy was eking out a living transporting goods with a horse and cart after losing both her fortune and her possessions. Miller noted that the average American soldier's pay exceeded that of Hungarian government ministers.

War's Aftermath: Budapest, Hungary, January 1946

Homeless girls in a Budapest street. Miller spent the first winter after the war in Hungary and Romania. Both countries were in a state of economic collapse and falling under communist control. Her resentment of the Hungarians, who had fought alongside Germany, was tempered by compassion for those suffering genuine poverty.

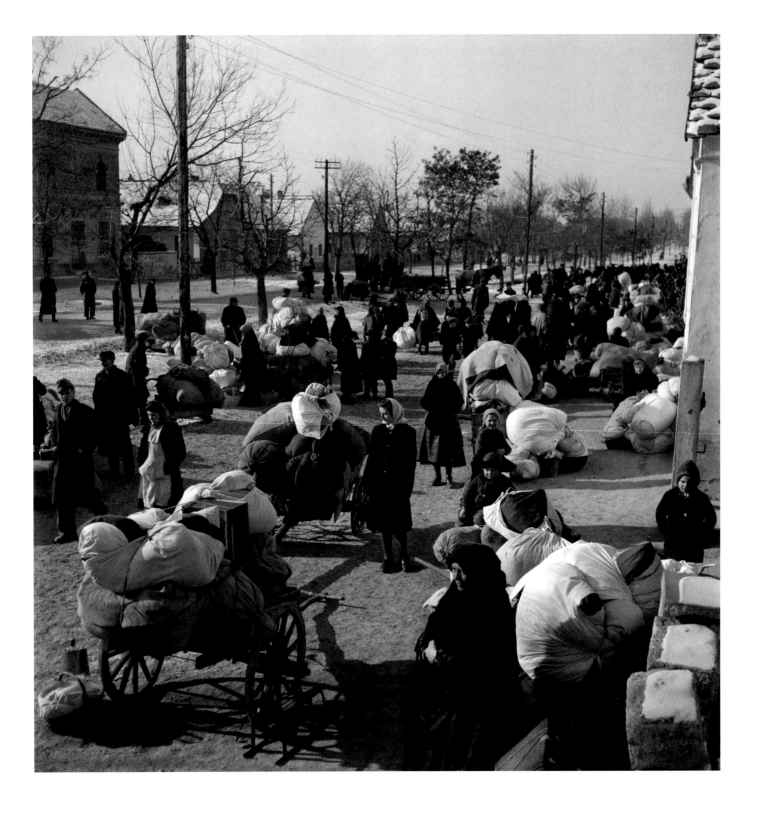

**War's Aftermath: Budapest, Hungary,
January 1946**

Ethnic Germans (known as Danube Swabians) flee
Budapest to avoid the threat of deportation to Siberia.

LEE MILLER: A WOMAN'S WAR

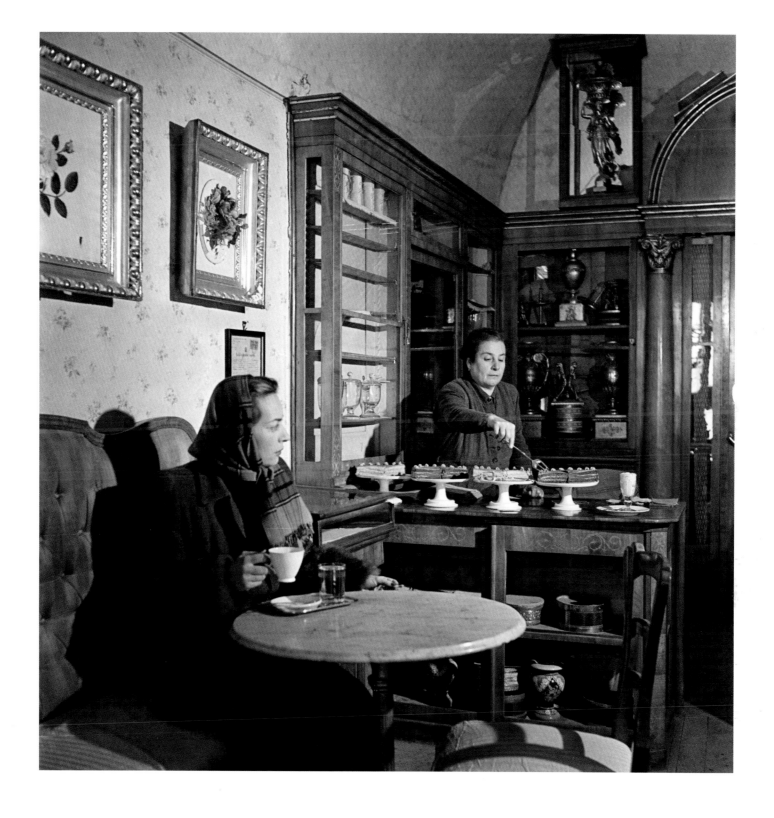

War's Aftermath: Budapest, Hungary, January 1946

Baroness Kata Schell in Café Ruszwurm. This photograph was taken in an attempt to cater for British *Vogue*'s renewed focus on fashion and lifestyle.

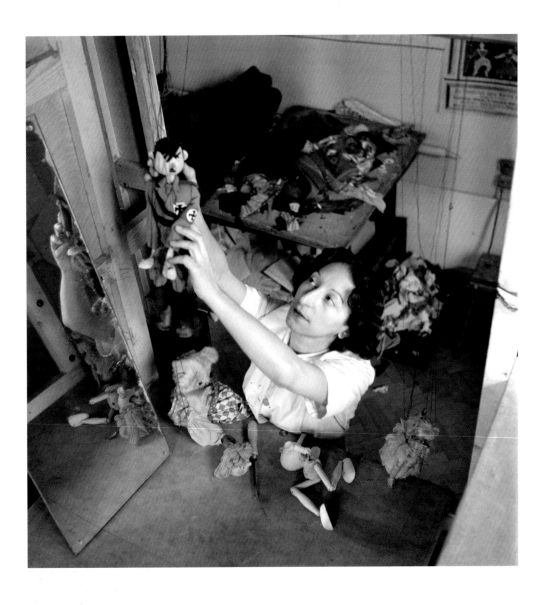

War's Aftermath: Bucharest, Romania, February 1946

Lena Constante, a Romanian artist and stage designer for the Țăndărică puppet theatre, hangs up a marionette of Adolf Hitler. Miller, who had fond memories of her pre-war trip to Romania in 1938, was sympathetic to Romanian women, but found the country a shadow of its former self.

War's Aftermath: Sinaia, Romania, February 1946

Queen Elena (mother of King Michael of Romania) photographed in the dilapidated surroundings of Peleș Castle on the royal estate of Sinaia. The castle was seized by the Romanian communist regime in 1947.

LEE MILLER: A WOMAN'S WAR

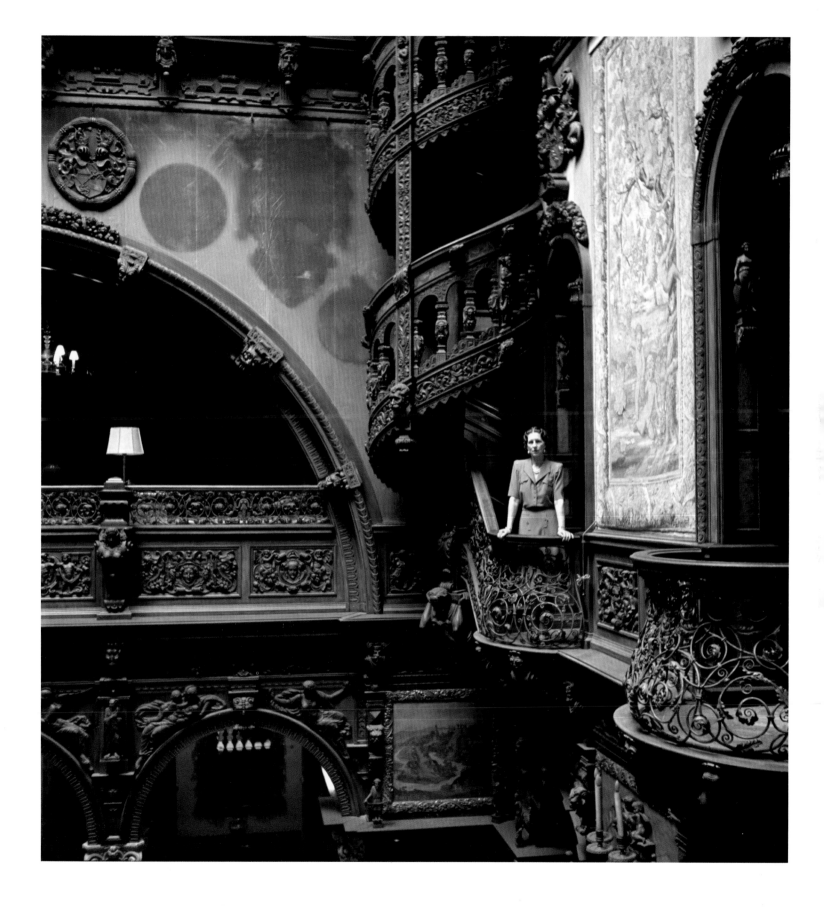

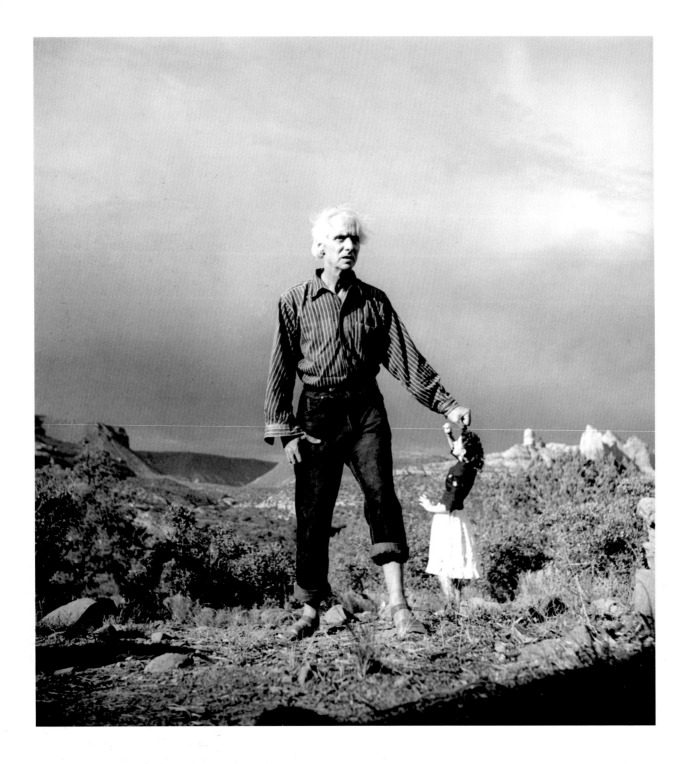

**Max Ernst and Dorothea Tanning,
Sedona, Arizona, USA, July 1946**

Miller and Roland Penrose were reunited with
Surrealist friends during their visit to the United
States. The Surrealist humour of this photograph
is underpinned by a stark statement about the
status of women in the post-war world.

**Dora Maar with her portrait, painted
by Picasso in 1937, Paris, France, c. 1956**

Miller continued to take photographs for occasional
projects in later life, most notably in support of Roland
Penrose's biography of Picasso.

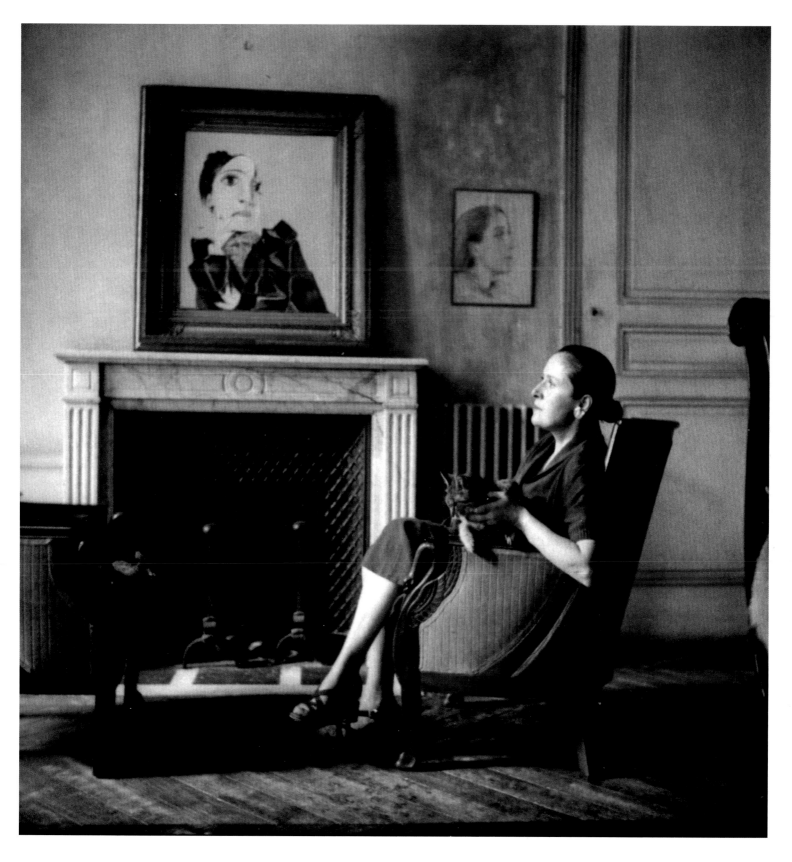

'SHE WAS RELUCTANT TO ABANDON THE ADVENTUROUS LIFE IN WHICH SHE HAD FOUND HER TRUE VOCATION AND SENSED RIGHTLY THAT SHE WOULD NEVER AGAIN HAVE THE OPPORTUNITIES IT HAD GIVEN HER'

Audrey Withers on Lee Miller to Carolyn Burke, October 1997

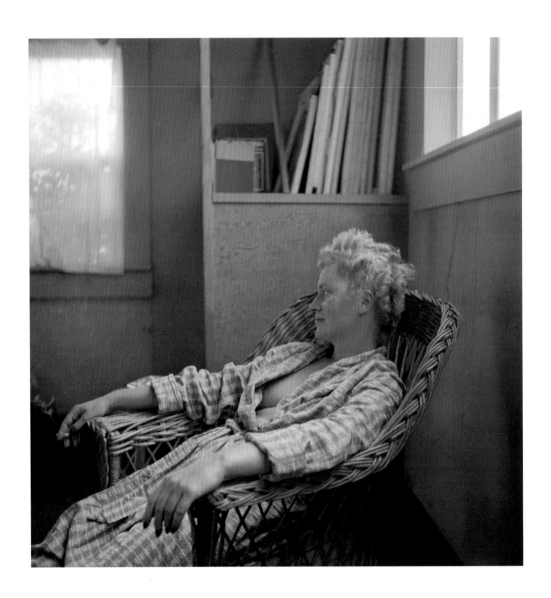

Lee Miller exhausted, Sedona, Arizona, USA, 1946 (photo: Roland Penrose)

Miller was reluctant to abandon her successful role as a war correspondent. By February 1946, however, she lacked the necessary resources to continue. Exhausted and close to total breakdown, she returned to Britain and Roland Penrose. To aid her recovery, the couple visited family and friends in the United States.

The Hostess takes it Easy, **Farley Farm House, Sussex, England, July 1953 (photo: Roland Penrose)**

Miller takes a well-earned nap while guests carry out household chores at Farley Farm, Miller's new home in Sussex. The photograph was taken for 'Working Guests', her last major photoessay for British *Vogue*.

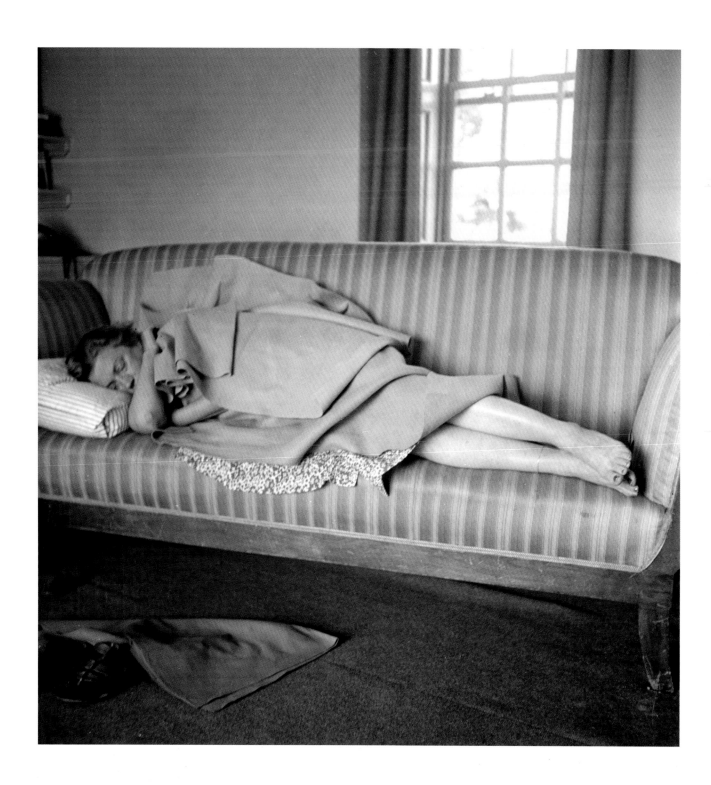

Roland Penrose, *Breakfast*, England, 1948

The war took a heavy toll on Miller and damaged her relationship with Roland Penrose. His portrait of Miller at the breakfast table is a bleak depiction of post-war depression and loss.

LEE MILLER: A WOMAN'S WAR

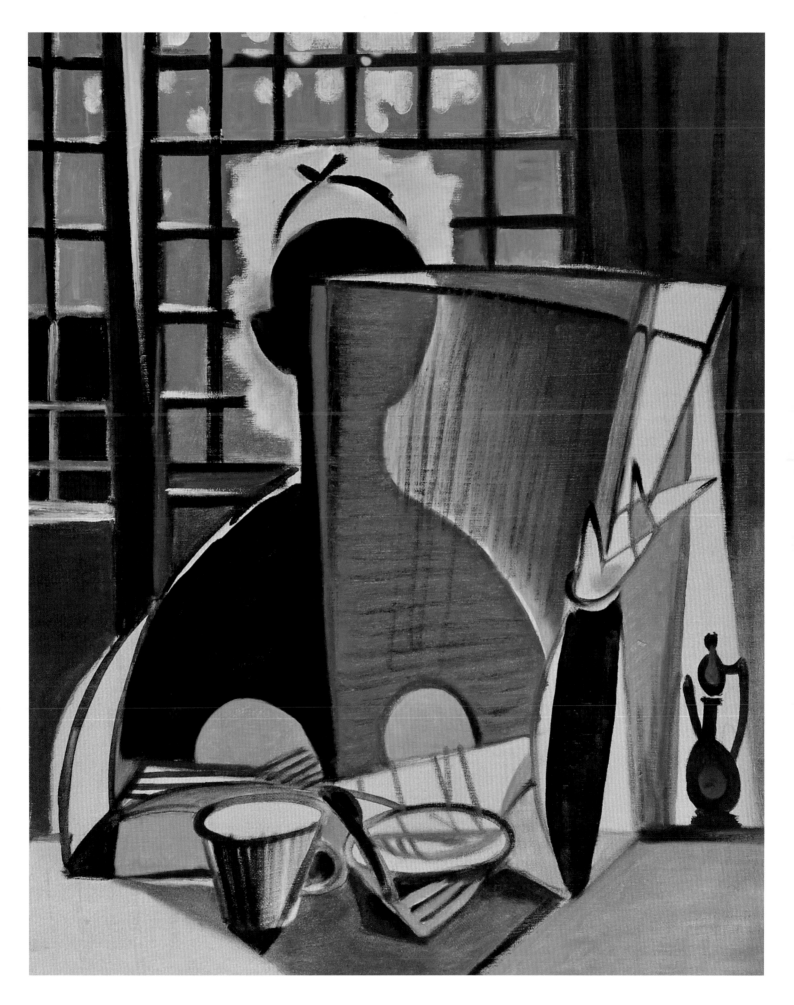

**Lee Miller and Antony Penrose, Florida, USA,
1952 (photo: Roland Penrose)**

Miller continued to travel widely. Her interests,
however, now focused on the cuisine of the
countries she visited.

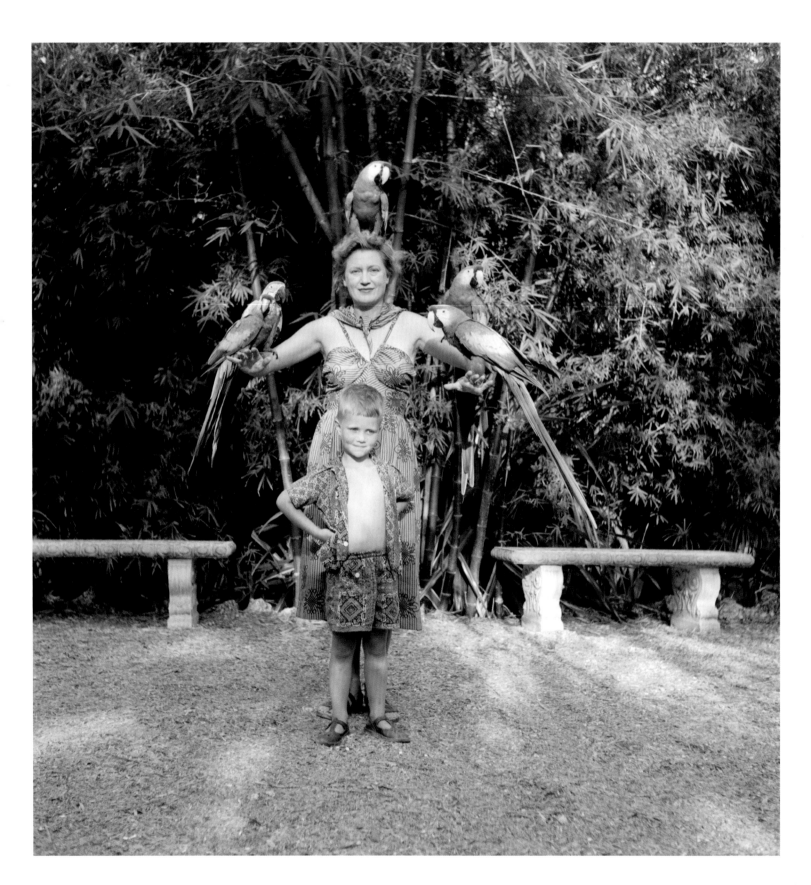

LEE MILLER: A WOMAN'S WAR

CHRONOLOGY

LEE MILLER & ROLAND PENROSE

Birth of Roland Penrose, third child of James Doyle Penrose, a successful British portrait painter, and Elizabeth Josephine Peckover, daughter of a wealthy Quaker banker, St John's Wood, London, Britain

Theodore Miller (1872–1971), an engineer and amateur photographer from Ohio, is appointed Superintendant of the US branch of the Swedish De Laval Separator Company, Poughkeepsie, NY, United States

Theodore Miller marries Florence MacDonald (1881–1954), a Canadian nurse from Brockville, Ontario

23 April: Birth of Elizabeth (nicknamed Li-Li) Miller, second child of Theodore and Florence Miller, Poughkeepsie, NY, United States

Penrose family moves to Oxhey Grange near Watford, Hertfordshire, Britain. Roland Penrose receives a strict Quaker upbringing

PHOTOGRAPHY & THE ARTS

Éduard Jean Steichen (1879–1973), a lithographer from Luxembourg, becomes a US citizen and takes the name Edward J. Steichen

Spanish artist Pablo Picasso (1881–1973) pays first visit to Paris, France

Birth of Luis Buñuel, Teruel, Spain

Picasso exhibits in Paris for the first time

Picasso settles in Paris

Birth of Salvador Dalí (1904–1989), Figueres, Spain

Birth of Cecil Beaton (1904–1980), Hampstead, London, Britain and Margaret Bourke-White (1904–1971) New York, United States

Picasso paints *Les Demoiselles d'Avignon*, France. His fractured treatment of form launches Cubism, an avant-garde movement which revolutionizes European art, informing Dada and Surrealism

Birth of Henriette Theodora Marković aka Dora Maar (1907–1997), Paris, France and Leonor Fini (1907–1996), Buenos Aires, Argentina

Paul Éluard (1895–1952), a young poet, settles in Paris, France, with his family

Birth of Henri Cartier-Bresson (1908–2004), Chanteloup-en-Brie, France

First Cubist exhibition, Paris, France

FASHION

Women's fashion features S-bend silhouette (achieved with corsetry), large picture hats and the Gibson Girl hairstyle

Paris boasts more than a hundred haute couture houses

Birth of George Hoyningen-Huene (1900–1968), son of an Estonian nobleman and an American mother, St Petersburg, Russia

Harper's Bazaar, an illustrated society and fashion magazine, launches as a monthly publication, United States

Max Factor (1877–1938), a Polish wigmaker, settles in the United States and launches a cosmetics business

Charles DeBevoise Company introduces the brassiere, United States

Parisian couturiers introduce straight, slim fashion silhouette which relies less on corsetry

World's first beauty contest, Britain

Condé Montrose Nast (1873–1942), publisher, acquires *Vogue*, an ailing weekly high society magazine, United States. He transforms it into a successful illustrated fashion magazine. Edna Woolman Chase (1877–1957) joins the magazine as a fashion reporter

WOMEN & SOCIETY

Women have limited access to education, which is orientated towards literacy, domestic and social skills. Many girls leave school at the age of twelve and enter domestic service. Few married women work outside the home or are financially independent. Divorce is socially unacceptable. Same-sex relations are legal between women (but not between men). Women possess few political rights but are increasingly demanding the right to vote

US Army Nurse Corps established

Denmark introduces maternity leave for women

A woman is arrested for smoking a cigarette in a car on 5th Avenue, New York, United States

Dora Montefiore (1851–1933) refuses to pay her taxes until women are given the vote, Britain

First major demonstration (the Mud March) by National Union of Women's Suffrage Societies (NUWSS), Britain

First Aid Nursing Yeomanry (FANY) established as a voluntary frontline ambulance service. Mabel St Claire Stobart (1862–1954), establishes Women's Sick and Wounded Convoy Corps, Britain

Suffragette campaign descends into violence, Britain

Women are permitted to join political parties, Germany

US Navy Nurse Corps and Canadian Army Nursing Corps established

Marion Wallace Dunlop (1864–1942), an imprisoned suffragette, goes on hunger strike, prompting introduction of forced feeding, Britain

JOURNALISM

Emily Hobhouse (1860–1926), a British welfare campaigner, begins to report on conditions in British concentration camps during the Boer War, South Africa

Horace W. Nicholls (1867–1941), one of Britain's first photojournalists, covers the Boer War, South Africa

Emily Hobhouse's report prompts investigation of conditions in British concentration camps, South Africa. Her work strengthens the British Army's hostility to war reporters and women in the war zone

Christina Broom (1862–1939), the world's first female press photographer, becomes the first woman photographer to be accredited to the British Army

Emmeline Pethick-Lawrence (1867–1954) launches suffragette newspaper *Votes for Women*, Britain

Tom Grant of the *Daily Mirror* photographs Constantinople Coup, Turkey

Albert Kahn, French banker and philanthropist, launches international photographic survey to promote peace through understanding

WORLD EVENTS

Second Boer War, South Africa

January: Battle of Spion Kop, South Africa
June: Boxer Rebellion, China
July: Archduke Franz Ferdinand marries Countess Sophie Chotek in a morganatic marriage, Austria-Hungary

January: Death of Queen Victoria. Edward VII becomes king, Britain
September: Black Hand, a secret military nationalist group, founded, Serbia

April: *Entente cordiale* between Britain and France signed
November: Theodore Roosevelt elected President of United States

August: Signature of Anglo-Russian Entente creates Triple Entente of France, Britain and Russia to counter Triple Alliance of Germany, Austria-Hungary and Italy

April: Herbert Asquith becomes Prime Minister, Britain
October: Austria-Hungary annexes Bosnia and Herzegovina, precipitating Bosnian crisis

April: Sultan Abdul Hamid II is overthrown and replaced as Ottoman emperor by his brother, Mehmed V, Constantinople, Turkey
July: Louis Blériot makes first flight across the English Channel

LEE MILLER & ROLAND PENROSE

Roland Penrose's family embraces pacifism, Britain. Two elder brothers register as conscientious objectors and serve with the Friends Ambulance Unit on the Western Front

Theodore Miller photographs Elizabeth (aged eight) in the nude for his study *December Morn*

Elizabeth attends Governor Clinton Elementary School, Poughkeepsie, NY, United States. As time goes by, her behaviour becomes increasingly disruptive

Theodore Miller experiments with stereoscopic (3D) photography, Poughkeepsie, NY, United States

Elizabeth Miller maintains a close relationship with her father, but is often at odds with her mother

Miller begins to take photographs (using a Kodak 0 Brownie given her by her father)

Penrose grows increasingly frustrated by his Quaker upbringing. His eldest brother, Alec, is diagnosed with shell shock, Western Front

PHOTOGRAPHY & THE ARTS

Max Ernst is drafted into the German Army, where he will serve on the Western and Eastern fronts. Paul Éluard is drafted into the French Army

André Breton (1896–1966), a French medical student and poet, works with shell-shocked French soldiers on a psychiatric hospital ward, Nantes, France

Picasso continues to work as an artist in Avignon, France

European artists opposed to the war gather at the Cabaret Voltaire, Zurich, Switzerland

Man Ray stages first solo art exhibition

Zurich artists opposed to the war name their movement Dada, Switzerland

British War Propaganda Bureau establishes War Artists Scheme. Muirhead Bone becomes Britain's first official war artist. Others will include Eric Kennington and Paul Nash

David E. Scherman born, New York, United States

Dada movement spreads to other countries

Éluard marries Gala. He is posted to a military evacuation hospital at Hargicourt, Western Front. He works as a grave digger and writes letters to bereaved relatives

Birth of Leonora Carrington (1917–2011), Chorley, Lancashire, Britain

FASHION

Paris couturiers suspend operations on outbreak of war, France. Poiret joins the French Army

As war disrupts French fashion industry, *Vogue* begins to encourage fashion in the United States. Chase organizes *Vogue*'s first fashion show. Proceeds are donated to Allied widows and orphans

Condé Nast appoints de Meyer *Vogue* chief photographer

Chase appoints Dorothy Parker to write such memorable fashion captions as 'Brevity is the soul of lingerie'

European fashions adapt to the war. Skirt lengths rise above the ankles and some women wear breeches for work. Uniforms become everyday wear. Women engaged in war work begin to cut their hair short for convenience. Coco Chanel turns short hair into a fashion statement (the bob)

Condé Nast establishes British edition of *Vogue* to address falling circulation arising from wartime paper shortages and non-essential shipping regulations. Chase is appointed editor-in-chief. Elspeth Champcommunal serves as its first editor in London, but has little editorial independence

Revolution forces Hoyningen-Huene to flee Russia. He later works as an interpreter for the British Expeditionary Force in South Russia

Women are asked not to buy corsets in order to conserve metal supplies, United States

WOMEN & SOCIETY

British political campaign for women's suffrage is suspended on outbreak of war. The war causes deep divisions within the suffrage movement

Propaganda campaigns exploit women's patriotism in recruiting drives.

Women volunteer for war service, mostly as nurses. Military nurses deploy to the war zone where they are supplemented by various privately funded voluntary units. 47,000 enrol as VADs in Britain

German execution of Nurse Edith Cavell (1865–1915) causes international condemnation, Belgium

VADs begin to serve overseas. Mabel St Clair Stobart's mobile hospital unit participates in the Serbian Army's winter retreat through Albania. Flora Sandes (1876–1956), a British Red Cross worker, serves with the Serbian Army as a soldier

Margaret Sangar begins to promote the diaphragm as a form of female contraception

Under the British government's Policy of Substitution, women are encouraged to join the civilian workforce, but at a lower wage. Poor working conditions and sceptical male supervisors are offset by a measure of financial independence

German trade unions block government attempts to employ women in factories

Women's Royal Naval Service (WRNS), Women's Army Auxiliary Corps (WAAC) and Women's Land Army established, Britain. WAACs deploy overseas. WRNS remain a land-based service

Women manufacture 80 per cent of British munitions. 200 die in industrial accidents

Women in Petrograd strike for Bread and Peace, triggering a chain of events that culminates in revolution, Russia

The Bolsheviks introduce votes for women and appoint world's first female government minister, Alexandra Kollantai (1872–1952)

JOURNALISM

Combatant nations introduce or tighten press censorship. Most ban civilian journalists and photographers from the war zone on security grounds. Britain introduces Defence of the Realm Act and establishes the War Propaganda Bureau (forerunner of the Ministry of Information)

Deprived of professional coverage, newspapers and magazines begin to publish personal photographs taken by military personnel and nurses in the war zone

Dorothy Lawrence (1896–1964), an aspiring journalist, poses as a British soldier to gain access to the Western Front. She is arrested. The War Office invokes Defence of the Realm Act to prevent Lawrence publishing an account of her experiences

France and Britain begin to appoint official military photographers to generate press and propaganda material, but fail to establish clear guidelines, leading to complaints of stage management

Women working as voluntary nurses begin to publish accounts, illustrated with snapshots, of their experiences in the war zone

Allied military official photographers, cinematographers and war correspondents start work on the Western Front

War Propaganda Bureau absorbed into new Department of Information, Britain. DoI assumes responsibility for official photography, film, art and war correspondents

German Army establishes Bild- und Filmamt. General Ludendorff's proposal for a German Ministry of Information is rejected

US armed forces establish professional service photographic capability. Steichen is appointed Director of US Army Air Service Photographic Section. General Pershing allows civilian press photographers front-line access to US troops, Western Front

WORLD EVENTS

July: European powers mobilize for war
August: Start of First World War. The United States declares its neutrality
September–October: Trench warfare develops on the Western Front
December: German Navy bombards British coastal towns, killing civilians. Unofficial Christmas truce, Western Front

January: First British civilians killed in a Zeppelin raid. First German use of poison gas, Eastern Front
February: Germany launches unrestricted submarine warfare
April–December: Gallipoli campaign
May: Sinking of *Lusitania*. 1,198 lives lost. British coalition government formed. David Lloyd George, Minister of Munitions, works to reduce shell shortage

January: Introduction of male conscription, Britain. Allied forces evacuate Gallipoli
February–December: Battle of Verdun, Western Front
July–November: Battle of the Somme, Western Front. Romania defeated by Central Powers, Eastern Front

February: Germany recommences unrestricted submarine warfare after a short interruption. In response, United States severs diplomatic relations. Britain introduces voluntary rationing to conserve food supplies
March: First Russian Revolution, Petrograd

April: United States declares war on Germany

July–November: 3rd Battle of Ypres (Passchendaele), Western Front
November–December: Second Russian Revolution

LEE MILLER & ROLAND PENROSE

Miller attends screenings of anti-German propaganda films at her local cinema, Poughkeepsie, NY, United States

Penrose leaves school. He joins the Friends Ambulance Unit and is posted to Italy in the final days of the war

Penrose studies architecture at Queen's College, Cambridge, but finds modern art more interesting, Britain. He meets members of the Bloomsbury Group and becomes aware of Picasso's work

PHOTOGRAPHY & THE ARTS

Éluard serves in the trenches. His health quickly gives way, France

Man Ray begins to take photographs, United States

Ministry of Information commissions Anna Airey as Britain's only female war artist of the First World War

Berlin Dadaists oppose the Weimar Republic. Max Ernst begins to create collages, Cologne, Germany

André Breton publishes his first collection of poetry and meets Éluard. Breton launches *Littérature* magazine with writers Louis Aragon (1897–1982) and Philippe Soupault (1897–1990), France

Dorothea Lange (1895–1965), a young American photographer, opens a portrait studio in San Francisco, United States

The Flapper, a silent comedy film, is released, United States. The rebellious, fun-loving lifestyle of its teenage lead character defines the flapper age. F. Scott Fitzgerald publishes *Flappers and Philosophers*, a collection of short stories

Dada exhibitions in Europe

Picasso begins to alternate between the cubist and classical styles

Breton meets Sigmund Freud in Vienna, Austria. Ernst befriends Éluard

Man Ray moves to Paris where he settles in Montparnasse and begins to associate with the local Dada circle, France

FASHION

Kimberly-Clark produce a surplus of cellulose cotton bandages for US troops on the Western Front. US nurses adapt them for use as sanitary towels

US Navy uses Sundback's Hookless Fastener in flying suits. Civilian clothing manufacturers begin to follow suit

Paris fashion houses reopen after the war. Post-war waistlines are low and the silhouette undefined

Poiret struggles to relaunch his fashion house which is on the brink of bankruptcy

Max Factor opens House of Make Up in New York, United States

Condé Nast establishes French and Italian editions of *Vogue*

Max Factor begins to use the term 'make up' as an alternative to 'cosmetics'

Hoyningen-Huene contracts typhus in Tsaritsyn (aka Stalingrad and Volgograd), Russia. He is evacuated to Britain

Coco Chanel introduces Chanel No. 5, France. It becomes the world's best-selling perfume

Hoyningen-Huene settles in France and studies painting. His ability to copy dress designs from memory brings him to the attention of French *Vogue*. Chase commissions him as an illustrator

WOMEN & SOCIETY

Women's Royal Air Force established, Britain

WAAC renamed Queen Mary's Auxiliary Army Corps. Official investigation discounts allegations of widespread 'improper relations' between QMAAC women and soldiers at the front

Britain grants the vote to women aged over thirty (if they or their husbands own property) and the right to stand for Parliament

Marie Stopes (1880–1958) publishes *Married Love*, a pioneering book on sex, Britain. Margaret Sanger wins legal battle to allow doctors to prescribe contraceptive devices to women, United States

Newly created European states extend women the right to vote. Of the combatant nations, only France retains its ban

Nancy Astor (1879–1964) is elected to Parliament and becomes the first woman to take her seat in the House of Commons, Britain. British women are granted equal access to professions, but Restoration of Pre-War Practices Act forces most to leave wartime jobs

Women's Royal Naval Service disbands, Britain

Women's Royal Air Force disbands, Britain

Oxford opens its degrees to women, Britain

United States introduces votes for women. US military nurses are granted officer status but without all associated rights

Queen Mary's Army Auxiliary Corps disbands, Britain. Female civil servants demand that married women should not be eligible to work for the service

JOURNALISM

British Department of Information upgraded to ministry, headed by Lord Beaverbrook

IWM commissions Olive Edis to photograph women in the armed forces on the Western Front. She is unable to gain access while hostilities are in progress

1st Lt E. R. Estep, US Army Signal Corps official photographer, is killed in action, Western Front

Olive Edis photographs women in the armed forces for Imperial War Museum, Western Front

Ministry of Information closes. IWM assumes responsibility for official photographers until demobilization

British Army photographers demobilize. RAF and Royal Navy retain a limited operational photographic resource.

Heinrich Hoffmann (1885–1957), a Munich photographer, joins NSDAP and befriends Adolf Hitler, Germany

British Foreign Office establishes British Library of Information, a small press bureau, to serve as an outlet for British propaganda disguised as information, New York, United States

Hoffmann is appointed Hitler's personal photographer, Germany. Together, they begin to shape Hitler's public image.

Hitler becomes sole owner of the *Völkischer Beobachter*, a weekly newspaper

WORLD EVENTS

January: Woodrow Wilson draws up Fourteen Points as a basis for any peace agreement
February: Rationing introduced in southern England
March: Germany and Russia end war on Eastern Front. German Spring Offensive, Western Front. Spanish flu breaks out in United States and spreads to Europe
September–October: British and French breach Hindenburg Line. American Expeditionary Force debuts as independent army, Western Front. Turkey signs armistice

November: Germany collapses as revolution breaks out. Kaiser Wilhelm II abdicates. The armistice ends hostilities

December: Allied troops enter Germany. Lloyd George forms coalition government, Britain

January–June: Paris Peace Conference, France
January: Unrest in Germany. German Workers' Party established
March: Benito Mussolini establishes Fascist movement, Italy
July: Weimar Republic established, Germany
September: Adolf Hitler joins German Workers' Party

January: League of Nations established, France. Prohibition introduced, United States
April: German Workers' Party changes name to NSDAP (Nazi Party), Germany
November: Rationing ends, Britain. Russian Civil War ends

June: Three-year period of hyperinflation begins, Germany. Unemployment reaches 2.2 million, Britain

July: Adolf Hitler becomes leader of NSDAP, Germany

LEE MILLER & ROLAND PENROSE

PHOTOGRAPHY & THE ARTS

FASHION

Margaret Bourke-White begins to study art and photography, Columbia University, United States

Miller is expelled from Governor Clinton School for bad behaviour. She is sent to Oakwood Friends School, a strict Quaker co-educational school, Poughkeepsie, NY, United States

Breton settles in Paris with his wife. Ernst abandons his wife and child and moves to Paris (using Éluard's passport to enter France illegally)

Dorothy Todd, an openly homosexual journalist with strong feminist ideals, becomes editor of British *Vogue*. She increases coverage of the arts, culture and avant-garde theory. Circulation falls

Penrose moves to Paris. He studies painting and becomes interested in the Surrealist movement. He befriends Man Ray

Man Ray meets Alice Prin aka Kiki de Montparnasse (1901–1953), Paris, France. She becomes his first partner, model and muse. He develops a successful career as a photographer, specializing in art, fashion and portraiture

Madeleine Vionnet (1876–1975), a French fashion designer, experiments with bias cutting techniques to echo the female form, Paris, France

Man Ray begins photographing Paris fashion at Paul Poiret's studio

Dalí studies art in Madrid and befriends Buñuel

Penrose settles in the south of France. He opens his first studio at Villa les Mimosas, Cassis-sur-Mer

Ernst, Éluard and Éluard's wife Gala establish a *ménage à trois*, Paris, France

Steichen replaces de Meyer as US *Vogue*'s chief photographer

French artists André Masson (1896–1987) and Yves Tanguy (1900–1955) join the Surrealists. Masson experiments with automatic drawing

Attorney General confirms women may legally wear trousers, Britain

The hookless fastener is renamed the zipper, United States

Vogue begins to credit shops where featured clothes are available

Penrose meets Valentine Boué, a French Surrealist poet who is homosexual, Cassis-sur-Mer, France

Miller is expelled from Oakwood school. She transfers to Putnam Hall to complete her education, United States. Her parents experience marital problems. Florence Miller attempts suicide

André Breton launches Surrealist movement and issues the first Surrealist manifesto, France. Dadaists join the new movement

Man Ray creates *Le Violin d'Ingres*, a modified photograph featuring Kiki that objectifies the female form, Paris, France

British *Vogue* publishes first photograph by Cecil Beaton and series of feminist essays by Virginia Woolf and Dorothy Richardson

Audrey Withers studies philosophy, politics and economics at Somerville College, Oxford, Britain

Leni Riefenstahl develops a career as a successful film actress alongside Marlene Dietrich, Germany

Miller leaves school and embraces the flapper style. She travels to Paris and enrols in L'École Medgyès pour la Technique du Théatre.

Picasso paints *The Three Dancers*, an expression of post-war despair, and begins a fruitful collaboration with the Surrealists

French *Vogue* appoints Hoyningen-Huene as an illustrator, France

Penrose marries Valentine Boué, France

First group exhibition of Surrealist art, Paris, France. Ernst experiments with Surrealist art forms including frottage

Max Factor begins to produce cosmetics for the mass market, trading on the flapper style (which makes heavy use of eye and lip make up), United States

WOMEN & SOCIETY

Marie Stopes opens first birth-control clinic, London, Britain. Margaret Sangar establishes American Birth Control League. Kotex launches first advertising campaign for sanitary towels, United States

NSDAP adopts policy of excluding women from political life, Germany

Britain grants women equal rights in divorce, allowing both genders to petition on grounds of proven adultery. No other grounds are permitted

Mothers are granted equal status in legal claims relating to their children, Britain

Refrigerators go on sale, Britain

Holland-Rantos Company begins manufacturing the contraceptive diaphragm, United States

Fascist regime establishes Opera Nazionale ed Maternita ed Infanzia (ONMI), a national maternity organization which discourages contraception and abortion, Italy

JOURNALISM

British Army calls up one of its former official photographers to document Irish Civil War

Launch of British Broadcasting Company (BBC) radio service

Heinrich Hoffmann photographs Munich Putsch, Germany

Berliner Illustrirte Zeitung becomes Germany's most popular illustrated paper

NSDAP launch *Völkischer Beobachter* as a daily newspaper, Germany

Photojournalism begins a period of rapid development, fuelled by the introduction of the Leica (the world's first 35mm roll-film camera), Germany

Hitler publishes *Mein Kampf*, Germany

Stefan Lorant (1901–1997), Hungarian film director, begins a new career as an editor of pictorial publications, Germany. He will play a pivotal role in promoting the work of emerging photojournalists

WORLD EVENTS

November: National Fascist Party formed, Italy

February: Egypt granted independence from Britain
April: Stalin elected General Secretary of Communist Party, Russia
October: Mussolini takes power in Italy

January: Union of Soviet Socialist Republics (USSR) established
August: Heinrich Himmler joins the NSDAP, Germany
November: Munich Putsch, Germany

January: Death of Lenin, USSR Ramsay MacDonald forms first Labour government, Britain
May: Air Raid Precautions Committee established, Britain

January: Mussolini establishes Fascist dictatorship, Italy
February: Hitler resurrects NSDAP on his release from prison, Germany. Heinrich Himmler joins the party's paramilitary organization, known as the Schutzstaffel or SS

LEE MILLER & ROLAND PENROSE

Miller returns reluctantly to the United States. She studies stage and lighting design at Vassar College, Poughkeepsie, NY

After a boyfriend accidentally drowns, she moves to New York. She joins the Art Students League, where she befriends Tanja Ramm, and works as a lingerie model at Stewart & Co.

Theodore Miller photographs Elizabeth, Tanja Ramm and others in the nude

Miller is 'discovered' by Condé Nast in New York and invited to model for US *Vogue*, United States. She adopts Lee Miller as her professional name. Illustrator George Lepape's (1887–1971) portrait of her appears on the cover of US *Vogue*'s March edition

Miller poses for Steichen, Arnold Genthe and others while leading a glamorous social life

Steichen's photograph of Miller features in adverts for Kotex sanitary towels, damaging her modelling career. She decides to become a professional photographer

Penrose stages first solo exhibition, Paris, France. He meets Max Ernst and Joan Miró (1893–1983), a Spanish artist

Miller moves to Paris and meets Man Ray. She becomes his student, muse, model, assistant and partner. They accidentally rediscover the Sabattier effect and name it 'solarization'

Miller models for Hoyningen-Huene at French *Vogue*. He teaches her *Vogue*'s style of fashion photography

Penrose befriends Éluard and Breton, France. He begins to use frottage technique

Miller asserts her independence from Man Ray. She establishes a studio and performs in Jean Cocteau's Surrealist film *Blood of a Poet*.

PHOTOGRAPHY & THE ARTS

René Magritte and others establish a Surrealist group in Belgium

Dalí visits Paris for the first time and meets Picasso, France

Dora Maar returns to Paris. She studies photography and painting while experimenting with Surrealism

Beaton experiments with Surrealist styles, taking portraits of Edith Sitwell, William Walton and others

Breton joins Communist Party. A Surrealist Gallery opens in Paris, France

Leonora Carrington, aged ten, meets Éluard and is introduced to Surrealism. Ernst marries Marie-Berthe Aurenche, France

Margaret Bourke-White establishes a photographic studio, specializing in architecture and industrial photography, Cleveland, Ohio, United States

Dalí and Buñuel join the Surrealist movement

Maria ('Nusch') Benz (1906–1946) settles in Paris. She works as a stage performer and artist's model, France

Introduction of Rolleiflex Twin Lens Reflex medium format camera

Man Ray begins creating a series of images of Miller which fragment and objectify her body. Miller generates her own versions using other sitters. They both explore solarization in their photography

Gala leaves Éluard for Dalí (whom she later marries) France. Dalí stages his first solo exhibition

Johannes Ostermeier introduces flashbulbs (light bulbs filled with magnesium foil), Germany

Breton issues second manifesto of Surrealism, following a series of disputes and expulsions from the Surrealist movement, France. The movement adopts a stronger political stance with some members joining the French Communist Party

FASHION

Alison Settle (1891–1980), a champion of women's rights, replaces Dorothy Todd as editor of British *Vogue*. Its focus returns to fashion and society

Coco Chanel introduces the 'little black dress', France. US *Vogue* dubs Chanel's designs the 'Garçonne' (little boy) look

Hoyningen-Huene appointed chief photographer at French *Vogue*. He begins to apply Surrealism to fashion photography

Fashion photography begins to replace graphic illustration in the pages of *Vogue*.

Elsa Schiaparelli (1890–1973), an Italian fashion designer, launches a knitwear line, Paris, France. Her designs are heavily influenced by Surrealism

Beaton joins British *Vogue* with a contract to supply photographs and illustrations

Beaton works for US *Vogue* in New York. He photographs Miller. The assignment marks the beginning of an acerbic working relationship between Beaton and Miller, United States

Condé Nast suffers huge financial losses in the Great Depression

Michel de Brunhoff (1892–1958) is appointed editor of French *Vogue*, Paris, France

Dr Mehemed Fehmy Agha (1896–1978), a Ukrainian designer, is appointed art director at US *Vogue*. He introduces pictorial features and improves the relationship between text and images

Poiret's fashion house closes, after failing to adapt to the post-war era

Fashion becomes more conservative during the Great Depression. The American film industry provides glamorous inspiration

WOMEN & SOCIETY

Britain introduces legislative changes linked to the enfranchisement of women. The legal age of marriage is reduced from twenty-one to sixteen for both genders. Children born out of wedlock are allowed to be legitimized by the subsequent marriage of their parents. Adoption is legalized

Fascist regime strengthens laws against abortion and introduces a tax on unmarried men, Italy

Mussolini launches 'Battle for Birth', a campaign to increase the birth rate in Italy. Loans and favourable tax incentives are offered to married couples who have large families. The campaign is unsuccessful

Britain lowers voting age for women from thirty to twenty-one, thereby giving women and men equal suffrage

Death of Emmeline Pankhurst

Mussolini abolishes women's right to vote in local elections, Italy

British general election (the first in which women aged 21–30 are allowed to vote) is nicknamed the 'Flapper Election'

Margaret Bondfield (1873–1953) becomes Britain's first female cabinet minister

Eva Braun, Hoffmann's darkroom assistant, meets Hitler in Hoffmann's studio, Munich, Germany. They begin a relationship which remains hidden from public view

Mary Bagot Stack establishes Women's League of Health and Beauty. National Birth Control Council established, Britain

Amy Johnson becomes the first woman to fly solo from England to Australia

JOURNALISM

Stefan Lorant appointed editor of *Münchner Illustrierte Presse*, Germany

British newspapers suspend publication during the General Strike. BBC radio broadcasts five news bulletins a day

John Logie Baird mounts first demonstration of television, Royal Institution, Britain

Associate Press launches News Photo Service. BBC (now British Broadcasting Corporation) is granted a Royal Charter. Sir John Reith appointed first Director-General

Martin Munkácsi (1896–1963), a Hungarian photographer, joins the *Berliner Illustrirte Zeitung* as a staff photographer, Germany. He works simultaneously as a news and fashion photographer

Bourke-White is appointed staff photographer and associate editor of *Fortune* magazine

Dorothea Lange begins to photograph impact of Great Depression, United States

Bourke-White photographs Krupp Steel factory in Germany for Fortune. She becomes the first Western photographer to gain access to the Soviet Union, where she documents Stalin's first Five Year Plan

WORLD EVENTS

February: Germany joins League of Nations
May: Troops are deployed during General Strike, Britain
July: US Army Air Corps established
December: Hirohito becomes Emperor of Japan (1926–1989)

February: British troops land in Shanghai, China
May: Charles Lindbergh flies the Atlantic
August: First Nuremberg rally, Germany

July: Hungary orders Gypsies to settle permanently in one place
September: Discovery of penicillin, Britain

January: Leon Trotsky sent into exile, USSR Himmler becomes leader of the SS, Germany
October: Wall Street Crash. Start of Great Depression, United States
British Army of the Rhine stands down and withdraws from Germany

Construction of Maginot Line begins, France

August: Unemployment exceeds two million, Britain

LEE MILLER & ROLAND PENROSE

Penrose performs in Buñuel's comic Surrealist film *L'Age d'or*. In an attempt to improve his struggling marriage, he moves to Château Le Pouy (close to Condom, Valentine's home town), France

Miller completes first major photographic assignment (for Bioscope at Elstree Film Studios), Britain. Her work is exhibited in Paris and published in British *Vogue*

She meets Aziz Eloui Bey. Her relationship with Man Ray deteriorates

Miller parts from Man Ray and returns to New York. She establishes a studio with her brother Erik Miller. Her work is exhibited at the Julien Levy Gallery

Penrose gains financial independence following the death of his parents. He begins to offer financial support to other artists. He and Valentine visit India

Miller works as a commercial photographer, concentrating on portraiture and fashion, New York, United States

PHOTOGRAPHY & THE ARTS

Éluard meets Nusch Benz, Paris, France. She becomes his muse and a Surrealist artist in her own right, using the collage technique

Kenneth Clark (1903–1983) is appointed Keeper of Fine Art at the Ashmolean, Oxford, Britain

Dalí paints *The Persistence of Memory*, France

Leonor Fini, now a self-taught artist, settles in Paris, France

Méret Oppenheim (1913–1985), a Swiss Surrealist artist, settles in Paris, France

Man Ray adapts his work *Object to be Destroyed*, adding a photographic cut-out of Miller's eye and naming it *Object of Destruction*

Riefenstahl directs *Das Blaue Licht* (The Blue Light), one of Weimar Germany's most successful films. She reads Hitler's *Mein Kampf* and becomes a devotee of National Socialism

Oppenheim joins the Surrealist movement, France. Breton is expelled from the Communist Party

Clark becomes the youngest director of London's National Gallery, Britain

German Reich Chamber of Culture established under leadership of Joseph Goebbels with a remit to foster racial purity in German culture. Hitler rejects modernism and the avant-garde. German students commence public book burnings to 'purify' national culture

FASHION

Audrey Withers is dismissed from her publishing job to make way for a man and becomes unemployed. This experience informs her political views for the rest of her life

Withers joins British *Vogue* as a sub-editor

Antoinette (Toni) Frissell (1907–1988), an American photographer, begins working for US *Vogue*

Elsa Schiaparelli's divided skirt creates a sensation at Wimbledon, Britain. Miller's photographs of Schiaparelli's designs are her first to appear in British *Vogue*

US *Vogue* publishes its first cover featuring a colour photograph (by Steichen)

Max Factor introduces lip gloss. Revlon begins to establish the concept of seasonal cosmetics, United States

Launch of *Woman's Own*, a weekly magazine for women aged 30–40, Britain

Withers appointed managing editor at British *Vogue*

The Nazi regime discourages German women from wearing trousers, high heels and make up, but the guidelines are frequently ignored

WOMEN & SOCIETY

South Africa introduces the vote for white women

Spain introduces votes for women

Female athletes allowed to participate in the Olympic Games

SS Marriage Order requires SS men to obtain certificates confirming the racial purity of both partners before marriage, Germany

Amelia Earhart (1897–1937), an American pilot, becomes the first woman to fly the Atlantic Ocean solo

BBC stops employing married women. Divorcees are forbidden to remarry in church, Britain

Carrier Engineering Company introduces the domestic air-conditioning unit, United States

Women are no longer represented in German Reichstag. NSDAP organizations replace existing women's associations in Germany

Gertrud Scholtz-Klink (1902–1999) is appointed head of NS Frauenschaft (Women's League) and promotes women as homemakers. Germany, like Italy, offers incentives to increase the birth rate. Unity and Diana Mitford, British socialites, become Nazi enthusiasts after attending the Nuremberg rally

First women's concentration camp established, Moringen, Germany

Fascist regime introduces quota system, limiting women to 10 per cent of the public sector workforce, Italy

JOURNALISM

BBC radio reports 'There is no news' on 18 April

Endre Friedmann is exiled from Hungary for dissident activities. He studies journalism at the Deutsche Hochschule für Politik, Berlin, Germany

Bourke-White publishes *Eyes on Russia*, United States

Friedmann starts photographing local stories for the Dephot picture agency, Germany. He publishes his first photographs (of Leon Trotsky)

Inspired by Munkácsi, Cartier-Bresson begins to develop a career as a photojournalist, France

Bill Brandt moves to Britain

Munkácsi photographs Hitler's appointment as Chancellor, Berlin, Germany

German Ministry of Propaganda is established under leadership of Joseph Goebbels (1897–1945), with a structure informed by Britain's 1918 Ministry of Information

Hoffmann monopolizes NSDAP visual propaganda. Goebbels commissions Riefenstahl to film 1933 Nuremberg rally

Lorant is arrested and removed from his post at *Münchner Illustrierte Presse*. Gerta Pohorylle is arrested for distributing anti-Nazi propaganda in Leipzig, Germany. Friedmann leaves Germany and settles in Paris, France

WORLD EVENTS

December: President Hoover requests an economic stimulus package to address the Great Depression, United States

August: Unemployment exceeds two million, Britain
September: Japanese Army occupies Manchuria in violation of orders issued by the Japanese government

February: Japan occupies Shanghai, China
July: NSDAP win control of the Reichstag, Germany
October: Oswald Mosley forms British Union of Fascists
November: Franklin D. Roosevelt elected President, United States

January: President Hindenburg appoints Hitler Chancellor of Germany
February–October: Reichstag fire. Hitler establishes dictatorship, Germany
March: Third Reich declared. Dachau concentration camp established, Germany. President F. D. Roosevelt launches New Deal to lift United States from Great Depression
April: Gestapo established, Germany
October: Germany withdraws from League of Nations
December: Prohibition ends, United States

LEE MILLER & ROLAND PENROSE

19 July: Miller marries Aziz Eloui Bey, abandons her photographic career and moves to Egypt

Roland and Valentine Penrose separate, France

Miller studies Arabic at the American University in Cairo, and tries to adapt to life as an expatriate in Egypt

Penrose returns to Britain and settles in London. Valentine moves to India

Miller resumes photography, working for pleasure, Egypt

Penrose stages Britain's first exhibition of Surrealist art. The exhibition includes Man Ray's *Observatory Time*, a painting featuring Miller's lips

Penrose meets Picasso and Maar. He travels to Barcelona to support the Spanish Republican cause

Erik and Mafy Miller join Lee Miller, who is becoming increasingly bored in Egypt. She travels to Europe for the summer. She meets Penrose in Paris. They holiday with Surrealist friends in Cornwall and south of France

PHOTOGRAPHY & THE ARTS

Éluard marries Nusch Benz, France. Together, the couple act as an anchor and hub for the Surrealist movement in France

Dalí is expelled from the Surrealist movement

Clark appointed Surveyor of the King's Pictures, Britain

Germany adopts the swastika as its official emblem

Leonora Carrington studies art in London, Britain

Maar meets Picasso. She becomes his muse and partner, but he also maintains relationships with others. His art becomes increasingly bleak as world events unfold. He befriends Éluard and Penrose

Man Ray meets Adrienne (Ady) Fidelin, a coloured dancer from Guadeloupe, France. They begin a relationship

Carrington sees Ernst's work at 'International Surrealist Exhibition', Britain

Oppenheim's solo exhibition featuring a fur-covered tea cup creates a sensation, Basel, Switzerland

Ernst meets Carrington in London. He abandons his second wife. Carrington and Ernst move to France where they live and work together

FASHION

Levi Strauss manufactures the first jeans for women, United States. Lady Levi's are intended for women living on cattle ranches

Hoyningen-Huene moves to *Harper's Bazaar* in New York, United States. Horst P. Horst takes over as chief photographer at French *Vogue*.

Munkácsi works as a fashion photographer for *Harper's Bazaar*, United States. He develops the concept of fashion shoots on location

Elizabeth (Betty) Penrose (1906–1972), a former merchandising editor for US *Vogue*, is appointed editor of British *Vogue*

Agha questions whether Surrealism is 'a circus or a madhouse' in an article for US *Vogue*

Schiaparelli's designs become increasingly Surreal, featuring gloves with painted-on veins and a goldfish bracelet

Beaton photographs Wallis Simpson for *Vogue* as the abdication crisis unfolds, Britain

Beaton, writing for British *Vogue*, complains that 'Surrealism has swept the country like a plague', Britain. US *Vogue* publishes Agha's article 'The Hippocratic Oath of a Photographer', in which he lampoons Surrealist photographic conceits

WOMEN & SOCIETY

Germany introduces compulsory sterilization of men and women afflicted with mental and physical disabilities (including alcoholism). Approx. 400,000 Germans will be sterilized against their will

Unity Mitford meets Hitler

At a meeting of the National Socialist Women's Congress, Hitler argues that the granting of equal rights to women will place them in situations where they are naturally inferior

Launch of clandestine SS Lebensborn programme to increase the Aryan population of Germany

Women fight with Republican forces, Spain

Gertrud Scholtz-Klink is appointed head of the Woman's Bureau in the German Labour Front and now encourages women to join the workforce

Membership of the Bund Deutscher Mädel (BDM) becomes compulsory for girls aged 10–21, Germany

Diana Mitford marries Sir Oswald Mosley, leader of the British Union of Fascists, at the Berlin home of Joseph Goebbels, Germany. Hitler is guest of honour after the ceremony

Permissible grounds for divorce are extended to include desertion, cruelty and insanity (in addition to adultery), Britain

Women must complete a year's compulsory factory work, Germany

JOURNALISM

German newspapers are nationalized. Riefenstahl films the 1934 Nuremberg rally

Cartier-Bresson, Friedmann and Polish photographer David Szymin aka 'Chim' Seymour (1911–1956) work for the Alliance Photo agency founded by Maria Eisner (1909–1991), Paris, France

Munkácsi moves to the United States. Lorant moves to Britain. Gerta Pohorylle moves to Paris and changes her name to Gerda Taro. She meets Friedmann

Imperial Defence Committee plans to re-establish the Ministry of Information should Britain go to war but omits to provide for photography and film

Bill Brandt publishes *The English at Home*, Britain

Taro works for Alliance Photo as a picture editor, France. Friedmann teaches her photography. Dorothea Lange photographs drought and depression for Farm Security Administration, United States

Friedmann and Taro cover the Spanish Civil War, releasing their work under the name of Robert Capa, a fictitious American photographer

Friedmann (aka Capa) photographs *Death of a Loyalist Soldier*, supposedly the first war photograph to show the moment of death in combat

Riefenstahl films the Berlin Olympic Games, Germany

Scherman and Bourke-White join *Life* magazine, United States. Bourke-White's photograph of Fort Peck Dam appears on the cover of the magazine's first issue

The Times publishes George Steer's reports on the bombing of Guernica, Britain. The report inspires Picasso to create his artwork of the same name

WORLD EVENTS

January: German–Polish Non-Aggression Pact
May: Drought turns prairies into dustbowl, United States
June: First meeting of Hitler and Mussolini, Venice, Italy
July: Himmler, SS leader, becomes responsible for concentration camps, Germany
August: Death of Hindenburg. Hitler becomes head of state, taking the titles Reich Chancellor and Führer, Germany

February–March: Expansion of armed forces, Germany
Prontosil, the world's first antibacterial drug, launched, Germany
September: Nuremberg laws define German citizenship and ban relations with Jews
October: Italy invades Ethiopia

March: Germany reoccupies the Rhineland
May: Italy annexes Ethiopia. General Strike, France
July: Start of Spanish Civil War
August: Berlin Olympics, Germany
October: Axis agreement, Germany and Italy. Start of Stalin's purges, USSR
November: Anti-Comintern Pact, Germany and Japan
December: Abdication crisis, Britain

January: Stalin's purges continue, USSR
February: League of Nations bans foreign nationals from fighting in Spain

April: German Condor Legion bombs Guernica, Spain

LEE MILLER & ROLAND PENROSE

Miller returns to Egypt but continues her affair with Penrose. They exchange ideas on Surrealist projects. He paints *Night and Day*, his first major portrait of Miller

Miller and Penrose tour the Balkans. The trip inspires Penrose's book *The Road Is Wider than Long*. He files for divorce from Valentine

Penrose purchases Éluard's collection of modern art and opens the London Gallery to promote Surrealist art. He organizes a world tour of Picasso's *Guernica* to raise funds for the Spanish Republican cause.

Roland and Valentine Penrose divorce, Britain. He visits Miller in Egypt

June: Miller and Eloui Bey separate. Miller joins Penrose in London

Miller and Penrose pay final visit to Surrealist friends in France, returning to Britain as war is declared

Miller rejects official advice to return to the United States and offers her services as a photographer to British *Vogue*. From November, she works on a voluntary basis pending issue of a work permit

Penrose joins Industrial Camouflage Research Unit, London. He contributes to Royal Academy's 'United Artists' exhibition, but his 'unseemly' art generates controversy. He is excluded from future invitations

PHOTOGRAPHY & THE ARTS

Picasso creates *Guernica*, a vast painting highlighting the impact of war on civilians, for the Spanish Pavilion in the Universal Exposition, Paris. Maar photographs the work in progress. The painting focuses world attention on the Spanish Civil War

Picasso paints portraits of Miller, the Éluards and Maar at Mougins, France

5,000 'degenerate' works of art are seized from museums, Germany. An exhibition pillories Dada and Surrealism

Peggy Guggenheim (1898–1980), a wealthy American art collector, opens the Guggenheim-Jeune Gallery in Cork Street, London to exhibit avant-garde art

Eduard Mesens, director of the London Gallery, launches the *London Bulletin*, one of the few Surrealist magazines to be published in English

Breton accuses Dalí of excessive commercialism, France. Leonor Fini curates exhibition of Surrealist furniture

London Gallery publishes *The Road Is Wider than Long* by Penrose, Britain

Clark supervises evacuation of the National Gallery's art collection to Wales, Britain.

Burning of 'degenerate' art, Berlin, Germany

The London Gallery and many other cultural institutions close for the duration of the war, Britain. Cinemas and theatres close briefly but soon reopen

Ministry of Information establishes War Artists Advisory Committee. It commissions artists to cover British forces and the Home Front but refuses to engage with the Surrealist movement

FASHION

Fidelin becomes the first coloured model to appear on the cover of a major fashion magazine when *Harper's Bazaar* publishes Man Ray's photograph of her

Schiaparelli collaborates with Cocteau and Dalí on Surrealist fashion designs. Some are worn by Wallis Simpson (later Duchess of Windsor), France

An anti-Semitic cartoon by Beaton causes outrage when it appears in US *Vogue*. Beaton is dismissed from *Vogue* and forced to issue a public apology

British *Vogue* publishes a major feature on the 'Exposition Internationale du Surréalisme' in Paris

Agha champions women photographers in an article for US *Vogue*

Beaton's career revives when he is invited to photograph Queen Elizabeth at Buckingham Palace shortly before the outbreak of war

Condé Nast launches *Glamour of Hollywood* magazine, United States

British and US *Vogue* feature Schiaparelli's Smoking Glove and Birdcage Hat designs

French and British editions of *Vogue* begin war coverage. Their readers are advised to maintain peacetime standards of dress (for the sake of morale and the fashion industry) and volunteer for war work

Withers becomes a part-time volunteer driver in the Auxiliary Fire Service

Introduction of nylon stockings, United States

WOMEN & SOCIETY

Ilse Koch (1906–1967) moves to Buchenwald concentration camp when her husband is appointed commandant. She subsequently becomes known as the Bitch of Buchenwald

Amelia Earhart goes missing during a flight over the Pacific Ocean

Auxiliary Territorial Service (ATS) and the Women's Voluntary Service for Civil Defence (WVS) formed, Britain

Edith Summerskill (1901–1980) establishes Married Women's Association to promote equality in marriage, Britain

Second women's concentration camp (at Lichtenburg, Germany) includes a training facility for female guards

Women's Land Army (WLA) and Women's Royal Naval Service (WRNS) are re-established

Women's Auxiliary Air Force (WAAF) established, Britain

Himmler orders SS and Gestapo men to father as many children as possible, to replace potential war casualties, Germany

Unity Mitford attempts suicide as war is declared, Munich, Germany. She survives. Hitler facilitates her return to Britain in January 1940

Introduction of air raid precautions, identity cards and petrol rationing, Britain

British families separate as men are called up for military service and children are evacuated to the countryside. The WVS plays a key role in the evacuation

British women's auxiliary services begin war work, undertaking a limited range of roles, including clerical work and driving duties. Recruitment remains voluntary

Germany introduces food and clothes rationing

JOURNALISM

Taro is killed while covering the Battle of Brunete, Spain. She is the first woman photographer to die while covering war

Capa, Cartier-Bresson and Seymour work as staff photographers for *Ce Soir* newspaper, France. Cartier-Bresson directs *Victoire de la vie*, a documentary film about the hospitals of Republican Spain

Lorant and Edward Hulton launch *Picture Post* magazine, Britain

Capa covers Sino-Japanese War before returning to Spain. Bourke-White photographs Czechoslovakia, following the German annexation of the Sudetenland

Cartier-Bresson directs *L'Espagne vivra*, his second documentary film about the Spanish Civil War

Ministry of Information planning is belatedly extended to include exploitation of film and photography, Britain

Circulation of *Picture Post* reaches 1.7 million, Britain

Capa returns to France after photographing fall of Barcelona. As war approaches, he moves to the United States. His negatives travel via a convoluted route to Mexico where they are discovered in the 1990s

Clare Hollingworth, *Daily Telegraph* journalist, breaks story of German invasion of Poland. Riefenstahl films the invasion

Cartier-Bresson joins French Army as an official photographer. British armed forces revive official service photography along First World War lines

WORLD EVENTS

May: Hindenburg disaster, United States Coronation of King George VI and Queen Elizabeth, Britain
July: Start of Sino-Japanese War

February: Hitler takes direct control of German armed forces. Gas masks and air-raid shelters are issued to the civilian population, Britain
March: Germany unites with Austria (*Anschluss*)
September: Munich Agreement forces Czechs to cede Sudetenland to Germany, temporarily averting war
October: International Brigades of foreign volunteers withdraw from combat in Spain
November: Kristallnacht, Germany

February: Hungary joins Anti-Comintern Pact. Public distribution of Anderson air-raid shelters begins, Britain
March: Germany occupies Czechoslovakia. Britain guarantees Polish independence
April: Spanish Civil War ends. General Franco takes power. Britain introduces compulsory military training for men aged 20–21
May: Germany and Italy sign Pact of Steel
August: German-Soviet Non-Aggression Pact. Britain is placed on a war footing

September: Germany invades Poland. Britain and France declare war. Phoney War begins

British Expeditionary Force lands in France. United States declares its neutrality. USSR invades eastern Poland. Romanian Prime Minister assassinated by nationalists
October: Deportation of Jews from Austria and Czechoslovakia begins
November: Winter War begins following USSR invasion of Finland
December: Battle of the River Plate, South Atlantic

LEE MILLER & ROLAND PENROSE

PHOTOGRAPHY & THE ARTS

FASHION

Breton and Éluard rejoin French Army. Ernst is interned briefly as an enemy alien, France. Éluard and Penrose secure his release. Carrington flees to Spain where she suffers a nervous breakdown. She later makes her way to Argentina

Peggy Guggenheim builds a collection of Surrealist art with a view to establishing a museum, France

Surrealist movement disintegrates as German forces advance into western Europe. Picasso, Maar, Fini, the Éluards, Fidelin and Cocteau remain in France

January: Miller joins staff of British *Vogue* on a weekly salary of £8. She photographs fashion, lifestyle and celebrities

Withers replaces Betty Penrose as editor of British *Vogue* and joins the board of Condé Nast. Staff work at home or in the office basement to produce the magazine during the Blitz. British *Vogue* becomes a monthly, subscription-based magazine, following the introduction of paper rationing. This initially restricts newspapers and magazines to 60 per cent of pre-war usage. *Vogue* begs subscribers to share their copies

February: Condé Nast refuses to appoint Miller as head of studio on grounds of technique, but believes she shows promise and advises patience
June: Penrose contributes to 'Surrealism Today' exhibition
July: Miller evacuates British children to Poughkeepsie, NY, United States
October: Miller appears in *Picture Post*'s feature 'The Taking of a Fashion Photograph'
September–December: Miller photographs London Blitz in her spare time. Participates in BBC Thanksgiving Day radio broadcast to the United States

Others, including Man Ray, Dalí, Tanguy and Ernst, move to the United States. Man Ray settles in Los Angeles and meets Juliet Browner, a dancer and artist's model

London Bulletin ceases publication. Zwemmer Gallery mounts 'Surrealism Today' exhibition, London

Vogue reemploys Beaton following positive public reaction to his photographs of the Queen and the Blitz. Beaton works simultaneously for *Vogue* and the Ministry of Information throughout the war. His ministry work creates opportunities for Miller. But overlapping assignments and professional rivalry cause strained relations between the two

Valentine Penrose, unable to return to occupied France, comes to live with Miller and Penrose. Roland Penrose becomes an air-raid warden and War Office camouflage instructor, working with the Home Guard at Osterley Park, Middlesex. Some paintings from his collection are destroyed during the Blitz

Clark and others establish Council for the Encouragement of Music and the Arts (CEMA), a forerunner of the Arts Council, Britain. The council channels government arts funding, helps form government cultural policy and plays a crucial role in developing propaganda and education through the arts. Early activities include financial support for lunchtime concerts by Myra Hess and others at the National Gallery

French *Vogue* ceases publication following German occupation of France

Elsa Schiaparelli moves to the United States. Coco Chanel closes her Paris couture house. Others continue to work. Lucien LeLong, President of Chambre Syndicale de la Couture, persuades Germans not to relocate French couture industry to Berlin

War Artists Advisory Committee establishes permanent wartime exhibition at the National Gallery

YMCA revives 'Snapshots from Home' League

Chase reverts to policy of promoting US fashion and defends US *Vogue* against accusations of frivolity, United States. Chase's failure to understand wartime conditions in Britain causes problems at British *Vogue*

Miller continues to photograph fashion for British *Vogue*. She contributes to Ernestine Carter's book *Grim Glory: Pictures of Britain under Fire*

Beaton publishes *History under Fire* with James Pope-Hennessy, a survey of the impact of the Blitz on London's historic buildings, Britain. Henry Moore sketches Londoners sheltering in Underground stations during the Blitz

Wartime shortages force changes in British *Vogue*'s editorial policy.

WOMEN & SOCIETY

German forces begin to abduct children who match the Aryan criteria from occupied territories. Approximately 250,000 will be abducted in total

Introduction of food rationing and recycling campaigns, Britain. Many women take up knitting

WVS supports troops, civilians and emergency workers throughout the year and particularly during the Blitz, Britain. Women undertake additional voluntary work as firewatchers, rescue workers and first aiders

More than 25 per cent of ATS recruits resign, disillusioned by conditions. British military nurses are evacuated with British troops from France

800,000 French women, whose husbands become German prisoners of war, face poverty following the fall of France. 10 per cent turn to prostitution to support their families. 20 per cent of French food production is diverted to Germany and a new rationing system introduced. Unequal distribution leads to shortages and a black market economy

German and Austrian women live well, supported by labour and resources from the occupied territories. Few volunteer for war work

Diana Mosley and her husband are arrested and imprisoned without charge, Britain

Britain introduces conscription for women aged 19–31 (December). Married women and women caring for children under fourteen are exempt

JOURNALISM

British Ministry of Information performs poorly due to inexperience and political in-fighting. Clark appointed Director of MoI Film Division. Hugh Francis appointed Director of MoI Photographs Division. Press censorship and war pool arrangements introduced. Control of Photography Order places restrictions on photographers

Thérèse Bonney photographs the war in Finland. Her photographs are published and exhibited in the United States

Clark becomes Controller of MoI Home Publicity Division. He instigates policy of propaganda through cultural activities and encourages civilian photographers to document the Blitz. He facilitates Beaton's appointment as a Ministry of Information official photographer

Bill Brandt photographs London air-raid shelters for Ministry of Information. Beaton and others photograph damage to London's historic buildings. Ed Murrow of CBS becomes famous in the United States for his radio reports on the Blitz

British armed forces recruit some of Fleet Street's best press photographers. But official military photography remains under-resourced. Its coverage of the war is poor

German Ministry of Propaganda gains an early advantage in the war for US public opinion with a plentiful supply of dramatic images. US press publishes four German official photographs to every British one. *Signal* magazine launched as German propaganda vehicle

900 British newspapers and magazines cease publication following the introduction of paper rationing

Cartier-Bresson is captured and becomes a prisoner of war, Vosges, France

Brendan Bracken is appointed Minister of Information and gradually improves MoI performance, Britain

WORLD EVENTS

February: Germany begins unrestricted submarine warfare
March: Winter War ends, Finland
April–May: Germany invades Norway, Denmark, Holland, Belgium, Luxembourg and France
May: Winston Churchill becomes Prime Minister. British forces are evacuated from France
June: Italy declares war on Britain and France. France falls and is partitioned between Germany, Italy and Vichy Regime
July–September: Battle of Britain
September: Germany, Italy and Japan sign (Axis) Tripartite Pact
September–December: The Blitz, Britain
November: F. D. Roosevelt re-elected as President, United States. Hungary and Romania sign Tripartite Pact
December: Joseph Kennedy, American Ambassador to Britain, resigns after claiming democracy is finished in Britain

February: German campaigns in North Africa and the Atlantic intensify
March: US introduces Lend-Lease scheme
April: German occupation of Greece and Yugoslavia

LEE MILLER & ROLAND PENROSE

June–September: Miller is investigated by British military intelligence, who suspect her of being a communist spy. No evidence is found

July: Miller begins to produce photoessays for British *Vogue*, starting with a feature on wartime life in Oxford

September–October: Miller photographs Wrens for 'WRNS on the Job', her first major photoessay on women in uniform. She publishes 'I worked with Man Ray' (*Lilliput* magazine), her first written article. Penrose publishes *Home Guard Manual of Camouflage*

December: Miller meets Scherman

February: Scherman comes to live with Miller and Penrose. He tutors Miller in photojournalism

March–July: Miller's fashion photography becomes more experimental as she grapples with increasingly austere designs. Condé Nast congratulates her on the improvement in her photography shortly before his death

Miller, mentored by Scherman, produces photoessays on the Air Transport Auxiliary (ATA), ATS and women factory workers for British *Vogue* features in support of female conscription. She is frustrated when text and layouts fail to do justice to her work

Miller photographs Bourke-White and Bonney

Miller, Scherman and Penrose collaborate to photograph *Lee Miller in Camouflage*, Highgate, London

December: Miller is accredited to the US armed forces as an official war correspondent for Condé Nast

PHOTOGRAPHY & THE ARTS

MoI War Artists Advisory Committee opens 'Britain at War' touring exhibition, featuring work by thirty artists in New York, United States

Breton and Ernst escape from France to the United States with the help of the Emergency Rescue Committee. Guggenheim also escapes and marries Ernst

André Kertész (1894–1985), Hungarian-born photographer, is designated an enemy alien and banned from working as a photographer in the United States

'Degenerate' artworks by Picasso, Dalí, Ernst, Klee, Léger and Miró are burnt in Paris, France. MoI War Artists Advisory Committee suffers loss of 111 paintings when the ship taking them to Rio de Janeiro is sunk

Breton issues the third Surrealist manifesto and launches *VVV*, a new Surrealist periodical, United States. An international Surrealist exhibition is held in New York. Ernst meets Dorothea Tanning, American artist, in New York

The Éluards work for the French Resistance and spend much time in hiding, France. Paul Éluard publishes a series of poetical works, including 'Poésie et vérité' and 'Liberté', which they circulate clandestinely to strengthen morale among Resistance fighters. Copies of 'Liberté' are dropped in pamphlet form over French cities by the RAF

Authors writing non-official books face two-year publication delays owing to wartime paper shortage, Britain

FASHION

Withers begins to work closely with the reformed MoI, devising features which support government campaigns and help women cope with wartime life. *Vogue*'s pattern house is destroyed in the London Blitz

British fashion industry adapts to clothes rationing and Utility clothing. Designers assist with redesign of uniforms for the women's services. Arnold Lever of Jacqmar begins to produce patriotic textile designs for scarves. Cyclax of London releases Stockingless Cream for legs

LeLong secures a controversial exemption from textile rationing for major Parisian fashion houses in an agreement which some view as collaboration. Women in Paris begin to use fashion as a resistance statement. Coco Chanel forms relationship with a German officer, France

Condé Nast suffers heart attack, United States

US *Vogue* commences war coverage. Nast dies. His possessions are sold to meet debts incurred during the Great Depression. Iva Patcevitch becomes president of Condé Nast publications

Eleanor Rathbone MP and James Griffiths MP demand that the Minister of Production force British *Vogue* to cease publication on the grounds of its frivolous and 'useless' content. The minister refuses. Withers commissions more features in support of MoI campaigns and female conscription

Max Factor supplies camouflage face cream to the US Marines. 60,000 US troops are equipped with Helena Rubenstein's camouflage cream, cleanser and sunscreen during the landings in North Africa

Christian Dior (1905–1957), French fashion designer, joins LeLong's fashion house, Paris, France

WOMEN & SOCIETY

4.25 million people are displaced by war in Europe. UNRAA work to support displaced people in occupied Germany

Allied forces evict many German women from their homes. Thousands are raped by Red Army soldiers

Allied forces impose military government on Germany and Austria

German civilians are forced to visit concentration camps. Camp guards, including women, are forced to bury the dead, before being prosecuted for war crimes. Allied military and civilian nurses work to relieve suffering in the camps. 913 of 8,703 Jewish women deported from France remain alive

Some German leaders, including Hitler and Goebbels, commit suicide with their wives and children. Others are taken prisoner. Gertrud Scholtz-Klink is detained by the Red Army but escapes and goes into hiding, Germany

The Allied armed forces begin demobilization after VE Day. The process will take eighteen months. The vast numbers of military and civilian personnel trying to return home and resume their lives, or trace those that have disappeared, cause stress, confusion and depression

Shortages increase throughout Europe. In Britain, the post-war age of austerity begins. An initial US ban on aid for German civilians is rescinded in December

Women vote in France for the first time. Family allowance payments introduced for mothers, Britain

The introduction of bread rationing (a consequence of the failure of the wheat harvest) leads to protests in Britain

Belgium, Italy, Romania and Yugoslavia grant women the vote. Women vote for the first time in Japan

JOURNALISM

Allied military photographers and civilian photojournalists photograph scenes inside German concentration camps. George Rodger decides to give up war photography after spending a day at Belsen on behalf of *Life* magazine

Martha Gellhorn and other correspondents report from German concentration camps. Bourke-White photographs Buchenwald and US forces in Germany. Bonney works for the French Red Cross. Frissell photographs African-American fighter pilots as well as the US women's services. Dickey Chapelle photographs battles of Iwo Jima and Okinawa for *National Geographic*. Riefenstahl is evicted from her home, arrested and imprisoned

Hoffmann is arrested and imprisoned as a Nazi propagandist. His photographs are confiscated by the United States

Joe Rosenthal photographs the raising of the US flag on Iwo Jima. Yvgeny Khaldei photographs the placing of the Soviet flag on the Reichstag in Berlin, Germany. Both photographs achieve iconic status but trigger debates about the authenticity of the moment

War correspondents leave the European theatre for home or move to the Far East

Beaton publishes *Far East* and a series of other books based on his 1944 MoI assignment

Bourke-White moves to India to document independence

BBC relaunches its television service, Britain. A news service follows in 1948

Eve Arnold (1912–2012) begins working as a photographer, New York, United States

WORLD EVENTS

January: Battle of Strasbourg, France. Red Army besieges Budapest, Hungary and liberates Auschwitz
February: Yalta conference. Allies bomb Dresden. French forces enter Colmar. US victory at Iwo Jima
March: Allied Crossing of the Rhine. US forces enter Cologne and Frankfurt, Germany Red Army enters Austria

April: Red Army launches Vienna offensive and enters Berlin. US and British forces liberate Buchenwald, Dachau and Bergen-Belsen concentration camps. Red Army and US forces meet at the River Elbe. War ends in Italy. Hitler commits suicide, Germany. Provisional government established, Austria
May: Germany surrenders. War in Europe ends

June: Germany and Austria are divided into zones of occupation. Britain begins to demobilize. United Nations Charter signed, United States
July: Potsdam Conference. Clement Attlee replaces Churchill as British Prime Minister
August: US drops atomic bombs on Japan, ending war in Far East
September: US terminates Lend-Lease arrangements with Britain

January: Austria is divided into Allied zones of occupation. First meeting of the United Nations, London
February: Hungary becomes a republic
March: Churchill draws attention to the division of Europe in his 'Iron Curtain' speech, United States
July: First US nuclear test, Bikini Atoll
September: Violence breaks out, India
December: First Indochina War begins. President Truman proclaims official end to Second World War hostilities in the United States

LEE MILLER & ROLAND PENROSE

PHOTOGRAPHY & THE ARTS

FASHION

First appearance of Abstract Expressionism in American art

Miller photographs James Joyce's Dublin for British *Vogue*

The Arts Council (formerly CEMA) commences work, Britain

ICA established by Penrose and Herbert Read, London, Britain. Work begins on '40 Years of Modern Art', the ICA's first exhibition

Christian Dior's 'New Look' signals a controversial end to wartime austerity in fashion and enables Paris to resume its pre-eminence in the international fashion industry. The exaggeratedly feminine silhouette, with a deliberately extravagant use of material, suggests a rejection of wartime austerity and return to traditional feminine values

Penrose and Miller marry in London following her divorce from Eloui Bey. Their son Antony is born

Miller and Penrose buy Farley Farm in Sussex. She struggles to adjust to life in the country

Opening of the ICA's second major exhibition, '40,000 Years of Modern Art', London, Britain (curated by Penrose)

Clothes rationing ends, Britain

Miller publishes 'Bachelor Entertaining', her first major feature on hospitality and cuisine for British *Vogue*, but struggles to find inspiration as a staff photographer at the magazine

Miller photographs fashion at Farley Farm for British *Vogue*

Ernst, Tanning and Picasso visit England

Picasso's hopes to attend a Communist Party peace conference are disappointed, but he visits Miller and Penrose at Farley Farm

Concept of ready-to-wear and teenage fashion, making heavy use of new, man-made fabrics, begins to emerge in Britain, France and the United States

Penrose stops producing art to concentrate on running ICA

Eve Arnold photographs fashion in Harlem, New York, United States

Miller reviews Picasso exhibition for British *Vogue*

The London Gallery closes, having made a financial loss

Man Ray returns to France with his wife Juliet and settles in Paris

Festival of Britain signals an end to the age of austerity, Britain

Chase retires from US *Vogue*. She is succeeded by Jessica Davies

Miller struggles with alcoholism and depression. Her relationship with Penrose suffers. Her last major feature, 'Working Guests', is published by British *Vogue*

Ernst returns to France with his wife Dorothea Tanning

Picasso separates from Françoise Gilot and forms new partnership with Jacqueline Roque, France

Beaton photographs the Queen for her official coronation portrait in a dress designed by Norman Hartnell, one of Britain's small group of established designers.

British *Vogue* produces coronation edition

WOMEN & SOCIETY

Divorce applications soar as men and women fail to re-establish relationships after the war

Ilse Koch stands trial for war crimes at Dachau. She is found to be pregnant, possibly by an American guard. Koch is sentenced to life imprisonment. Her child is removed at birth. Diana Mosley's passport is returned to her. She remains a lifelong supporter of fascism

UNRAA winds down relief operations in Germany

Repeal of National Service Act ends conscription of women

Simone de Beauvoir (1908–1986) publishes *The Second Sex*, a classic text of the feminist movement, France

ATS becomes Women's Royal Army Corps. WAAF becomes Women's Royal Air Force, Britain

Soap rationing ends, Britain

Women's Land Army disbands, Britain

India grants women the vote

Greece grants women the vote

Bread rationing reintroduced, Czechoslovakia

Gertrud Scholtz-Klink is released from prison but continues to be a life-long promoter of Nazi ideology

Britain introduces equal pay for women teachers

Vijaya Lakshmi Nehru Pandit becomes the first woman president of the United Nations General Assembly

JOURNALISM

Capa, Rodger, Cartier-Bresson and Seymour establish Magnum Photos New York, United States

Ministry of Information reconstituted as Central Office of Information, Britain. It transfers its wartime photographs and film to the Imperial War Museum

Paper rationing ends, Britain

Royal Commission on the Press criticizes newspaper owners for 'overly simplistic' reporting and proposes the establishment of a press council to govern press behaviour, Britain

British press celebrates end of paper rationing

Korean War covered by official and press photographers, including David Douglas Duncan, Carl Mydans, Bourke-White and Bert Hardy

Picture Post magazine suffers declining sales, eventually closing in 1957, Britain

Eve Arnold becomes first woman photographer to join Magnum

BBC Television coverage of the coronation marks a turning point for journalism, Britain

Scherman returns to *Life* magazine as a picture editor, United States

Bourke-White develops Parkinson's disease. Frissell joins *Sports Illustrated* with a small group of female sports photographers, United States

WORLD EVENTS

Start of Cold War

January–March: Nationalization of coal industry leads to fuel crisis during harsh winter, Britain
June: Drafting of the Marshall Plan, an American financial programme to aid recovery in Europe

April: Formation of North Atlantic Treaty Organization (NATO)
May: End of Berlin blockade and airlift
August: USSR detonates first atomic bomb
October: German Democratic Republic and People's Republic of China established

January: Republic of India established
June: Korean War begins

April: Battle of Imjin River, Korea
June: Guy Burgess and Donald Maclean, British communist spies, defect to the USSR
October: Churchill becomes Prime Minister, Britain

March: Death of Stalin, USSR
June: East German uprising put down by USSR forces
July: Korean War ends
August: USSR tests hydrogen bomb

1946

1947

1949

1950

1951

1953

LEE MILLER & ROLAND PENROSE

PHOTOGRAPHY & THE ARTS

FASHION

1953

1954

1958

1960

1961

1965

1966

Penrose is appointed to the British Council's Fine Arts Committee. He meets Diane Deriaz, a French trapeze artist, and considers divorce from Miller. Deriaz dissuades him

Miller leaves British *Vogue*. She travels to the United States where she supports her father following the death of her mother. Miller continues to struggle with alcoholism and depression but comes to a rapprochement with Penrose

Penrose begins work on a biography of Picasso

The Houses of Parliament commission Graham Sutherland, a leading modernist artist and former member of the MoI War Artists Scheme, to paint a portrait of Churchill to mark his eightieth birthday, Britain. Churchill dislikes the painting, which is subsequently destroyed by his wife

Chanel reopens her fashion house. Schiaparelli closes her fashion house after failing to adapt to changing tastes, Paris, France

Miller photographs Picasso for Penrose's biography, Cannes, France

Penrose publishes *Picasso: His Life and Work*

Emergence of Pop Art movement in Britain and the United States

Beaton wins an Academy award for his costume designs for the film *Gigi*, United States

Mary Quant, a young British designer, rises to prominence with her designs for young people, who now have unprecedented disposable income

Miller's last article, 'Picasso Himself', appears in a souvenir brochure. She begins to explore Surrealist cuisine. After completing a cordon bleu course, she travels widely, collecting cookery books, recipes and equipment from around the world

Withers retires from British *Vogue*, sensing that tastes in fashion are changing

Betty Jerman, a journalist for *The Guardian*, writes 'Squeezed in Like Sardines in Suburbia', an article about the boredom and social isolation faced by British housewives

Penrose curates an exhibition of Ernst's work, Tate Gallery, Britain

Henry Flynt, an American artist and nihilist, coins the term 'Concept Art'. He begins to experiment with conceptual art as a means of opposing the art establishment and superseding the avant-garde

Ailsa Garland appointed editor-in-chief of British *Vogue*

Jackie Kennedy becomes a fashion icon, United States

British *Vogue* publishes 'Lee and Roland Penrose: A Second Fame', a feature on Miller's cookery. Beaton takes the photographs

Miller wins her first cookery-competition prize, a trip to Norway

Beaton wins two Academy awards for his designs for the film *My Fair Lady*, United States

London replaces Paris as the leader of international fashion

The mini-skirt, promoted by Quant, becomes the defining fashion of the early 1960s, Britain. Quant's designs inform fashion in the United States. Jeans and other clothes made of denim become popular among the young

Penrose is knighted for services to art

Death of Breton ends Surrealism as an organized movement. Its ideas continue to inform others

British *Vogue* marks its golden jubilee

WOMEN & SOCIETY

Alfred Kinsey (1894–1956), American sex therapist, publishes *Sexual Behaviour in the Human Female*, one of two controversial but influential reports on sexuality

Food rationing ends, Britain

Women allowed to take their seats in the House of Lords, Britain

Maureen Nichol establishes National Housewives' Register (later renamed the National Women's Register) to address the concerns described in Jerman's article (see 'Fashion', opposite)

Introduction of the contraceptive pill, Britain. Its use is initially restricted to married women

Margaret Sanger wins legal campaign to legalize contraception for married couples, United States

International Women's Day is declared a national holiday in the USSR in acknowledgment of Russian women's contribution during the Second World War

WVS is renamed the Royal Women's Voluntary Service, Britain

Death of Margaret Sanger, United States

JOURNALISM

Capa is killed while photographing war in Indochina. Jean Peraud, a French photographer, is also killed

Rodger covers the Mau Mau uprising (despite vowing to give up war photography)

Today, BBC radio's flagship morning news programme, begins broadcasting, Britain

Don McCullin starts work as a freelance press photographer, Britain

Peter Leibing, an official photographer for West Berlin authorities, takes iconic photograph of GDR policeman Conrad Schumann leaping to freedom over barbed wire

The first of 267 women journalists are accredited to the US Army in Vietnam. Photographer Dickey Chapelle is killed while on patrol with the US Marines. Her death is photographed by Henri Huet, a photojournalist who would also die in Vietnam

McCullin undertakes his first assignment in Vietnam for the *Illustrated London News*. US Army combat photographers start work in Vietnam

McCullin starts work for the *Sunday Times Magazine*, Britain. *The Times* begins to publish news on its front page

WORLD EVENTS

January: Launch of USS *Nautilus*, the world's first nuclear powered submarine, United States
August: End of First Indochina War. Vietnam, Cambodia and Laos achieve independence from France
November: French-Algerian War begins

February: First meeting of Campaign for Nuclear Disarmament (CND), Britain
March: Nikita Khrushchev becomes premier of the USSR
April: First Aldermaston march, opposing nuclear weapons, Britain

July: Communist insurgents defeated in Malaya
February: France tests first atomic bomb
August: Cyprus granted independence
November: John F. Kennedy elected President, United States

April: Bay of Pigs: US invasion, Cuba. First manned space flight, USSR
August: Construction of Berlin Wall, Germany

January: Funeral of Sir Winston Churchill, Britain
March: US military build up and bombing campaign, Vietnam. Civil rights protests, United States
August: SS guards are tried for war crimes at Auschwitz, Germany. Indo-Pakistan War

International protests against United States intervention in Vietnam

May: Cultural Revolution begins China
June: France leaves NATO

LEE MILLER & ROLAND PENROSE

Miller becomes Lady Penrose. She undergoes a facelift and is interviewed by Shirley Conran for the article 'Cook Hostess in Action'

British *Vogue* pays tribute to Miller's war photography

Miller's cookery features in *House & Garden* magazine and US *Vogue*

Miller acquires one of Britain's first microwave ovens and a deep freezer. She experiments with an electric crock pot and develops a new interest in classical music

Miller represents Man Ray at Arles Photography Festival, France. Her work is exhibited at the Art Institute of Chicago, United States. Miller is diagnosed with terminal cancer

Penrose resigns, disillusioned, from the ICA

Death of Lee Miller, Farley Farm, Sussex, Britain

PHOTOGRAPHY & THE ARTS

Bill Brandt publishes *Shadow of Light*, a compilation of his best work

ICA moves to its present location at Carlton House Terrace on the Mall, London

Death of Pablo Picasso, France

Death of Edward Steichen, United States

Beaton collaborates with curator Gail Buckland on *The Magic Image*, a history of photography

Steven Sasson of Kodak designs and builds the first digital camera, United States

Death of Max Ernst, France

Death of Man Ray, France

Susan Sontag publishes *On Photography*

FASHION

Lesley Hornby, aka Twiggy, rises to prominence as a British fashion model and is voted British Woman of the Year. Her androgynous blonde looks are reminiscent of a young Miller

Twiggy becomes an international fashion icon, heavily photographed by Beaton, Norman Parkinson, David Bailey and other leading fashion photographers. Her picture appears on the cover of every international edition of *Vogue*

Fashion designers respond to rising economic and environmental concerns by seeking inspiration from traditional ethnic values

Twiggy pursues an acting career. Quant concentrates on designing for the home and cosmetics

Designer jeans are worn by men and women throughout Europe and the United States

Women's fashions featured in *Vogue* include maxi skirts and flared trousers

WOMEN & SOCIETY

Indira Ghandi, niece of Vijaya Lakshmi Nehru Pandit, becomes Prime Minister of India

Non-married women are now entitled to use the contraceptive pill, Britain. Abortion is legal for women up to twenty-four weeks pregnant. Homosexuality is legal

Women workers at the Ford motor plant in Dagenham strike for equal pay, Britain. Barbara Castle becomes First Secretary of State

Rape Crisis network established to raise awareness of sexual violence, Britain

Women granted legal right to abortion, United States

Virago Press, a publishing house for women's literature established, Britain

United Nations International Women's Year

Margaret Thatcher becomes the first woman leader of a political party, Britain

Sex Discrimination Act, enshrining the principle of equality of opportunity for men and women, and statutory maternity pay introduced, Britain

Mairéad Corrigan and Betty Williams of the Northern Ireland Women for Peace movement are awarded the Nobel Peace Prize

Women are admitted to the US Naval Academy

Abolition of women's branches of the US Navy. Women are fully integrated into the service

JOURNALISM

Cartier-Bresson leaves photojournalism and withdraws from active involvement in Magnum in order to focus on art, France

Nine journalists are killed in Vietnam. Eddie Adams (Associated Press) photographs Brig. Gen. Nguyen Ngoc Loan as he executes a Viet Cong prisoner in the street, Saigon, Vietnam

McCullin photographs US marines during Battle for Hue, Vietnam. Ron Haeberle, US Army photographer, documents My Lai massacre

Scherman publishes *The Best of Life* following the magazine's discontinuation as a weekly publication

Nicholas Tomalin, British journalist, is killed on the Golan Heights by Israeli tank fire while covering the Yom Kippur War

Stanley Forman photographs Diana Bryant and her young goddaughter as they fall from a collapsing fire escape in Boston, United States. Bryant is killed. The subsequent publication of the photographs gives rise to widespread debate about media ethics

James Nachtwey starts work as a press photographer in New Mexico, United States

Eddie Adams wins the Robert Capa Gold Medal for photojournalism, United States

WORLD EVENTS

July: England wins the World Cup
October: Aberfan disaster, Wales

January: Tet Offensive, Vietnam. Khmer Rouge formed, Cambodia
April: Martin Luther King assassinated, United States. Prague Spring, Czechoslovakia
May: Student protests in Paris, France

January: Britain joins European Community
March: US forces leave Vietnam
October: Yom Kippur War. Arab countries restrict oil supplies to the West

South Vietnam falls under communist control

Khmer Rouge commits genocide in Cambodia

Massacre of Palestinians, Beirut, Lebanon

Soweto uprising begins, South Africa

Jimmy Carter becomes US President

Death of Mao, China

Silver Jubilee of Queen Elizabeth II, Britain

FURTHER READING

Norberto Angeletti *et al.*, *In Vogue: An Illustrated History of the World's Most Famous Fashion Magazine*, 2nd edn, New York, 2012

Carolyn Burke, *Lee Miller: On Both Sides of the Camera*, London, 2005

Richard Calvocoressi, *Lee Miller: Portraits from a Life*, London, 2002

Becky E. Conekin, *Lee Miller in Fashion*, London/New York, 2013

Hanna Diamond, *Women and the Second World War in France, 1939–1948: Choices and Constraints*, Harlow, 1999

Carol Harris, *Women at War 1939–1945: The Home Front*, Stroud, 2000

Mark Haworth-Booth, *The Art of Lee Miller*, London, 2007

Nathalie Herschdorfer, *Coming into Fashion: A Century of Photography at Condé Nast*, London, 2012

Margaret R. Higonnet *et al.* (eds), *Behind the Lines: Gender and the Two World Wars*, New Haven, Conn./London, 1987

Virginia Nicholson, *Millions Like Us: Women's Lives in the Second World War*, London, 2011

Antony Penrose, *Lives of Lee Miller*, London, 1985

Antony Penrose (ed.), *Lee Miller's War*, London, 2005

Roland Penrose, *Scrap Book 1900–1981*, London, 1981

Roland Penrose, *Man Ray*, London, 1989

Phillip Prodger, *Man Ray/Lee Miller: Partners in Surrealism*, London/New York, 2011

Michael Remy, *Surrealism in Britain*, Aldershot, 1999

Dorothy Sheridan (ed.), *Wartime Women: A Mass-Observation Anthology of Women's Writing, 1937–1945*, London, 2002

Katherine Slusher, *Lee Miller, Roland Penrose: The Green Memories of Desire*, Munich/London, 2007

Jill Stephenson, *Women in Nazi Germany*, Abingdon/New York, 2013

Penny Summerfield, *Reconstructing Women's Wartime Lives: Discourse and Subjectivity in Oral Histories of the Second World War*, Manchester, 1998

Audrey Withers, *Lifespan: An Autobiography*, London, 1994

PICTURE AND TEXT CREDITS

Illustrations

Frontispiece: © Succession Picasso/DACS, London 2015; page 27: © Frederick A. Smith, Gallup Studio, Poughkeepsie, NY, USA; page 28: *Vogue* © The Condé Nast Publications Ltd; pages 30 and 32: © Man Ray Trust/ADAGP, Paris and DACS, London 2015; page 34: *Vogue* © George Hoyningen-Huene/*Vogue* Paris; page 35: *Vogue* © The Condé Nast Publications Ltd; pages 47 and 56: © Roland Penrose Estate, England 2015. All Rights Reserved. www.rolandpenrose.co.uk; page 71: © Unknown; page 179: © Succession Picasso/DACS, London 2015; pages 180, 181, 183 and 184: © Roland Penrose Estate, England 2015. All Rights Reserved. www.rolandpenrose.co.uk; page 224: *Vogue* © The Condé Nast Publications Ltd

Quotations

Page 10, 'She was an absolute natural writer …': David E. Scherman © Courtesy Lee Miller Archives, England 2015; page 18, 'a few thousand ultra-fastidious women …': *Vogue* © The Condé Nast Publications Ltd; page 18, 'I am very well aware …': © Peter Owen Publishers and Audrey Withers; page 19, 'Women's magazines had a special place …': © Peter Owen Publishers and Audrey Withers; page 19, 'And women's first duty …': *Vogue* © The Condé Nast Publications Ltd; pages 19–20, '[The photographer] was king …': © Peter Owen Publishers and Audrey Withers; page 20, 'a barrage of hardships …' and 'Rage against all things German …': © Virginia Nicholson, 2011. Reproduced by permission of Penguin Books Ltd (English language)/© Virginia Nicholson, *Millions Like Us*, Viking 2011 (all other languages); page 21, 'Paper was strictly rationed …': © Peter Owen Publishers and Audrey Withers; pages 21 and 165, 'And where do they go from here …': Staff, Audrey Withers/*Vogue* © The Condé Nast Publications Ltd; page 190, 'Brevity is the soul of lingerie': *Vogue* © The Condé Nast Publications Ltd; page 200, 'a circus or a madhouse': *Vogue* © The Condé Nast Publications Ltd; page 200, 'Surrealism has swept the country like a plague': *Vogue* © The Condé Nast Publications Ltd

ACKNOWLEDGMENTS

I would like to extend my sincere thanks to the staff of Imperial War Museums, the Lee Miller Archives, the Penrose Collection, Thames & Hudson, Praline and Condé Nast who have contributed to the production of this book.

Particular thanks are due to Antony and Roz Penrose. I would also like to thank Ami Bouhassane, Elizabeth Bowers, Carol Callow, Jamie Camplin, Terry Charman, Lance Downie, Caitlin Flynn, Sarah French, Kate Henderson, Madeleine James, Tracy Leeming, Brenda Longley, Kerry Negahban, Johanna Neurath, Mark Ralph, David Tanguy and Romilly Winter.

INDEX

LEE MILLER: A WOMAN'S WAR